ATHOS
THE HOLY MOUNTAIN

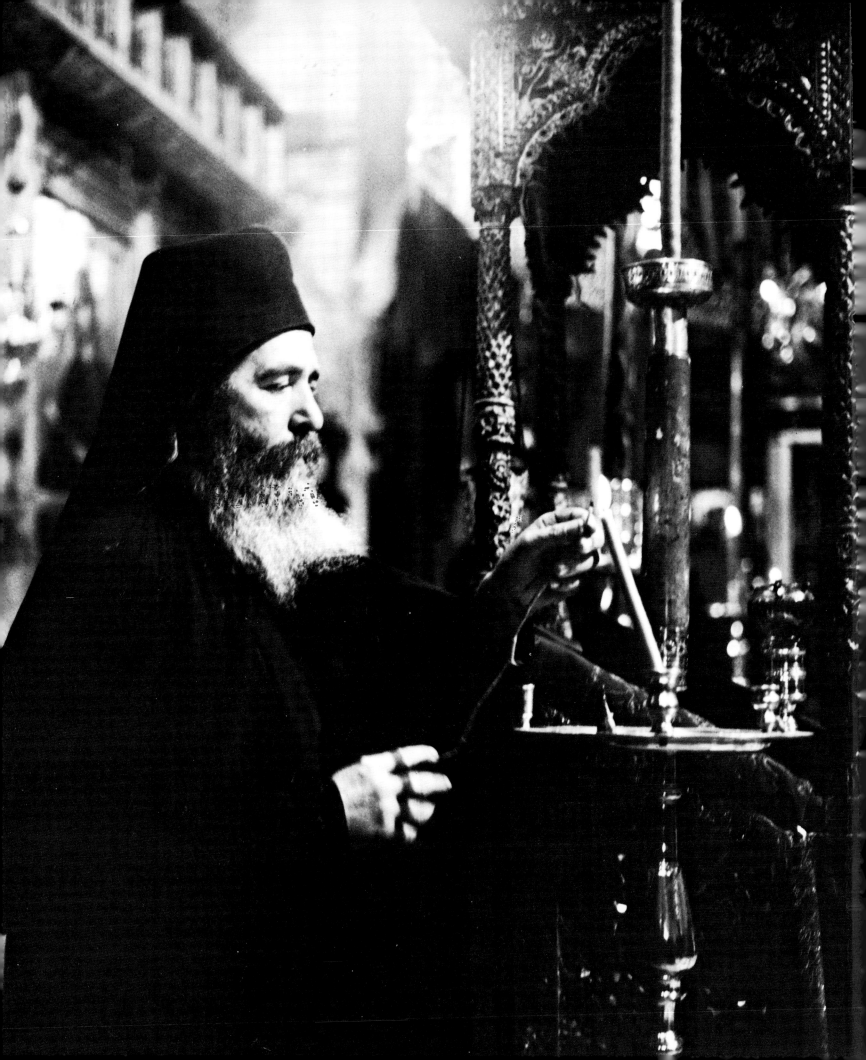

ATHOS
THE HOLY MOUNTAIN

Philip Sherrard

Photographs by
Takis Zervoulakos

THE OVERLOOK PRESS
WOODSTOCK · NEW YORK

First published in the United States by
The Overlook Press
Lewis Hollow Road
Woodstock, New York 12498

© 1982 Alexandria Press Ltd, London

This book was designed and produced by
John Calmann and Cooper Ltd, London

**Library of Congress Cataloging in
Publication Data**

Sherrard, Philip.
 Athos, the holy mountain.

 Includes bibliographical references
and index.
 1. Athos (Greece) I. Zervoulakos,
Takis.
 II. Title.
BX385.A8S36 1985 271'.8
 84–16571
ISBN 0–87951–988–6

Filmset by Keyspools Ltd, Golborne,
Lancs.
Printed and bound by Toppan Printing,
Singapore

Jacket back: The monastery of
Dionysiou.
Right: Aeterington, *Chief Court of the
Monastery of Kilantari*. Nineteenth-century
engraving.

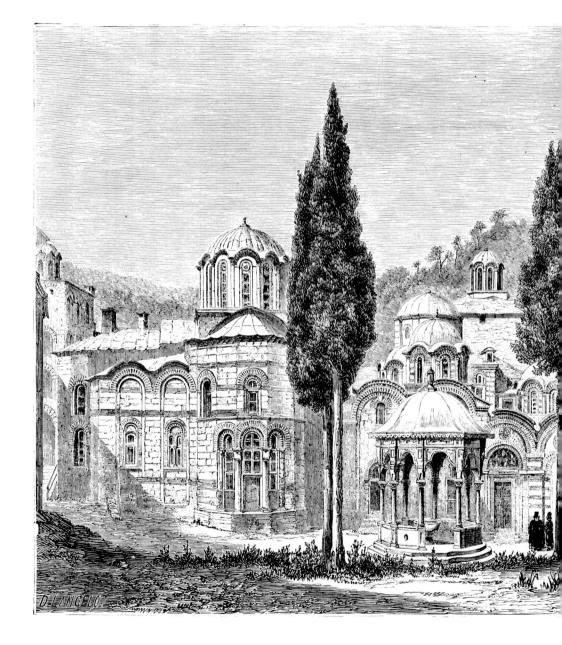

CONTENTS

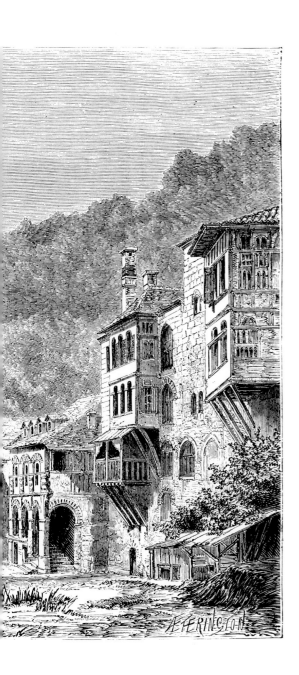

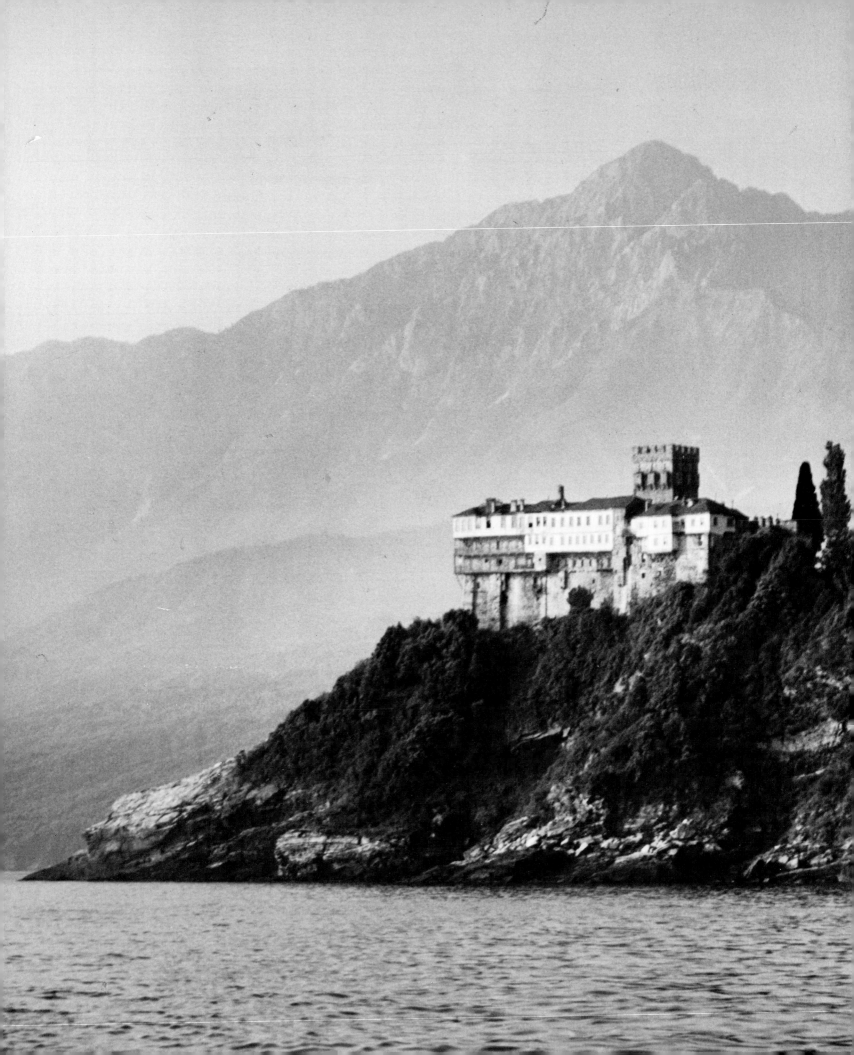

INTRODUCTION

From the northern seaboard of Greece, from the low treeless shore of Halkidiki, three long arms of land reach out into the Aegean. It is at the extreme end of the third and most easterly arm that the mountain which has given the whole of this peninsula its name – Mount Athos – rises some six thousand feet sheer out of the sea, culminating in a single perfect peak, its white marble gleaming against the blue sky. Below this peak a wooded ridge, at no place wider than five, and in some places only two miles across, runs for thirty miles northwards until by a narrow isthmus it joins the mainland of Macedonia. Robert Curzon, an English traveller who visited Mount Athos in the 1830s, describes the journey along this ridge as it could still be described today:

Our road lay through some of the most beautiful scenery imaginable. The dark blue sea was on my right at about two miles distance; the rocky path over which I passed was of white alabaster with brown and yellow veins; odiferous evergreen shrubs were all around me; and on my left were the lofty hills covered with a dense forest of gigantic trees which extended to the base of the great white peak of the mountain.[1]

Despite certain inroads and the felling of much of the heavy timber, Athos has kept its natural beauty. The often steep sides of the valleys that cut into the ridge are covered with olives and vines, ilex and arbutus, wild smilax and osmunda fern. In April Athos is a flower garden. Great golden tufts of St John's wort, with grey leaves and big yellow flowers, line the paths, and above them hang the bright purple flowers of the Judas tree and the white plumes of the Manna ash. Springs abound, and streams run through the thick undergrowth, in summer spilling themselves quietly into the waters of an inlet of the sea, in winter pouring down in white angry cascades. Wild boar and deer still roam the woods, though the wolf's howl and the jackal's cry are now but rarely heard.

The attraction that Athos exerts, however, does not derive simply from its natural beauty. For here, in the valleys, or perched perilously on some steep crag above the sea, rise the weathered walls of monastery and tower, church and chapel. At the base of the great peak, in the crannied southernmost cliff-face, groups of hermits and solitary anchorites keep watch in their stone cottages like eagles in their eyries. For a thousand years and more Athos has been the site of a large monastic community, the habitation of the saints and

1 The monastery of Stavronikita stands high above the sea in the heavily wooded country on the north side of the peninsula. Although it has suffered badly from fires, especially during the nineteenth century, the gate, the walls, and the *katholikon* or church, survive from the original sixteenth-century buildings, together with the great tower, one of the finest on Athos.

7

humble monks who together have earned it the epithet, 'holy', that is now an intrinsic part of its title: Aghion Oros, the Holy Mountain.

Of the twenty monasteries that today constitute the main element of this loose-knit, semi-autonomous community, the oldest – the Great Lavra – was built over a thousand years ago. But all the other nineteen also date from the last centuries of the Orthodox Christian empire of Byzantium and either were founded, like the Great Lavra itself, by imperial decree, or were built and endowed with imperial resources in the form of moneys, land and treasures, though private benefaction complemented this royal patronage. Thus all the monasteries share a rich heritage. The names of Byzantine emperors are still commemorated in their churches. Imperial chrysobulls are zealously guarded in the library of each monastery. The buildings still often bear the scars of their long and turbulent past. Crusaders, Saracens, Franks and Catalans have all left their mark, drawn here by the lure of the immense wealth that poured into the monastic treasuries in the form of gifts from emperor and empress, prince and chatelaine, rich burgher and pious merchant of every part of the Orthodox world, from Jerusalem and Alexandria to Moscow, Kiev and the great Constantinople itself. These gifts are the basis of collections that together make Athos a storehouse of works of art and beauty – icons, illustrated manuscripts, jewelwork, woodcarvings and much else – that must today have few rivals. For through all these centuries, in spite of invasion, piracy, occupation and the more subtle depredations of antiquarian and art-dealer, the monasteries have survived, determining the dominant pattern of communal life on Mount Athos and forming the foundation of its administration and government.

Yet, prior to the establishment of the monasteries, monks and hermits had been living on the peninsula from at least the ninth century and even, according to legend, from much earlier: one tradition states that Constantine the Great, first Christian emperor and peer of the Apostles, himself came to the Mountain in the fourth century and built three churches there, though these were later destroyed by his anti-Christian successor, Julian the Apostate. Be that as it may, the expansion of Islam into the eastern territories of the Byzantine empire, as well as the great quarrel over the veneration of icons – the iconoclastic movement of the eighth and ninth centuries – provoked a considerable displacement of Christians, and it is likely that early colonization of the Mountain is not unconnected with these factors. At all events, its extraordinary geographical conditions and position – paradoxically both its craggy isolation and its proximity to the neighbouring shores of Asia Minor and the rest of Greece – make it especially propitious to the living of the solitary life. The lack of natural harbours, the plummeting southern cliffs, the alarming suddenness of its storms, all contribute to the seclusion and immunity. And although the combined ills of tourism and modern technology have done much to violate these qualities, hermits and solitaries still follow the path of their early forerunners, living witnesses in perhaps the

2 Byzantine ivory carving depicting the twelve main feasts of the Christian year. From the monastery of Vatopedi.

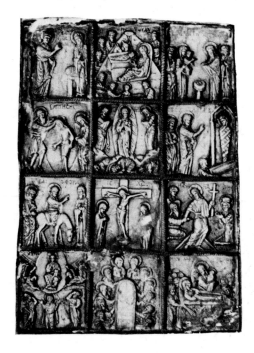

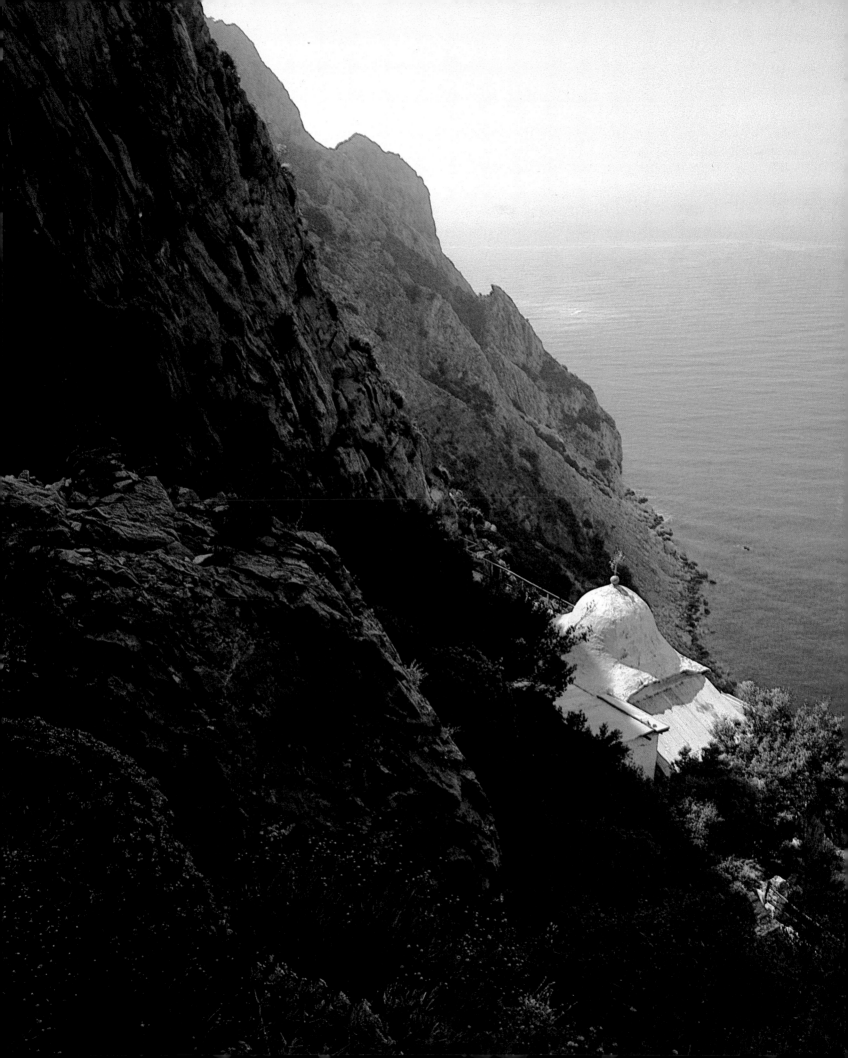

most intense form to the inner realities of the spiritual tradition to which the whole Mountain is dedicated.

For, if Athos continues to exercise a singular compulsion over the heart and mind of man, this is not because of the scenery, lovely though it is, nor because it is a unique medieval survival in the modern world, nor because of its potentialities as the richest museum of Byzantine art and culture that exists. Ultimately it is because it is the centre of a vital form of the spiritual life, a place where man responds to the highest demands that can be made upon his nature and follows a particular and well-charted way towards their fulfilment. Athos has been called the bastion of Orthodoxy; and it is true that throughout the ages the monks have persisted in affirming the doctrinal and liturgical traditions of the Orthodox faith with a tenacity and conviction that make Christianity as lived on the Mountain apostolic in the true meaning of the word.

Yet Athos is also the bastion of Orthodoxy in a deeper sense. For Orthodoxy is not only, or even primarily, a matter of doctrine and liturgical practice. It is, above all, that to which these factors act as indispensable pointers and supports, namely, the living of the spiritual life and the actual experience of the mysteries in which all things are involved. And these are the goals to which the monks on Athos remain dedicated. Through the pursuit of a discipline demanding scrupulous attention to both outer action and inner

4 A chain serves as a support on this hazardous pathway, often the only sort of access to solitary hermitages.

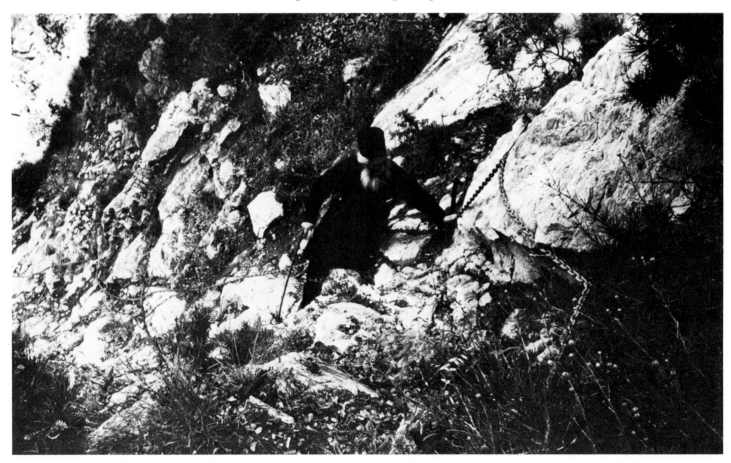

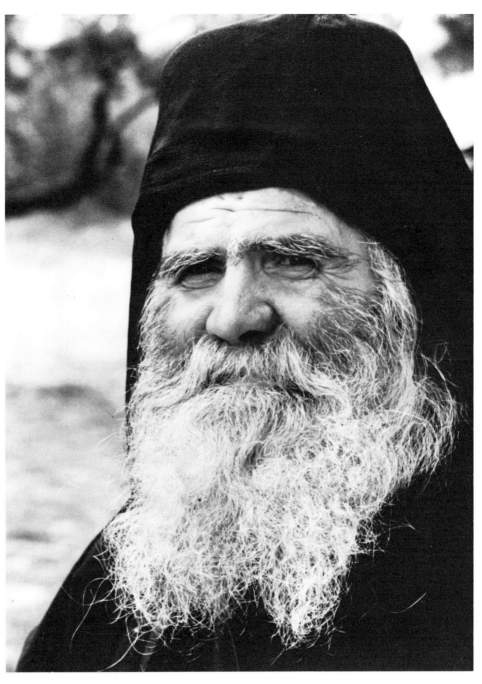

5 A monk of Mount Athos.

prayer, they aspire to traverse the road that leads, by way of ascetic practice and the higher forms of contemplation, to the attainment of the peace that surpasses the understanding. All who visit the Holy Mountain and are touched, however remotely, by that peace, will recognize that they have entered the realm of some presence that, judged by ordinary human norms, can only be described as supranatural. And they will realize that it is not for nothing that Athos has been called, by one of its own poets, 'the domain and garden of the Holy Virgin'.[2]

Katounia, Limni, Evia
Spring 1982. 11

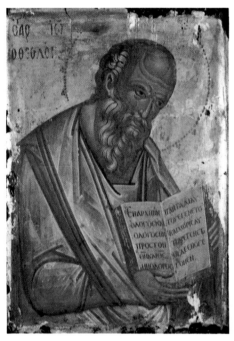

6 'In the beginning was the Word.' St John holding his gospel. Icon of the Cretan school, from the monastery of Koutloumousi. Sixteenth century.

For the beginnings and development of monastic life on Athos, we have to rely on a cycle of legends and traditional stories, a few contemporary accounts and fewer still contemporary documents. The stories of the early history of Athos as a Christian centre, however, have become part of the living texture of the place. They provide a glimpse of that other landscape transformed by visions and wonders into 'the land of miracles'. Although the leading figures – founders, emperors, saints, monks and sinners – are authentic, it is not history that has been the shaping influence over the community so much as divine providence, an immanent and mysterious power overshadowing the Mountain.

In their engravings of the Holy Mountain, the monks depict high over the peak of Athos the figure of the Holy Virgin, Mother of God, its celestial patroness and protectress. Her arrival about AD 49 is told in an apocryphal account. When the apostles, after the death and resurrection of Jesus, cast lots to decide where each of them should go to spread the gospel, it is said that Our Lady asked to join them. Her lot fell for Athos and Georgia. But before she set out the angel Gabriel appeared and told her to delay, and so she remained on in Jerusalem. Then Lazarus, raised from the dead and now a bishop in Cyprus, asked her to visit him before he died again; she agreed and he sent a ship to collect her on the coast of Palestine. Having set sail with St John the Evangelist, their ship was blown off course and, instead of Cyprus, the first land they sighted was a long, wooded mountain ridge culminating in a huge, pale peak of marble. The Virgin looked up to the high peak, saying: 'This mountain is holy ground. Let it now be my portion. Here let me remain.' The vessel put in to a shallow bay at Clementos, where there stood a temple and oracle of Apollo, the site of the monastery of Iveron. As the Virgin came ashore, there was a great crashing sound as pagan idols fell shattered on the ground. A voice issued from the statue of Apollo proclaiming itself to be false and empty. It called on all Athonites to descend to the harbour and worship the Mother of the great god Christ. The Athonites were converted and she baptized them, blessing the mountain and all its inhabitants, her prayers being answered by a voice from heaven. Afterwards she resumed her voyage to Cyprus.

This visit is supposed to be alluded to in the vision in the twelfth chapter

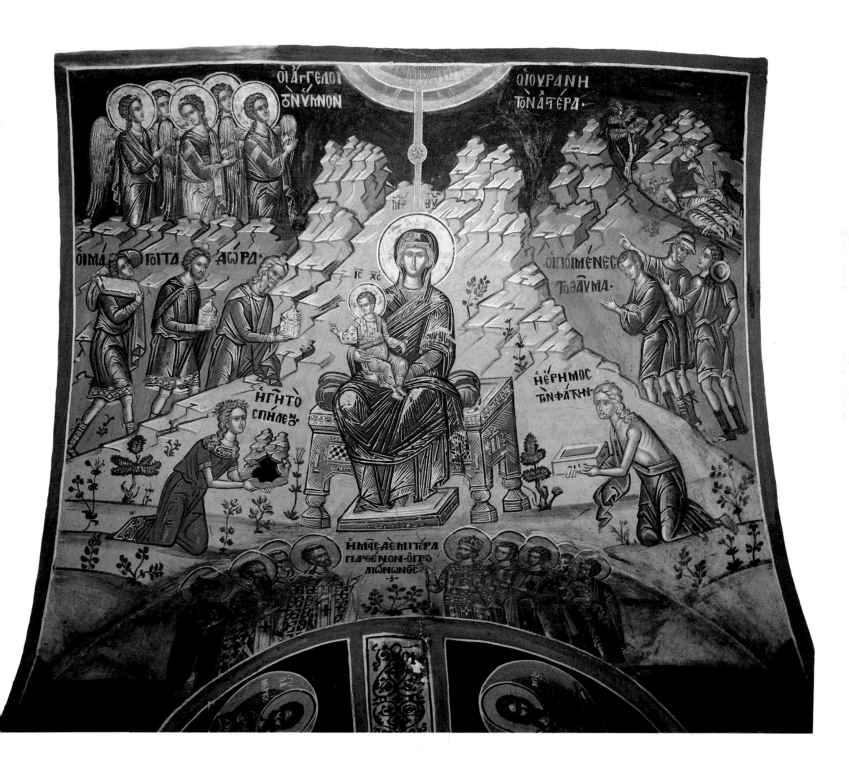

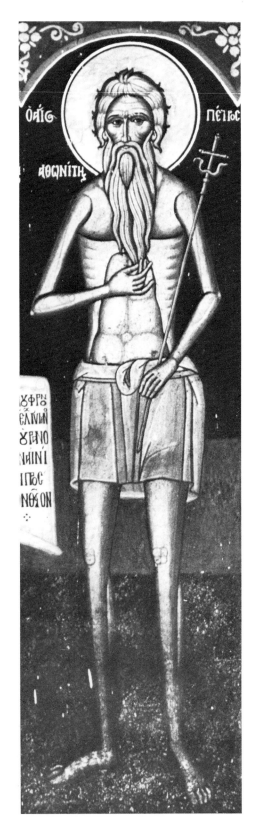

of the Apocalypse: the woman clothed with the sun and with the moon beneath her feet, after her son had been carried away up to the throne of God, fled to the desert, where a place had been prepared for her. The monks on Athos understand the desert to be Athos, in particular the wilder, barer part near the point, called the Erimos ('desert').

The first definite account of the beginnings of the eremitical life on Athos is the story of the ninth-century monk and saint, Peter the Athonite. As a young man Peter vowed to become a monk, but instead joined the Byzantine army fighting against the Arabs in Syria. He was captured and imprisoned, a misfortune he blamed on his failure to keep his vow. Invoking the intervention of St Nicholas, whom even the Arabs venerated as a great protector and wonder-worker, Peter again promised to take up the religious life in return for his freedom. After the saint's intercession Peter was released and sailed to Rome to be ordained by the pope. Later he returned on a ship bound for the Levant. On the way he dreamed that he saw St Nicholas and the Virgin talking together. She told him how she had received Athos as her own and she said that Peter would live the rest of his life there under her protection.

Soon afterwards the vessel sailed close to Mount Athos where it was inexplicably delayed. The hagiographer takes up the tale:

Though the wind still blew and the sails billowed, the ship suddenly stopped. The sailors were at a loss and asked each other: 'What is this sign, this new wonder that in an open expanse of sea and with a favourable wind the ship is not moving?' Anxious to put their minds at rest, the saint told them: 'Children, if you wish to know the meaning of this, tell me the name of this place'. They replied: 'It is the Holy Mountain, venerable father, which from ancient times has borne the name of Athos'. Then he said to them: 'Perhaps this sign has occurred on my account. Unless you abandon me here you will not be able to proceed'. Sadly the sailors lowered the sails and approached the shore, and with tears and lamentations left him there. He climbed up a difficult path and, after resting on a cool and level place, began to explore his new retreat. Passing through streams and valleys and over hills, he came to a dark cave. It was surrounded by thick vegetation and so many animals that they outnumbered the stars of the heavens or the grains of sand in the sea. It was also infested by a host of demons who raised up so many trials against the holy man that no tongue could recount or even credit them.[3]

Within two weeks of Peter's arrival, so the pious biographer records, Satan appeared gathering together his hosts 'armed with bows and arrows' to launch the attack. He was repulsed but, undaunted, returned in fifty days, then again after a year. Finally, seven years later, when Peter had reached a perfect state of humility and mental purity, Satan struck again, disguised as an angel of light. But the last attack was no more successful than the first and Peter emerged from his trials triumphant.

With the wild beasts and wilder demons for company, Peter spent fifty years in the cave, which can still be seen near the edge of a cliff close to the

Great Lavra monastery. Towards the end of his life, he was accidentally discovered by a hunter who was pursuing a stag over the desolate solitudes. Peter told him his story, advising him to follow his example and embrace the ascetic life. The hunter agreed and, after paying a farewell visit to his family, he returned with some companions a year later. They found the old hermit dead and took the corpse away in their boat. Opposite the monastery of Clementos, however, where the Virgin had landed, the boat was stopped suddenly. The monks put out from the shore, and when they discovered the body on board they forced them to land and hand it over. The hunter did so and withdrew.

St Peter is a true example of the solitary monk or anchorite, whose life is a long struggle against hostile forces and whose final victory blazes a trail for others to follow. On Athos, as in Egypt five centuries earlier, the monastic beginnings are found in the solitary life. The next development on Athos, also as in Egypt, was the establishing of a *lavra*, a colony of hermits loosely associated with each other. An early biography describes St Euthymios,[4] the first founder of such a *lavra*. A spiritual guide who attracted others through the force of his personality and ascetic reputation, St Euthymios is the Athonite counterpart of the Egyptian St Pachomios. He was born in 823, married early, but soon abandoned his wife and child to become a monk. The monastery he entered proved unsatisfactory and he left to become a hermit on Athos. On the way he told his family of the decision and persuaded them to follow his example – all except his daughter Euphrosyne who was supposed to continue the family line. Mother, wife and sisters, we are told, all followed his advice and retired to convents, while Euthymios continued onwards to Athos. When he arrived there, he and a companion, Joseph, commenced austerities by living like cattle, going around on all fours and eating grass. Thereafter they took up residence in a cave, intending not to emerge from it for three years. Joseph was forced to retire halfway through since 'the opposition of the lower creation was so pronounced'. But while Euthymios struggled on alone, his friend eagerly proclaimed his feat to the world, and when three years were up Euthymios emerged from his cave to find numerous monks in dwellings nearby, waiting for him to assume his role of guide.

By the end of the ninth century there were many hermits living in such *lavras*, and they had become sufficiently organized to send a representative to Constantinople. This man, Andreas, was styled 'first hesychast' which is the first mention of what was afterwards the important position of *protos* or primate of Athos. On behalf of the hermits he successfully lodged an appeal with the emperor against encroachments on their territories on the Mountain.

The third stage in Athos' monastic development was the founding in the middle of the tenth century of the Great Lavra by St Athanasios. The orphan of wealthy parents from Trebizon, he was brought up in Constantinople where he met Michael Maleinas, abbot of Kyminas monastery and uncle of a Byzantine general, Nikephoros Phokas, who later became emperor.[5]

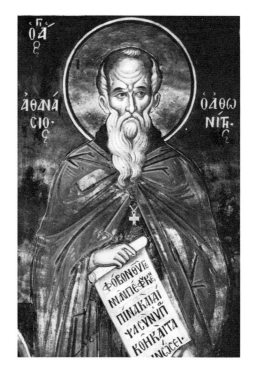

9 St Athanasios the Athonite, founder of the Great Lavra, the first monastic foundation on the Mountain. Wall-painting by Tzortzis, from the *katholikon* of the monastery of Dionysiou. Mid-sixteenth century.

15

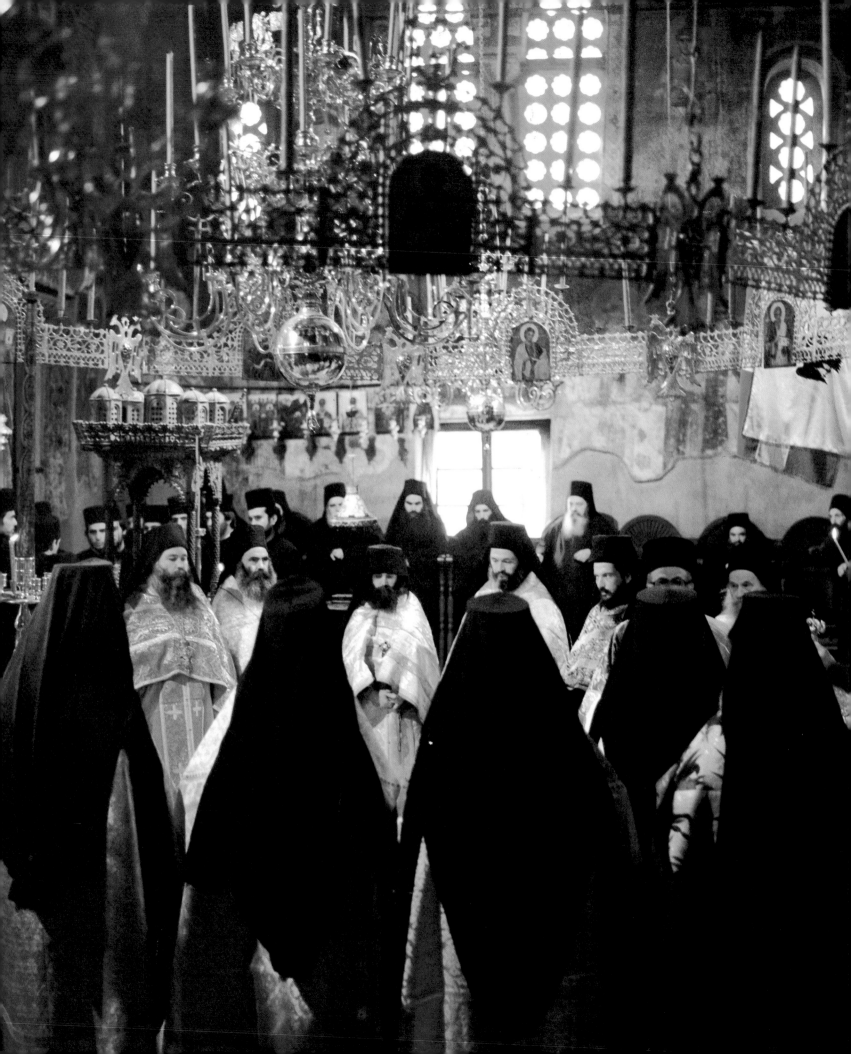

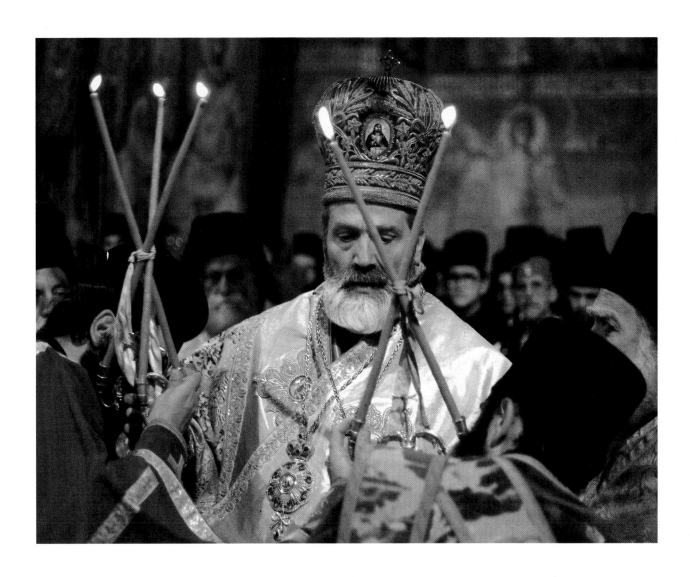

10, 11 Inside the Protaton, Karyes. A ceremony for the installation of the *protos* or head of the Athonite community. *Above* A bishop in
splendid regalia officiates at the ceremony.

Athanasios became a monk in this monastery, was nominated abbot on Michael's death and at the same time was appointed Nikephoros' confessor. Nikephoros, who was to become known as the 'White Death of the Saracens', was a mystic as well as one of Byzantium's greatest soldiers. He often told his friend Athanasios of his longing to quit his military campaigns and retire to the contemplative life. But Athanasios was reluctant to wait for him, perhaps foreseeing Nikephoros' great imperial role. Disguised as a peasant he left Constantinople and escaped to Athos.

When Athanasios arrived there, according to his biographer:

he walked through the whole length and breadth of it. Seeing all the ascetics and solitaries, and the harshness of their rough and lonely lives, he marvelled and rejoiced and was greatly edified. For these good fathers neither cultivated the earth nor got involved in possessions. They weren't distracted by bodily cares, they didn't own beasts of burden, asses, or dogs, but lived in grass huts where, summer and winter, scorched by the sun and frozen by the cold, they simply endured. When they had to convey something from place to place they put padding on their shoulders to support the load and carried it where they could. They ate acorns and wild fruit, and when someone anchored a ship near the mountain, they exchanged some of this for corn, millet or other kinds of grain. This did not take place without a great deal of anxiety and the exercise of much care and caution for there were frequent raids by impious Arabs from Crete who used to set ambushes in the rocky hollows of the shore. They used to kill many monks of the mountain for the sake of their fruit.

Impressed by the simplicity of life, Athanasios, still incognito, became a hermit at the *lavra* of Zygon. Nikephoros, however, discovered his whereabouts and arranged for him to be given a special cell, probably in the cliff-face at the promontory's southern tip. He also visited Athanasios, calling for his blessing for a successful Cretan campaign against the Arabs. If the strategic goal of driving them out be accomplished, he promised that he

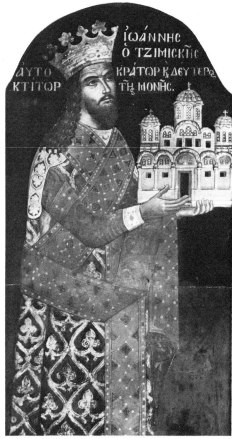

13 The Emperor John Tzimisces holding the Great Lavra, to which he presented a *typikon* or charter at the end of the tenth century. Wall-painting by Theophanes the Cretan, from the Great Lavra. Mid-sixteenth century.

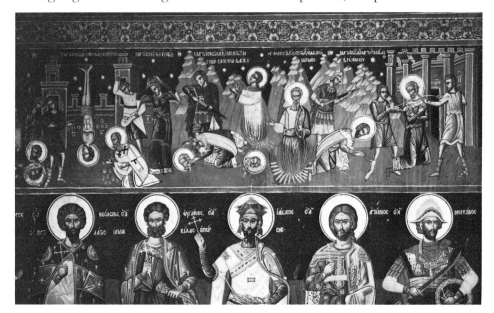

12 Martyrologia: scenes depicting the persecution of martyrs. Wall-painting of the 'Cretan school', following the style of Manuel Panselinos, from the refectory of Dionysiou. Seventeenth century.

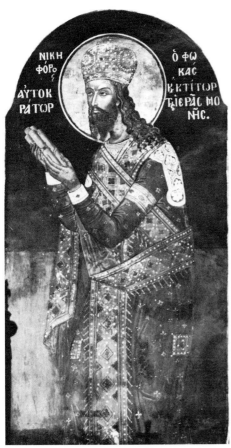

14 The Emperor Nikephoros Phokas, 'founding patron' of the Great Lavra, holding the chrysobulls in which he granted the monastery lands and privileges at its foundation. Wall-painting by Theophanes the Cretan, from the Great Lavra. Mid-sixteenth century.

would become a monk in return. In due course the Arabs were beaten, their naval supremacy in the eastern Mediterranean was broken and Nikephoros failed to keep his word. To appease his conscience he offered the holy man a share in the plunder. This was to go towards the building of a great monastery on the mountain where Nikephoros might retire in his old age. Athanasios refused many times but finally agreed; and so began the raising of Athos' oldest and most famous monastery, the Great Lavra.

But there were uncanny opponents. Athanasios' biographer says that meddlesome demons pulled down by night whatever the saint and his builders put up by day. The interference went on till he was in despair. Men, money and materials were exhausted. He left the site, perhaps to leave the mountain altogether. On his journey along the north-east coast, some two hours along the path, he met a woman. Then, as now, women were barred from the mountains and Athanasios suspected she was another pestilential apparition. On his making the sign of the cross, she declared she was the Holy Virgin. Still hesitating, he asked for some further assurance. She replied that he should make the sign of the cross on the rock by the path and strike it with his staff. Athanasios did so and at once a stream of clear, cool water gushed out. With the promise of her help and protection, he returned to the building, which with her divine aid was finally completed.

Just before its completion, news of Nikephoros' acclamation as emperor reached the Mountain and with it the report that he had married the Empress Theophano, widow of his murdered predecessor Romanus II. Athanasios hurried to the capital to remonstrate with his old friend at such inexcusable behaviour. He declared that he was no longer interested in Athos and would not be returning. The emperor threw himself on his knees, imploring forgiveness and swearing that one day he would join him on the Holy Mountain. He gave Athanasios a chrysobull granting formal recognition of the new monastery and making it independent of all but imperial authority. Other grants lavished revenues on the monastery, including an annual income of 244 gold coins from the neighbouring island of Lemnos. Among the gifts he showered upon the saint to soften the agony of his conscience were the great jewelled Bible and the reliquary of the True Cross, still among the greatest treasures of the Mountain. Athanasios returned to Athos. Not so Nikephoros, who later was murdered in his bed by Theophano and her lover, John Tzimisces, who seized the throne.

The chrysobull gave the new monastery a dominant position on the Mountain. Its eighty monks would all take part in the community's ruling body at Karyes, the administrative centre of the Mountain, and yet would be immune from any sort of interference. The other fathers wasted no time in sending off the community's *protos* to John Tzimisces to complain of such favouritism. Athanasios, they said, was oppressing the Mountain and destroying its ancient customs and practices: 'For he has built magnificent buildings and constructed towers and harbours. He has changed the course of

19

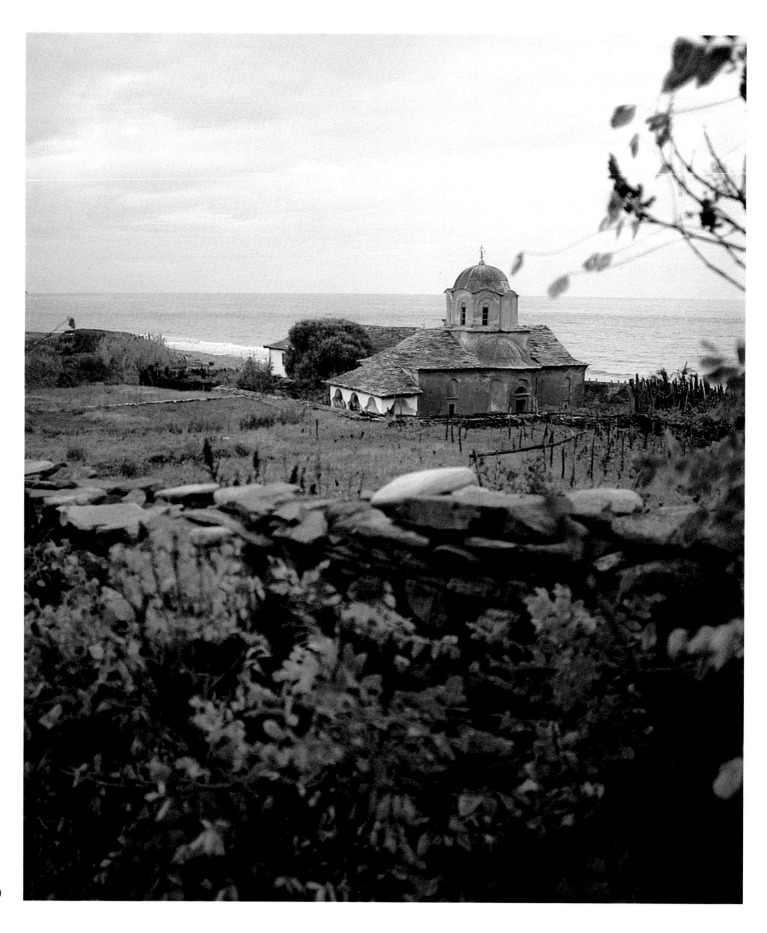

15 *Left* A chapel near the monastery of Iveron.

16 The Presentation of the Virgin at the Temple. Detail of a wall-painting by the thirteenth-century painter, Manuel Panselinos, from the Protaton, Karyes.

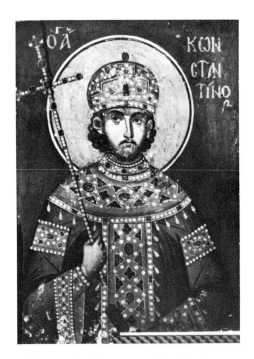

17 Constantine, the emperor saint who, in 313, established Christianity as the religion of the Roman Empire and the capital at Constantinople, the ancient Byzantium. Wall-painting by Manuel Panselinos, from the Protaton, Karyes. Thirteenth century.

streams and brought pairs of oxen, cultivating fields and planting vineyards. In short, he has given a worldly aspect to the mountain.' But the investigation ordered by the emperor only resulted in a confirmation of the Great Lavra's position.

By the time of St Athanasios' death, between 997 and 1011, the population of Athos had risen sharply with an influx of monks from all over the empire, as well as from Rome, southern Italy and Armenia. Of the monasteries that survive today, three more had come into being – Iveron, Vatopedi and Esphigmenou. Eight followed in the eleventh century; two in the twelfth; one in the thirteenth; four in the fourteenth; and one in the sixteenth. Meanwhile, the number of hermits had also increased and differences between the two communities inevitably came to a head. The hermits sensed, correctly, that they were being taken over; territorially and economically they were being reduced to a state of dependence on the larger monasteries, which gradually absorbed and came to control the eremitical establishments. But the immediate reason for lodging a new complaint with Emperor Constantine IX were the abuses and commercialism which had grown up in the community's capital. Immorality on the part of the monks was not actually alleged, but the new *typikon* or charter of 1046 expressly prohibited beardless youths and eunuchs from the Mountain, as well as the selling of certain items – which the emperor confessed himself ashamed to name – in the Karyes market.

In spite of gaining imperial condemnation of these abuses, the hermits found that the monasteries' dominant status was affirmed, and that their own leader – the *protos* – had his powers reduced. In 1094 Emperor Alexios Comnenos took the development a stage further by granting independence to the Mountain from the two bishoprics of Ierissos and the Macedonian capital, Thessaloniki. Alexios also granted the community large tax exemptions, in the hope that 'the most royal and divine Mountain should stand above other mountains of the universe, as Constantinople stands above other cities'. During his reign, however, occurred a scandal which deferred the brilliance.

Women had long been included in the general proscription from Athos of female creatures. In making this proscription, the monks had followed the advice of St Theodosios the Studite, one of the great fathers of Orthodox monasticism:

Have no animal of the female sex in domestic use, seeing that you have renounced the female sex altogether, whether in house or field; for none of the holy fathers had such, nor does nature require them. Be not driven by horses or mules without necessity, but go on foot, in imitation of Christ. But, if there is need, let your beasts be the foal of an ass.[6]

Moreover, there was a particular prescription which applied to Athos: Heaven's Queen claimed the monks' whole devotion, a devotion she was unwilling to share with any of her earthly images, however exalted. Legend tells how a nephew of Emperor Theodosios was on his way to Constantinople to see him when he was shipwrecked at the site of the later monastery of

Vatopedi. When he had been rescued and come to shore, he heard a voice telling him to rebuild the church originally founded on that spot by Constantine the Great, but destroyed by Julian the Apostate. The building material for this undertaking was sent from Rome and with it the four great columns to support the dome of the church. While clearing the site, workmen found a deep well from which they brought out an icon of our Lady and Christ. When the church was completed, Empress Placidia went with her husband Theodosios to admire the work. The Icon of our Lady was now hanging by the north wall of the church in a dark narrow passage from the narthex to the side chapel of St Demetrios. As Placidia entered the church she heard a voice speak from the icon: 'Go no further; in this place there is another Queen than you.' Placidia retreated, having never enjoyed the beauty of the church which she had helped to build.

The scandal that disturbed the tranquillity of Athos in the reign of Emperor Alexios concerned not one woman but many, and not of exalted rank but simple peasants. Groups of nomadic shepherds, mainly Vlachs from the Danube, settled within the frontiers of the Mountain, pasturing their flocks and trading with the monks. Their presence, three hundred families strong, was disquieting:

for the devil had entered the hearts of the Vlachs, who brought their women with them dressed in men's clothes, like shepherds, and the women pastured the flocks and worked for the monasteries, bringing to them cheese and milk and wool, and even baking during the festivals. In brief, they were very much liked by the monks to whom they were as serfs. And the things that occurred are shameful both to tell and to hear.

18 A chrysobull of the Emperor John Paleologos, from the monastery of Vatopedi.

An uproar followed, and some of the monks made an appeal to Constantinople. At this stage the issue took a fresh turn: for the first time in the history of Athos the patriarch interfered in the internal affairs of the monastic community, expelling the shepherds and excommunicating the monks involved in the scandal. But this patriarchal intervention seemed as potentially dangerous to the monks as the invasion of the Vlach shepherds which it had repulsed. 'Many', it was recorded, 'not only of the ignorant monks, but of the well-educated abbots and hesychasts were disturbed.' At Christmas 1097 the monks gathered as usual in Karyes for the feast. The festivities began with an anathema against the disturbers of the peace of the Holy Mountain. A committee of three was elected, provided with a letter to the emperor, and sent to Constantinople to inform him that 'the order of the Most Holy and Ecumenical Patriarch has made the Mountain a desert'. Alexios responded with a letter to the patriarch: 'God, as you know, gave an order to our progenitors while in Paradise, which the latter did not obey for one day, perhaps not even for three hours; and yet he did not destroy them. Your Holiness, on the other hand, has destroyed the Holy Mountain through your order, in spite of the fact that Athos is not under your jurisdiction, but under Royal Authority.' In his answer to the emperor the patriarch replied

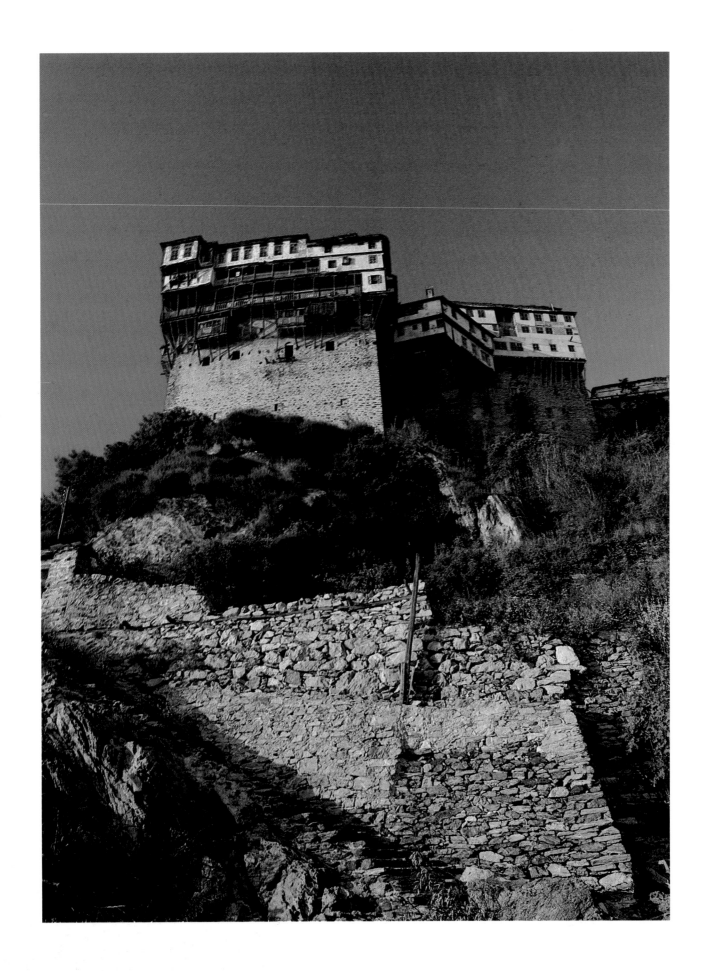

that he had not given 'orders' to the Holy Mountain, but 'only reproofs and instructions so that the Vlachs should remain outside Athos', a right which he possessed by the grace of God. The exchange of letters continued, while conditions on the Mountain became more and more deplorable.

The affair was not closed till the death of the chief figures in this controversy, when, in 1177, a new patriarch issued an order limiting the responsibility for the violation of rules to those who broke them. Life on Athos resumed its normal course, and once more the number of monasteries grew: at the beginning of the thirteenth century, three hundred monasteries are mentioned as existing on Athos. But the scandal had one permanent result: it established the patriarch of Constantinople's right to interfere in the affairs of Athos; and this right, modified and refined through the centuries, has continued down to the present day.

New troubles were soon to disrupt the peace of Athos. This time the disturbing element came from the west. The motley armies of the pontifically sanctioned Fourth Crusade, ostensibly bound for the Holy Land, were diverted northwards and set against Constantinople. In 1204 they captured the city, committing against their Christian brethren atrocities far in excess of those committed by the Muslim Turks when they captured the city in 1453. In the division of the empire following the Latin conquest, Athos, together with the 'Kingdom of Thessaloniki', fell to Boniface of Montferrat, and was placed within the jurisdiction of the bishop of Sebaste by Benedict, papal legate to this ill-begotten and transient kingdom. The consequences to the Holy Mountain were disastrous. The Latins, subscribers to an alien creed, regarded the Greeks with as great a dislike as they regarded the Muslims. The bishop of Sebaste built himself a castle (today known as Frangocastro) on Athos. This he used as a base for the systematic plunder of the Holy Mountain. Monasteries were pillaged, churches destroyed, monks tortured. At last, in deference to the representations of the Latin emperor, Henry of Flanders, Pope Innocent III restored to Athos its original status of dependence on none but the head of the state, accompanying his edict with sententious comments on the Mountain's arid soil but spiritual fecundity. Athos was, apparently, not disturbed by baron or bishop during the latter part of the Latin domination, though it is by no means clear whether this was due to the pope's intervention or to the fact that the most valuable treasures had already been successfully looted from the Mountain. In 1261 the Greeks recaptured Constantinople, and Athos returned to the Byzantine fold.

This return was, however, the prelude to yet another series of troubles. Michael VIII Palaeologos, the first emperor after the Greek restoration, sought to strengthen the structure of his empire by bringing about a reunion of the divided halves of Christendom. A prerequisite of this was agreement on theological questions and, more important, on ecclesiastical organization. Such an agreement was only likely to be effected if the ideas of the Greeks on these questions could be subordinated to those of the Latins. Michael

19 *Opposite* The monastery of Dionysiou, perched on its sheer foundation of wall overlooking the sea on the south side of the peninsula. Founded in 1380, it was largely rebuilt after a fire in the sixteenth century.

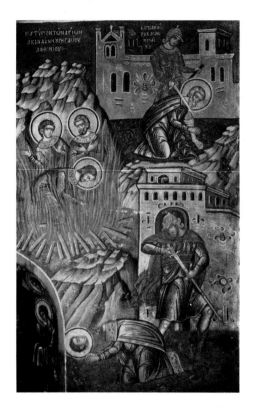

20 The sufferings of the martyrs. Wall-painting from the monastery of Koutloumousi.

21 *Opposite* Sunday gathering of monks at the Protaton, Karyes. Reputedly the oldest building on Athos, the church is said to be a tenth-century rebuilding of an original church by Constantine.

Palaeologos, with the aid of the patriarch of Constantinople, Bekkos, sought to achieve this. Their efforts met with an indignant and violent resistance both from the capital itself and from Athos. The monks had had one bitter experience of Latin overlordship and exploitation already, and were not anxious to have another. Moreover, they were, from the dogmatic point of view, the most stubborn and tenacious element among Orthodox Christians. They sent a delegation to Constantinople with a 'dogmatic' letter upholding the traditions of Orthodoxy, and refusing to transfer their allegiance to Rome. Legend has it that Michael sent a punitive expedition to Athos, and even that he came himself. Monasteries on the Mountain were attacked and burnt; monks were expelled, or drowned. Two cenotaphs at the church of Karyes, the Protaton, are today pointed out to the visitor as indicating the place where many victims of imperial wrath are buried, while another cenotaph at the monastery of Zographou is indicated as the place where twenty-six monks had fortified themselves within the tower only to be burnt alive. It is also said that the monastery of the Great Lavra yielded to pressure and allowed the Latin mass to be celebrated. A black mist fell and covered the monastery while the mass was in progress, and the bodies of those monks who took part in the mass did not decompose at death, and lie to this day in an inaccessible cave, the Cave of the Wicked Dead, in a cliff-face not far from the monastery. Their hair and their nails still grow.

The persecution of the Athonite monks ended with the death of Michael VIII in 1282, when the new Emperor Andronikos II Palaeologos rescinded the union with the West and helped the monks to restore their properties. But the memories of the Latin occupation, of the attacks by the Emperor Michael and the Patriarch Bekkos, and of the abortive attempts at union in the last days of the empire, created in the Athonite mind a general attitude of resentment against, and suspicion of, the Latins and their activities. A wall-painting in the monastery of Hilandari reveals this attitude. It shows the ship of the Church voyaging through the troubled and threatening seas of the world. It repels the attacks of Muhammad and of the leading early Christian heretic, Arius. Then the pope, using his pontifical cross as a grappling-iron, tries to draw the ship to him. But he fails, and the ship sails on to port, where St Paul at Christ's command prepares to cast anchor. Orthodox priests draw the ship in towards the shore. On the stretch of land where the enemies of the Church stand, a gulf suddenly opens, and they fall into the gaping mouth of hell.

What was perhaps the worst devastation in its history fell on the Mountain during the following century. In rescinding the union with the West, Andronikos had deprived himself of a possible source of aid in his attempts to defend the threatened territories of the empire. He sought other aid, and in 1302 had an army of mercenaries imported from Spain, mainly from Catalonia. For a short period they served the empire in Asia Minor, but their habit of plundering and oppressing the people they had been sent to protect compelled Andronikos to recall them. This the Catalans did not approve of.

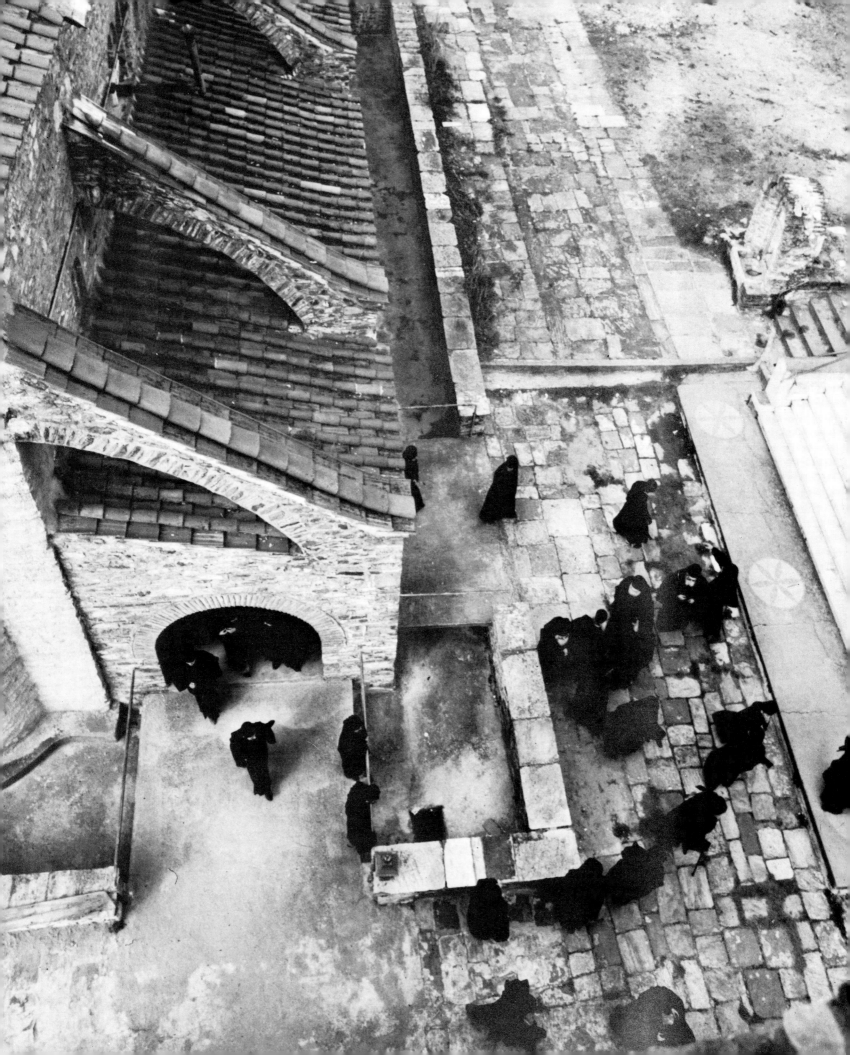

Encamped at Gallipoli, they threatened to attack the capital itself. After a time they moved westwards, and in 1307 established themselves on Cassandra, the first of those promontories reaching out into the Aegean from the shores of Halkidiki. For two years Athos was exposed to the raids and ravages of these merciless professionals. The monks were 'slaughtered like lambs', monasteries were abandoned, treasures plundered. Of the more than two hundred monasteries existing in the thirteenth century, only twenty-five survived in the fourteenth century. In 1309, the Catalans continued their march southward and moved into Thessaly.

In the fifteenth century, by which time Athos had made at least a partial recovery, another change in its status took place. In 1430, the Turks, penetrating deep into the lands of the disintegrating Byzantine empire, captured Thessaloniki. By a timely capitulation to the Sultan Murad II in that same year, the Athos monks escaped another series of devastations of their territory. In addition, they secured from the sultan a recognition of the autonomy of the Athonite community. The political control of the Byzantine emperor over the affairs of the Mountain was now at an end. Nor did the sultans, when twenty years later they began their four centuries of rule from

22 The *Katholikon* domes in the courtyard of the monastery of Vatopedi.

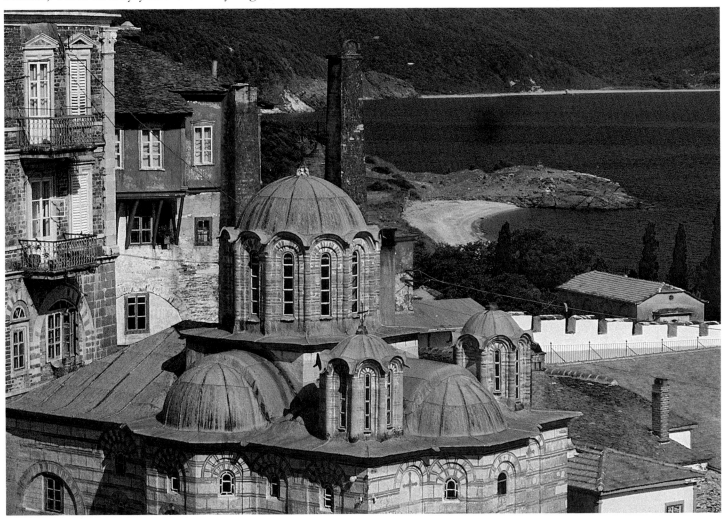

Constantinople itself, ever revive this control to the extent of seriously interfering on Athos or of attempting to regulate conditions there. During this long period of Turkish rule, Athos was in fact, like the rest of the Greek world, placed within the temporal jurisdiction of the ecumenical patriarch; but the patriarch's power, unsupported by the sultan's political arm, or opposed by the monks, tended to be ineffective.

In the absence of this external control, Athonite history was relatively undisturbed if also unspectacular during this period. In the sixteenth century some of the monasteries were rebuilt through the generosity of the princes of Moldo-Wallachia, who were to be the great benefactors of Athos up to the nineteenth century. In 1540, the monastery of Stavronikita, the latest of the twenty ruling houses that exist today, was re-established. In 1574, the Patriarch Jeremiah sought to remedy the financial plight of the monasteries by calling upon the Constantinopolitan Guild of Furriers to audit their accounts, and it was at this time also that the number of ruling monasteries was fixed at its present figure of twenty. In the seventeenth century, a Turkish governor, with the same kind of functions as a French *sous-préfet*, was appointed as adviser to the community.

23 The monastery of Vatopedi, screened by wooded hills. Founded in the tenth century, it is an idiorhythmic monastery.

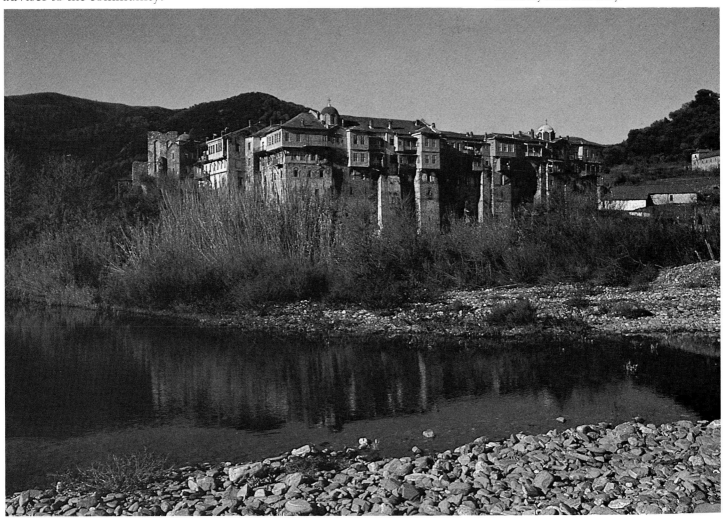

29

In 1749 a school, or Academy, was founded on Athos. It seems to have been promoted mainly by the abbot of the monastery of Vatopedi, and was supported morally and materially by the Patriarch Cyril V. A product of the movement towards 'enlightenment' that was then beginning to spread into Greek lands and to captivate the Greek mentality, the school was directed by a committee of laymen and by the abbot of Vatopedi, and was designed to teach, not only theology and ecclesiastical subjects, but also secular subjects such as logic, rhetoric and Aristotelian science. Laymen as well as monks were admitted, and in 1753 these were exempted from the old regulation excluding beardless people from the Mountain. The school, of which the gaunt ruin still remains on a small hill near the monastery of Vatopedi, did not last long. It reached the height of its reputation under the directorship of the then leading Greek representative of the 'enlightenment movement', Eugenios Bulgaris; but the general repugnance of his teaching to the Athonite mentality led to a reaction among the monks, whose charges finally compelled him to resign. In his place the patriarch appointed Nicolas of Metsovo; but there was little support for the school, and in a few years neglect and a fire reduced the building to its present state.

In an attempt to reform the internal government of the Athonite community and to provide some check on abuse and laxity, in 1783 Patriarch Gabriel issued a new *typikon*. By this charter the twenty monasteries were divided into five groups of four monasteries, each group being assigned the administration of the community as a whole for one year. The committee formed annually by the representatives of the four monasteries was called the Epistasia, and served as the executive body of the general assembly to which all the monasteries sent representatives. In addition to its executive duties, this body was constituted as a court of the first instance, the general assembly of all the representatives serving as a court of appeal. Furthermore, the Epistasia was given the right to interfere in the affairs of 'small' monasteries should their financial condition demand it. Thus a central administrative body was formed which was empowered to control the affairs of the entire community.

This attempt to give stability to the government of Athos was, however, interrupted during the first quarter of the nineteenth century by an abortive rising of the monks in sympathy with the Greek revolutionaries who in 1821 began their war of independence against the Turks. Legend has it that a cross of light appeared on the summit of Mount Athos, bearing, as it once had to Constantine the Great, the words, 'In this sign conquer'. As a consequence of this rising, a Turkish army invaded the Mountain. Comprised of some 3,000 soldiers, it was quartered in various monasteries for nine years, and the monks were made to pay its expenses. In addition, a heavy indemnity was imposed on the entire community. The reprisal that their rising had provoked proved too heavy for the monks to bear. Many left the Mountain: the number of monks is said to have fallen from six thousand to one thousand. Lands remained uncultivated, and conditions on the Mountain reached a low ebb. It was only

after the withdrawal of the Turkish troops that the surviving monks, through the strenuous collection of alms and by the exploitation of their possessions, managed to pay the accumulated debts, and to begin the renewal of normal Athonite life.

Turkish sovereignty over Athos came to an end in 1912. Except for the above incident, which the monks themselves had provoked, in many respects Athos enjoyed more freedom and independence under the Sultans than under the Byzantine emperors, for the former had no particular interest in interfering in the internal affairs of the community. The Turkish *kajmakam* at Karyes summed up this conclusion to two French travellers at the time of the 'liberation' of Athos by the Greeks in 1912. He is reported to have said:

Look round you, look at these thousands of monks; visit their monasteries, question them yourself. Of what, in reality, can they complain? Have we touched their rules? Have we violated their property? Have we forbidden their pilgrimages? Have we altered a single item of their secular organization? . . . Always the West is talking of Turkish fanaticism. But what race, I ask you, what conqueror could have treated these people with greater humanity, greater moderation, greater religious tolerance? Under our law they have remained as free, even freer, than under the Byzantine emperors. And . . . they have not had to endure under our domination a hundredth part of the vexations that you have imposed on your monks in France. . . . They will regret us, monsieur.[7]

Meanwhile, a different problem of international relationships, this time between the Russian and the Greek element on Athos, had grown up during the nineteenth century. Orthodox monks of all races and languages had been admitted to Athos since the very beginning of the present monastic system, for Athos was essentially a pan-Orthodox centre independent of racial and linguistic categories. St Athanasios himself had aided John the Iberian to

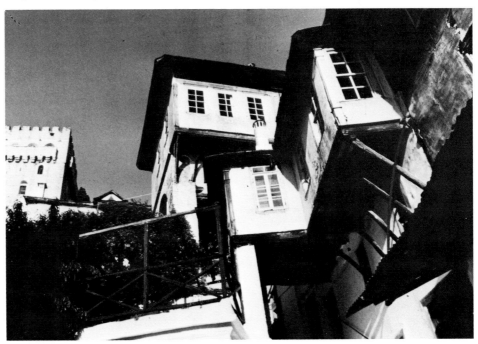

24 Dokheiariou: the great tower from the court. The monastery was traditionally founded by Euthymios, superintendent of stores (*dokheiarios*) at the Great Lavra.

establish himself on Athos, and the foundation of the Iberian monastery (Iveron) dates from AD 1000 or even earlier. In a few years it was one of the leading houses, and excited the admiration and envy of the Greeks. About the middle of the fourteenth century the Greek majority, by intriguing with the *protos*, sought to displace the Iberians. On the recommendation of the *protos* the patriarch decided that the services in the *katholikon*, the main church of the monastery, should be in Greek, while the Iberians and their language should be confined to one of the smaller churches. The abbot was to be elected from among the Greek monks.

The secret history of this intrigue has, naturally, disappeared; but it seems very similar to that of the later intrigue by the Russians for the capture of the monastery of Panteleimon, the only monastery they at present hold on the Mountain. Slav races appear in monasteries as early as the twelfth century, when the Russians were established at the now vanished monastery of Xylourgou, the Bulgarians at Zographou and the Serbians at Hilandari. The growing political importance of the Serbians during the reign of Stephen Dushan and down to the battle of Kossovo (1389) is marked by the Serbian foundation of Simonopetra and the refoundation of St Paul's. A century later, the monasteries of Grigoriou, Dionysiou and Dokheiariou are also cited as being Serbian. These monasteries have now been lost to the Serbs, even Hilandari having been Bulgarian for a time. The other non-Greek monasteries in 1489 – the Bulgarian Simonopetra and Philotheou, with the Albanian Karakallou – are likewise now Greek; St Paul's and Xenophontos, two more of the twenty ruling monasteries now existing, were still Slavonic in the seventeenth century, becoming Greek with the rise of the Phanariotes, the leading Greek families in Istanbul, during the eighteenth century. The process of conversion was probably the same in all cases: monasteries impoverished and in debt were bought up by the rich Greeks. In this way the monastery of Panteleimon became, in the early part of the nineteenth century, a dependency of a Phanariote family, and was wholly occupied by Greek monks.

However, after the war of independence and the occupation of Athos by Turkish troops, the Greek monks of Panteleimon fell heavily into debt again and in 1839 accepted the entrance fee of fifteen Russian probationers. Other Russians followed. In twenty years they had paid off the outstanding debts, and new buildings were erected. By 1869 the Russian element was strong enough to win the privilege of using Russian in the services of the *katholikon* on alternate days. After a series of unedifying intrigues as to the nationality of the next abbot, a commission appointed by the community decided that the monastery had always been Greek (this was a definite lie) and that the abbot and two-thirds of the monks must always be so. But this decision of the community was overruled by the Patriarch Joachim II who, in return for substantial presents from St Petersburg, threatened the community with condemnation to eternal flames unless it acceded to the Russian wishes. A

25 The monastery of Simonopetra was founded in 1363 by a hermit named Simon, with the help of John Uglitch, King of Serbia, whose daughter, according to tradition, was healed by Simon's intercession. Built on a huge and sheer rock some thousand feet above the sea, facing south, it recalls the vertical architecture of the monasteries in Meteora, Thessaly.

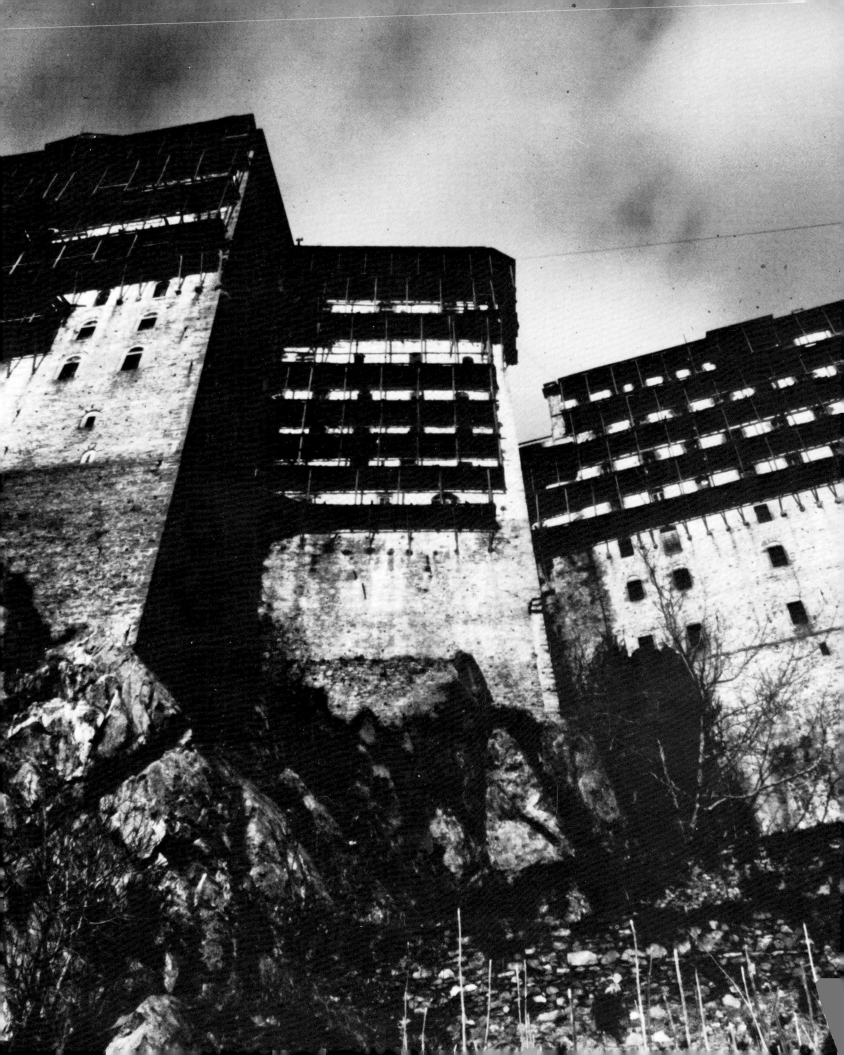

Russian abbot was elected in accordance with the patriarch's decision, and the Russians had again secured the control of one of the ruling monasteries.

The Russo-Turkish war followed. The Treaty of St Stefano, in 1878, on its conclusion, contained this passage: 'The Monks of Mount Athos of Russian origin shall be maintained in their former possessions and hermitages, and shall continue to enjoy . . . the same rights and prerogatives as those assured to the other religious establishments and convents on Mount Athos.' Thus, the Sultan recognized the existence of exclusively Russian communities on the Mountain, and confirmed their rights. In the same year Article 62 of the Treaty of Berlin had the following clause: 'The monks of Athos, whatever their country of origin, shall be maintained in their former possessions and advantages, and shall enjoy, without any exception, complete equality in privileges.' Thus, the autonomy of Athos of the preceding nine centuries was reaffirmed by international treaty.

Encouraged by a foothold on what was now virtually an Aegean government immune from Ottoman interference, the Russians began what amounted to a large-scale occupation of Athos. They could not actually increase the number of ruling houses, since this was limited to the already existing twenty; but they bought up small monastic establishments, which they then proceeded to inflate to gigantic sizes. Existing buildings in these establishments were replaced, and the Mountain disfigured with garish semi-oriental domes and a vacuous and cheaply sentimental iconographic style whose influence has not yet been eradicated. What had been minor monastic dependencies often grew two or three times the size of the parent monastery. In one way and another, by 1912 when the Turkish rule on Athos came to an end and the Greeks occupied the promontory, the Russians had control of one monastery and many hugely inflated lesser establishments, and constituted a numerical majority of the monastic population.

One consequence of this politico-religious occupation by the Russians – based on the idea that the premier Orthodox state should predominate in ecclesiastic affairs throughout the Orthodox areas – was an outbreak of nationalist fervour among the Greeks, which threatened and still does threaten, to subvert the whole Orthodox character of the Holy Mountain. The bad effects of this nationalism had, indeed, been noted by a Greek monk writing in the 1880s:

26 Witness of the Ottoman past: marble plaque with carved arabesques and Turkish inscription.

We may be able to console ourselves by remembering that such divisions and boastings divided the Christians even during the apostolic times. 'I belong to Apollos; I, to Paul; and I, to Christ' made the blessed apostle of the nations ask with paternal wrath, 'Has Christ been divided?' But today there is no one to rebuke such conduct. And so, miserable racial recriminations occur even between men who belong to the same nation, men who suspect each other; for during the last twenty-five years the division of those on Athos not only according to nationality, but also according to the various provinces of one and the same nation, has reigned supreme in an evil way. He who has seen has borne

witness; and he has seen, unfortunately, Greeks rejoicing, as if a great honour had been bestowed upon them, that they had come from liberated Greece, while the others, I know not in what land they were born, suspecting one another as an enemy, a Philistine, a Samaritan. The writer has heard many things; and having heard, he was horrified that men live today who secretly introduce a schism into their own nation.[8]

The Russian expansion on Athos was so great that it now seemed likely that the Mountain would fall entirely under Russian control. The immediate prospect of this in fact happening was removed by the Russian revolution in 1917. There followed a few uncertain years. Finally, by the Treaty of Sèvres, afterwards ratified at Lausanne in 1923, the sovereignty of the Greek state over Athos was recognized and assurances were given upholding the traditional rights and liberties of the monastic community. In 1924 a mixed committee composed of representatives of the Greek nation and the Athonite community formulated a constitutional charter for the Holy Mountain. While affirming that all monks inhabiting the Mountain are automatically Greek subjects, irrespective of their previous nationality, the main articles of the charter enshrine certain privileges and confirm the independence of the community, particularly in respect of administration of the law and of taxation. The charter was also ratified by the patriarchate, for it contains

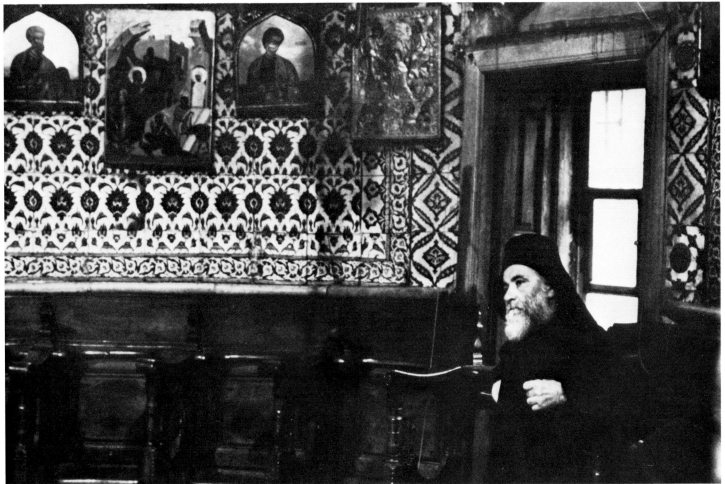

27 One of the two choirs in the *katholikon* of the Great Lavra, covered with seventeenth-century Ottoman ceramic tiles from Iznik, the ancient Nicaea.

articles regulating the ecclesiastical jurisdiction of Athos, including one that proclaims the spiritual jurisdiction of the 'Great Eastern Orthodox Church of Christ' over all the monasteries of the Mountain. Patriarchal jurisdiction is, however, limited to questions which concern the religious and ecclesiastical life of the Athonite community only.

The monastic population of the Mountain has varied considerably through the centuries. For the early years only certain figures have survived. In 1489, for instance, the monasteries alone contained 2,246 monks. The total population of the promontory at this time must have been considerably greater. During the seventeenth century, there is a report of a population of 6,000. Following the abortive rising of the monks at the time of the Greek war of independence the number of monks declined drastically – and has been put as low as 1,000. According to the Turkish census of 1885, however, the numbers had again risen to 5,526. A high-level figure was reached at the time of the great Russian invasion of the Mountain towards the end of the nineteenth century, and in 1903 the number of monks was calculated to be 7,432. With the gradual withdrawal and death of many Russians in the following quarter century, the numbers again dwindled, and by 1928 are put at 4,858. There has been a further decline since that date, and now the total number of monks on the Holy Mountain is less than 3,000.

29 *Right* Looking westwards over the monastery of Dokheiariou.

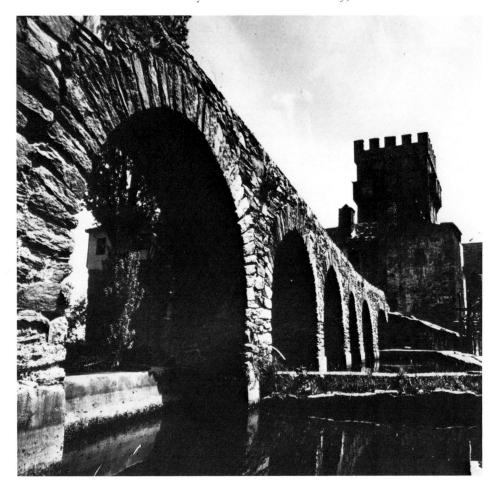

28 The aqueduct to the monastery of Stavronikita, part of the large-scale engineering works carried out by monks on Athos.

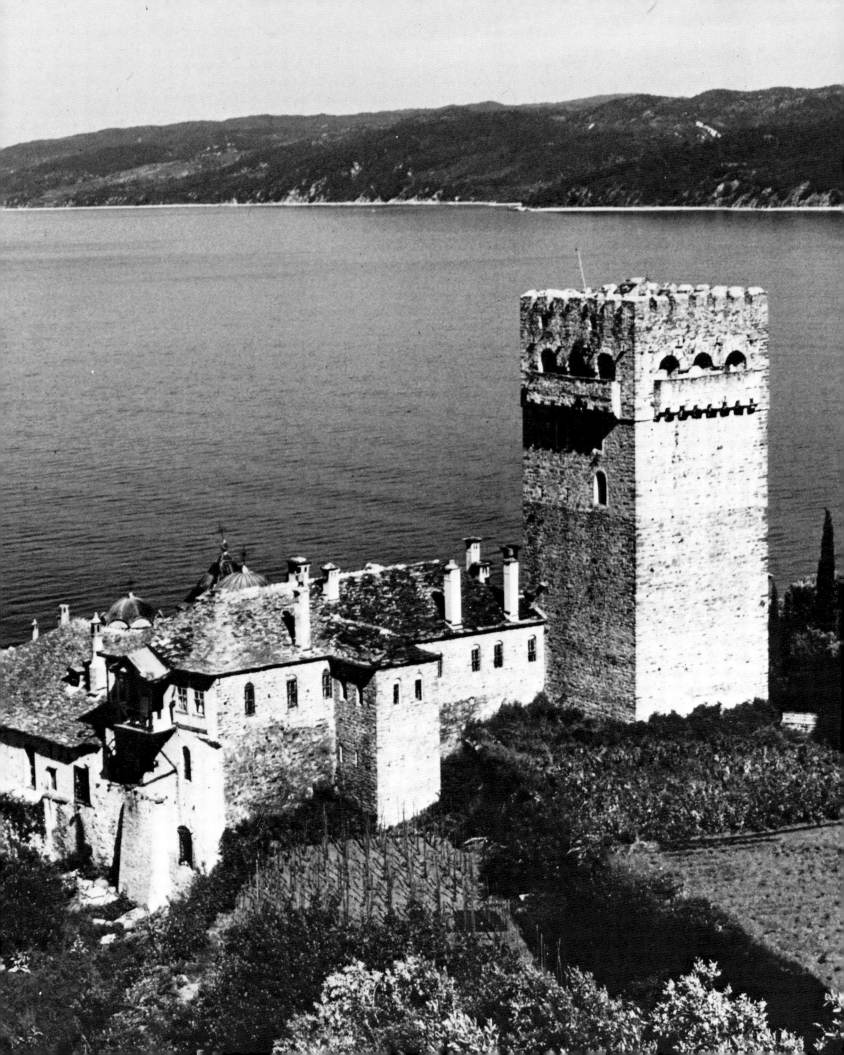

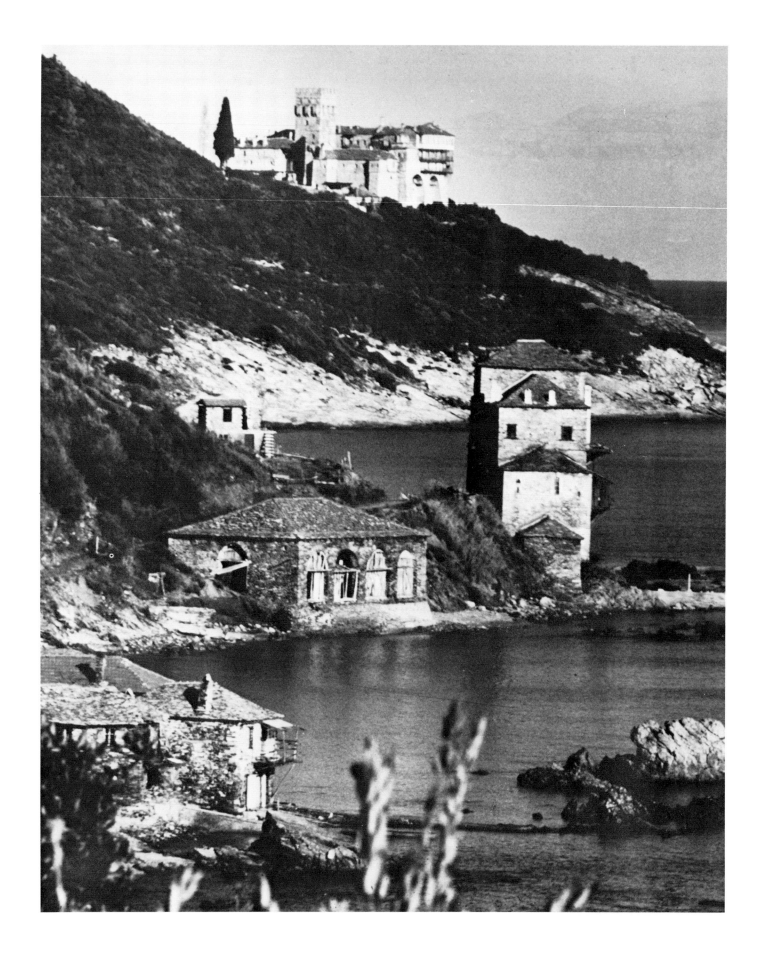

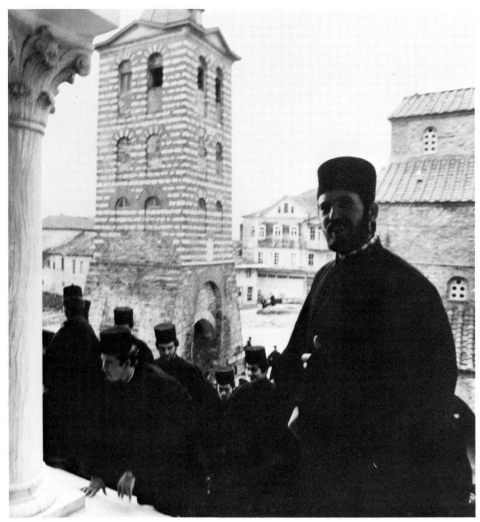

31 A congregation of novice monks. In the background is the bell tower of the Protaton, Karyes, a later addition to the tenth-century basilica.

30 *Left* The monastery of Stavronikita and its landing stage. Founded by a Byzantine officer in the tenth century, the monastery has an imposing site on the eastern seaboard above the rocky shore.

In recent years, however, there has been a change, although it is still too early to say how significant it is. New recruits are entering the monasteries in increasing numbers. The sense of inevitable decline is no longer present. Capable figures, fully aware of their responsibilities, watch over the administration. For the moment, indeed, Athos is even holding its own against the insidious infiltrations of state and commerce which threaten to turn it into a glorified Byzantine museum and a centre for tourism. Whether this apparent revival can be maintained largely depends on the monks themselves. At the end of a thousand years they are in possession of a constitution that enshrines and secures, in so far as a paper constitution can, the privileges and independence of the Holy Mountain. The geographical and political boundaries of the Mountain are clearly defined. There is an administrative organization fit for the preserving of internal order and stability. There are what one might describe as adequate conditions for the pursuit of the monastic life.

But in addition to the external threats, Athos is now faced with a new challenge from within; and it is on the capacity of the monks to face and rebut this challenge that its future as a spiritual centre is likely to depend.

32 An old monk struggles up a steep path in the 'desert' of Athos.

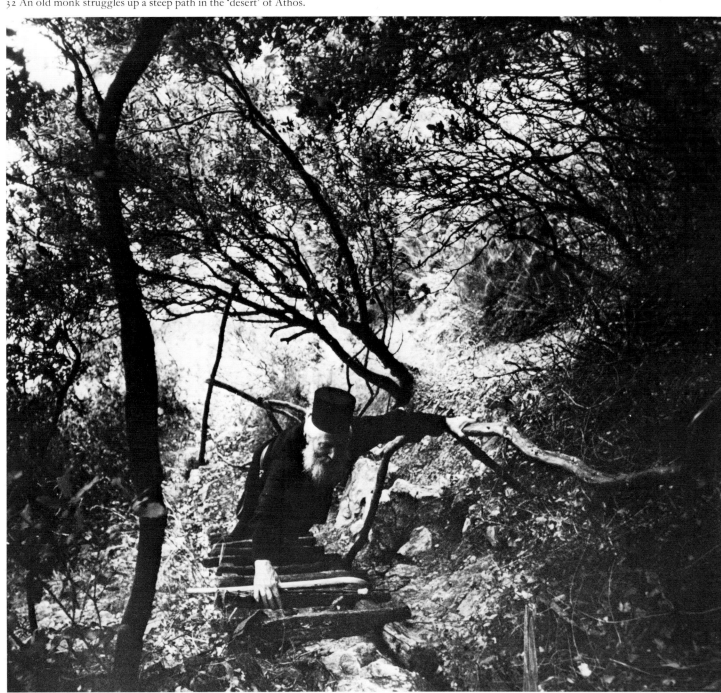

ATHOS AND
THE MODERN WORLD

We have noted that the building of the monasteries and their maintenance was in the past made possible largely through donations from emperors and others. It was Nikephoros Phokas, for example, who opened the golden stream through which imperial and private wealth flowed into the monastic establishments of Athos for many centuries when he provided Athanasios with moneys to build the Great Lavra and to maintain it. In the same way, many of the present twenty monasteries were built and endowed with gifts. The monastery of Xenophontos was reconstructed in 1083 at the expense of Stephan, a high official of Nikephoros Botaniates. Hilandari was built in 1197 with moneys given by Stephan Nemanja, ruler of Serbia. The Emperor Alexios III Comnenos provided the funds for the building of the monastery of Dionysiou, while John Ugles, also of Serbia, provided them for Simonopetra. Moreover, the monasteries were often endowed with estates. In 1341, John III Palaeologos issued a chrysobull conferring on the Lavra property at Constantinople. Stephan IV Dushan of Serbia gave immense stretches of land and a number of villages to Hilandari; and there were several other endowments of a similar kind to other monasteries. At the beginning of the nineteenth century, monasterial property extended over the Aegean islands across to Asia Minor, over Halkidiki, Macedonia, Thrace, Rumania, as far as Russia. Each such property outside the Athonite promontory was called a *metochion*, and many a *metochion* covered huge tracts of agricultural land where the vine, wheat, olives and other crops were farmed, usually by lay workmen under the supervision of monks. In addition, the monasteries owned buildings in large cities and towns throughout the Near East. In all, the revenue from these properties was more than enough for the support of the monasteries, and often the small patches of land on Athos were left uncultivated, and the Athonite forests unexploited.

However, the various nationalist movements of the nineteenth century, product as they were of entirely non-Christian, not to say anti-Christian, ideas, did much to destroy the whole economic system which nine hundred years of imperial, princely and private benefaction had built up. Greece herself initiated this process. As part of its policy of territorial annexation, in 1834, five years after the signing of peace with Turkey, the Greek government

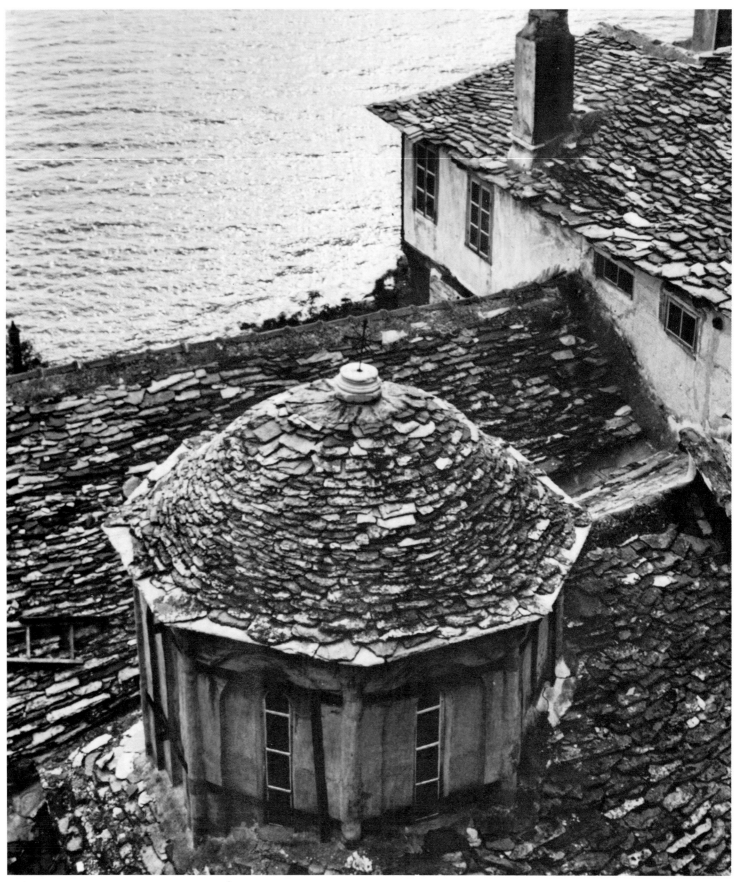

42

33 Part of a slate-covered monastery roof, a typical feature of Athonite architecture. Abandoned in the late nineteenth century in favour of machine-made red clay tiles, slate is now making a tentative comeback.

under Capodistria confiscated all Athonite lands within the borders of the Greek state. A far more serious annexation was that of 1863, when the Rumanian government, under the leadership of the national hero Prince Couza, and in an attempt to support its tottering economy, confiscated all the properties belonging to monasteries in the country. Buildings, furniture, documents, land, were all seized, and in the process Athos was deprived of one of its chief sources of revenue. In that proud spirit of independence which has often characterized the behaviour of the Athonite community in its dealings with the secular outside world, the monks refused all offers of indemnity, and so made the loss absolute. Then, in 1873, Russia took over Athonite lands in Bessarabia. Finally, in 1925, after the disastrous war with Turkey had resulted in two million refugees arriving from Asia Minor, the Greek government authorized the minister of agriculture to negotiate with the monastic authorities of Athos for the 'renting' of their *metochia* for a ten-year period. This 'renting' has amounted in fact to annexation, for the refugees settled on these lands are virtually impossible to move now.

Thus, after a century of dispossession, the land on the Athonite peninsula itself is all that remains to the monasteries. It is the cultivation of this, combined with an annual payment made by the Greek government, and a certain income from a small amount of property in cities and from foreign investment, that saves the monasteries from economic collapse, and the margin of survival is in some cases slight. One unfortunate consequence of this dependence on native territory is that the monastic community has been forced to exploit its own resources, and in particular the forests, on a scale unknown hitherto. This has meant the introduction of modern techniques and machinery, as well as of the mentality which inevitably accompanies them. The consequence is the development of a situation which threatens to disrupt the whole traditional norm of Athonite life, and whose implications should be assessed within a wider perspective of this life.

Curiously enough, it is with reference to the paths of Athos that some of the implications in question can best be pin-pointed. These paths used to be a major feature of the Holy Mountain. Until recent times they provided virtually the only means of moving about the peninsula. On arrival at the port of Dafni, one walked up to Karyes – if one had not indeed walked in from the frontier itself. From Karyes, one walked to whatever monastery one had chosen as a starting point. From then on, one continued the journey from monastery to monastery, or from *skete* to *skete*, on foot. One could get a boat down the west coast or round to places like Kapsokalyvia; but such boats were few and fairly erratic and on the whole one was more likely to get there by walking. And the state of the paths reflected this pedestrian norm – a norm not simply for the visitor but for the monks as well. Many of them were beautifully cobbled. All were clean and well-maintained. Many were clearly signposted, the signposts sometimes even stating the number of kilometres to the destination they indicated, or the number of walking hours. Wayside

34 Known by their Turkish name of *kalderim*, stone paths like this used to be virtually the only way of getting from monastery to monastery.

fountains or drinking places were kept clean, and sometimes a drinking vessel was to hand. Wayside shrines were tended.

Today, the normal way of moving about the peninsula, again both for visitors and for monks, is not walking or even riding a mule. It is some form of motor transport, terrestrial or maritime. This means first of all that roads – motor-roads – have cast their blight on the Mountain. Thirty years ago there was not a single such road on Athos, nor was there a single motor vehicle. Then the monastery of St Paul opened a road to bring wood from its forest lying high above it, just below the ridge, down to the port below it. Other monasteries followed this example. The groans and clankings of lorries carrying wood began to murder the silence. Then came greater disaster. With the excuse that it was beneath the dignity, or the capacity, of 'important' guests – royalty, ambassadors, bishops, professors – attending the millennium celebrations in 1963 to walk from Dafni to Karyes, a road was bulldozed so that they could go by bus or jeep or even car. Another road – from Iveron to Karyes – soon completed this first public desecration. The habit spread. Individual monasteries began to open roads for all kinds of reasons, plausible or specious. As a consequence, Athos is now full of roads; and more are threatened.

The result is, of course, that the whole rhythm and pattern of movement on Athos has completely changed. One can no longer walk into Athos from the borders. One is compelled to take the boat to Dafni or Iveron, and not allowed to get out anywhere en route. On arrival at Dafni one is herded into a bus although one can still escape this if one shows enough determination. Police jeeps buck and bounce anywhere between the Great Lavra and Stavronikita. Abbots and others on monastic business journey in the private transport of their individual monasteries. The lorries carrying wood groan

36 *Top right* This aerial view of the monastery of St Paul, situated by the southernmost tip of the peninsula, shows how deep has been the penetration of mechanized transport.

37 *Bottom right* An aerial view of the quay and arsenal tower beneath the monastery of the Great Lavra.

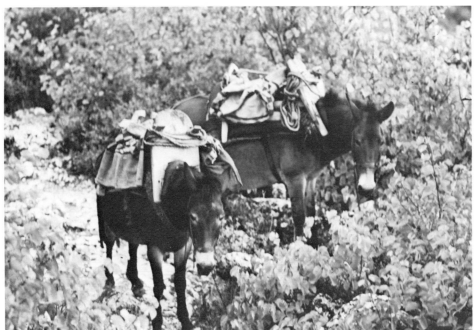

35 On the paths of Athos, mules are still part of the traditional transport linking monasteries.

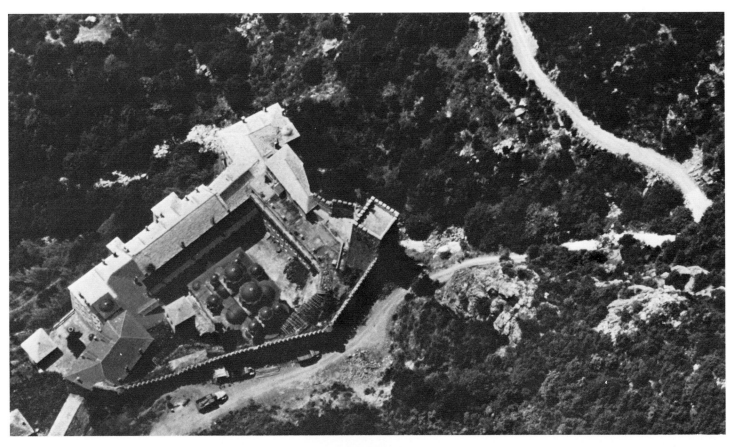

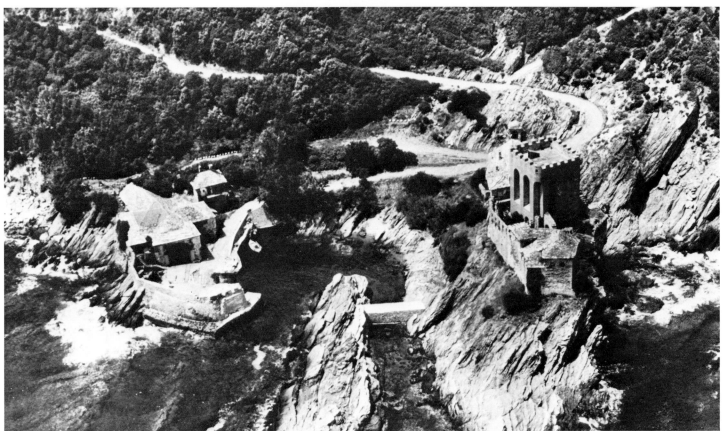

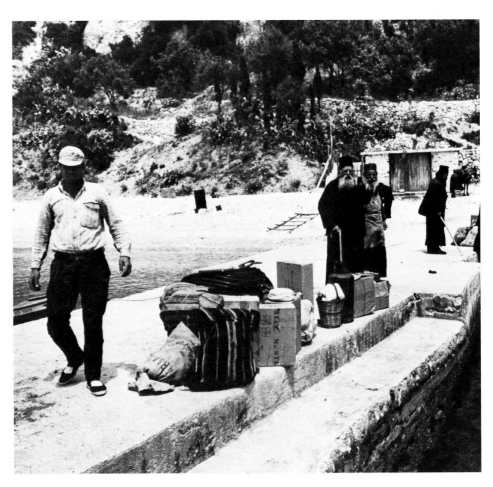

39 Waiting for the boat, the life-line linking monasteries to one another and to the mainland.

and clank in greater numbers. The normal way in which visitors and monks move from monastery to monastery is to take the bus from Karyes down to either Dafni or Iveron and then to use the larger, faster, more frequent and reliable motor-boats which now ply up and down the coast on both sides of the peninsula. Walking – except perhaps for a few local walks, from port to monastery, or from one monastery to another if this lies close at hand – is now definitely out, both for visitors and for monks. Indeed, if one chooses to walk when some form of motor transport is available, the monks themselves regard one with astonishment. It is not what they would choose.

All this, naturally, is reflected in the state of the paths. They are used less and less and in some cases not at all. They are not cleared or maintained. There is hardly a signpost left. The cobbles are disintegrating or in many cases have already disintegrated. The wayside shrines and fountains are dilapidated. Many paths – and among these some of what used to be the main arteries – are now so overgrown with shrub and bramble as to be unusable.

A direct result of this is that the sense and the possibility of the pilgrimage is undermined. A pilgrimage is not simply a matter of getting to a particular shrine or holy place. It is a deliberate sundering and surrender of one's

38 *Left* The motor-boat has not yet eliminated the peace and quiet of the past.

47

habitual conditions of comfort, routine, safety and convenience. Unlike the tourist, whose aim is to see things and to travel around in conditions which are as comfortable, secure, familiar, convenient and unchallenging as possible, the pilgrim breaks with his material servitude, puts his trust in God and sets out on a quest which is inward as much as outward, and which is, in varying degrees, into the unknown. In this sense he becomes the image of the spiritual seeker. He removes himself as far as possible from the artificiality within which he is enclosed by his life in society. Of this spiritual exploration, inward and outward, walking is an essential part. His feet tread the earth – the earth from which he is made and from which he is usually so cut off, especially in the more or less totally urbanized conditions of modern life. Through his eyes, ears, nose, he renews his sense of natural beauty – the beauty of God's creation. He watches the flight of bird or insect, the ripple of light on leaves, the tameless vistas of the sea; he listens to the song of water, the calls of God's creatures; he breathes in the scent of tree and flower and soil. His feet tire, his body aches, sweat drips from his head and trickles into his eyes and down his neck. He tastes rigour and hardship. But through all this – and only through all this, and through his prayer and dedication and confidence – slowly an inner change is wrought, a new rhythm grows, a deeper harmony. The pilgrimage is at work.

The pilgrimage is also a process which must not be hurried. The bonds of routine, dependence on material comforts, on the familiar and the settled, have a far stronger hold on one than one is aware of. The conditions of modern life have so blunted the senses that it may take days, weeks even, until they begin to respond truly to the beauty about them. If the aspiring pilgrim attempts to speed this process up, or refuses to face the conditions, including the hardships, which are essential for the development of the pilgrimage, then he becomes a mere tourist. And in fact most of the visitors to Athos today probably are tourists, however much they might like to think they are not. The advent of modernization has made the pilgrimage a thing of the past.

Far more important than this, however, is the challenge presented to the monastic community itself. For this community the value of the paths and of other traditional survivals has to be weighed against its own economic viability. Doubts over the latter are reinforced by the kind of ideas and beliefs instilled in monks who have received – as virtually all the educated ones have – a modern, secular education. And when these beliefs somewhat naïvely hold science and technology to be the source of all material advance, the Athonite environment is imperilled. There is little understanding, for example, that the opening of roads over which mechanized transport can pass must, bit by bit, result in the disruption of the wider pattern of Athonite life. Sometimes, even, a kind of double-think takes over. It begins to be thought that one can live the traditional Athonite spiritual life while allowing these infiltrations from the modern mechanized world, on the grounds that they concern only the exterior material world and not, therefore, the inner spiritual dimension. In

48

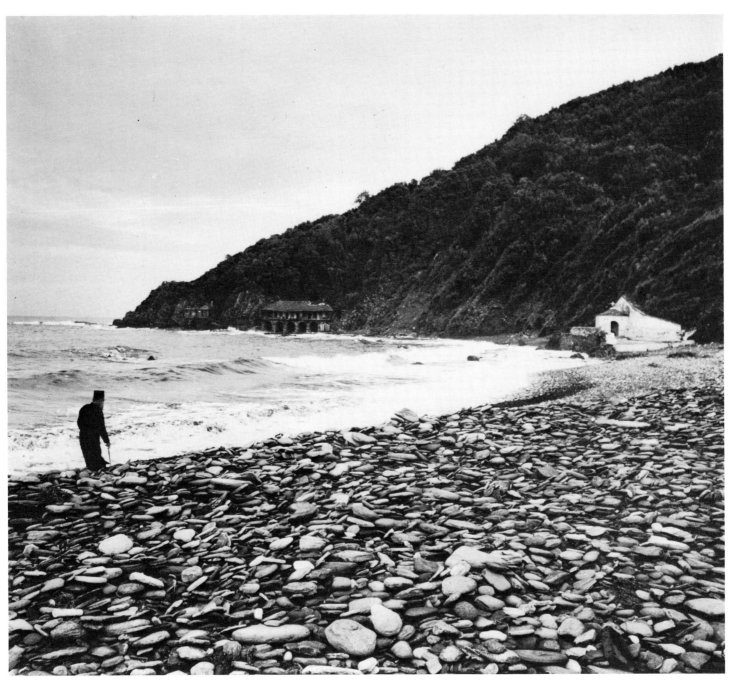

40 A pebble beach near the monastery of Iveron in the winter.

other words, a form of dualism – a radical dualism between the material and the spiritual – begins to take over.

Dualism in one form or another always appears to be a danger implicit in any pursuit of the path of spiritual realization. A stage of such a pursuit demands a certain withdrawal and distancing from the world of the senses, a certain dying to the life determined by physical actions and reactions, the pleasures and pains, likes and dislikes of the body. Sensual beauty becomes a temptation leading attention outwards into the world of multiplicity and transience. The pulls and propensities of the flesh threaten to engulf the clear eye of spiritual vision. But what is a phase can often be diverted into an end in itself. The monks of Athos are in danger of regarding the material plane of life, not as evil, or as the product of an evil agent, but as neutral, as something which lies outside and does not affect the life of the spirit. One must be indifferent to, one must even despise, what happens on the material plane of life. The spiritual life is superior to all that and can be practised whatever the material circumstances and conditions.

Athos claims to represent the highest form of spiritual life known in the Christian tradition. It claims to reproduce an 'angelic' pattern of life on earth, in so far as this is possible in a fallen world. A basic element of this pattern of life is complete trust and confidence in God and dependence on him. It is the injunction, 'Take no thought for the morrow', applied in the most positive, literal sense. Those who consecrated Athos to this pattern of life chose it not only because it was remote from the distractions and frivolities of the secular world, its getting and spending, its endless preoccupation with the morrow. They chose it because this very remoteness and inaccessibility promoted – indeed, made essential – that sense of complete dependence on God which is

41 A Turkish inscription is incised on the stone set in this niche at the entrance to the Great Lavra.

the hallmark of holiness: one simply could not continue to live on Athos without developing such dependence.

It is this basic constituent element in the pattern of life that Athos claims to represent which is being destroyed by that introduction of modern technological products and processes which the opening of the roads both presupposes and induces. With these products goes a whole mentality – a mentality directly contrary to that expressed in the injunction, 'Take no thought for the morrow'. For they are the most devastating evidence of man's total failure to be dependent on God alone. Their whole intention is to help man to secure, to master his environment and his economic future without having to take God into account at all. And it is here – as well as in their destruction of the conditions of pilgrimage and of the silence – that their total incompatibility with the type of life that Athos claims to represent is most clearly displayed.

Of course, the monastic community as a whole is far from being unaware of this situation. While it is true that a number of monks would like to see Athos turned into a highly efficient monastic state, with a strong central administration and roads opened between all the monasteries as well as to the outside world, these monks are still a minority.

The majority is probably uncertain as to where it stands. But there is another minority that is aware and that is beginning to measure up to the extent of the danger. Recently, one member of this minority, the Abbot Vasilios of Stavronikita, wrote a letter to the Monastic Council of Athos, in which he called on the Council to give its most urgent attention to the growing desecration of the Holy Mountain as a result of the introduction of the various modern technological processes. He wrote:

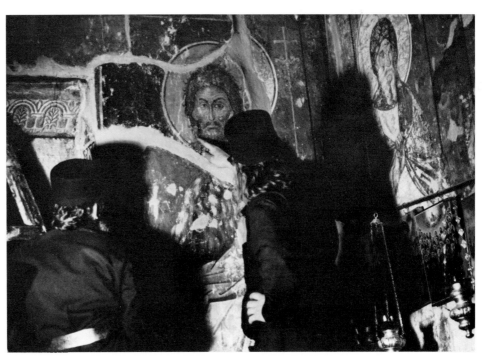

42 In the Protaton, Karyes, monks examine restoration work which has uncovered separate layers of work on the wall-paintings.

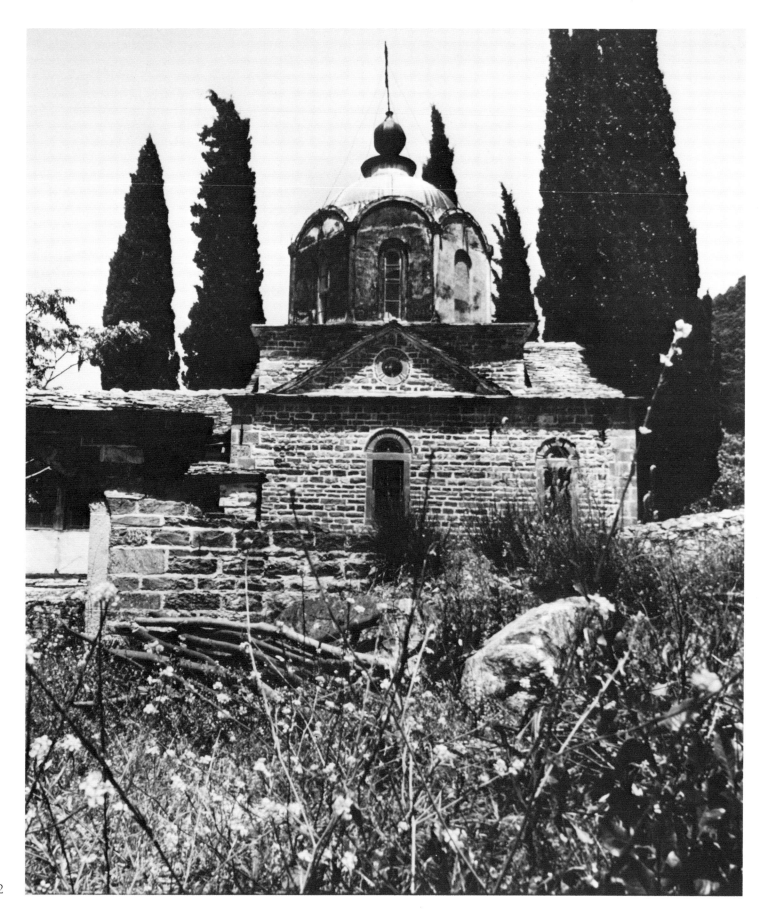

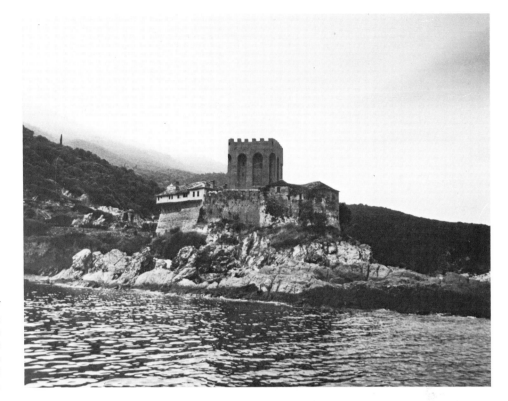

44 This arsenal tower, known as the Tower of Tzimisces, guards the approach to the shore beneath the Great Lavra monastery. As well as being one of the boldest and most massive towers, it is amongst the earliest on the Mountain. Sadly, it has recently been rendered in cement.

Because of the modern mechanical means of destruction, it is quite possible for us to betray centuries of labour to extinction through a single ill-considered decision or action. We ourselves, the monks, can become self-slaughterers and murderers of the Holy Mountain. The devil does not joke. And the voraciousness of the dragon of the modern world has no limits. The smallest surrender on our part can have fatal consequences. If we leave the smallest crack open to the spirit of this world, the pressure and persuasion of the devil can widen it to a gaping crevice and chasm in order to swallow us down.

This voice is certainly not alone on the Holy Mountain. Indeed it expresses what is the true conscience of the monastic community, however much this conscience may be muted or comatose. For if the monastic community is aware of the spiritual purpose to which Athos is consecrated, and the conditions within which this can be fulfilled, then it will automatically eliminate from the material environment all that is not in harmony with it. It will eliminate those products and processes which already violate this harmony, and which threaten to destroy it altogether. But to the degree to which it has lost its sense of its spiritual vocation – its true conscience – it will permit what is at odds with this vocation and conscience. To that degree it will permit roads, machines and all the rest. At the moment, things appear to be in the balance. It may still be possible to resist the enormous pressures operating to destroy the Holy Mountain as a centre of spiritual life. It may still be possible to contain the 'spirit of this world', even partly to repel the advances it has made in the name of economic necessity. But unless and until this happens, it still remains premature to speak of a spiritual revival on Athos, however encouraging the signs may be.

43 *Left* The cemetery chapel at Dokheiariou, flanked by the ubiquitous cypress trees.

FORMS AND ORIGINS
OF ATHONITE MONASTICISM

On Athos monastic life takes three main forms. There is, first, the eremitical form, in which a desolate piece of country is sought out for a life of solitude, such as that practised by Peter the Athonite. Secondly, there is the form represented by the *lavra*, which is made up of a collection of hermit cells, more or less widely scattered, and growing round a common centre provided by the retreat of some hermit of remarkable fame who has attracted others to him. An example of such a *lavra* is that which formed round St Euthymios during his three-year sojourn in a cave, and of which, on emergence, he became the head. Finally, there is the stricter rule of the monastery proper, with definite buildings and fixed regulations, under the direction of an abbot or *hegumen*. Of this form, the Great Lavra, the monastery founded by St Athanasios, is the earliest existing example on Athos. Although this final form was to become and to remain the dominant one on the Mountain, the other two forms have also persisted. Indeed, all three are integral to the whole nature and tradition of Orthodox monasticism.

The founder of this monasticism may be said to be Christ himself. 'If any man will come after me', he said, 'let him deny himself, take up his cross daily, and follow me.' He who wishes to do this must, then, renounce his selfish inclinations and strive as best he can to imitate the divine Master. The two duties are correlative, renunciation having for its only purpose the following of Christ, while at the same time marking by the generous or reluctant spirit with which it is practised the degree of that imitation. For detachment from self may be more or less perfect, and is in any case not demanded from all in equal measure. The rich young man who asked about everlasting life was told that he could secure it by keeping the commandments. There is, thus, a minimum of Christian observance necessary at once and sufficient for salvation. But in the Father's house there are many stages, and he who would enter into the finest among these must travel along higher and more strenuous paths. 'If thou wilt be perfect', said Christ to the excellent and eager young man, 'go, sell what thou hast, and give to the poor . . . and come, follow Me.' Were this invitation accepted, further sacrifices would be demanded in due course, for 'every one of you that doth not renounce all that he possesses cannot be my disciple'. Elsewhere in the New Testament the Master expressly mentions as objects of detachment the love for father and mother, wife and

45 A *kellion*, or cell, at the tip of the peninsula.

children; even the love for life itself. Included in this, according to the interpretation generally accepted since the earliest times, is the recommendation to chastity. For those who aspire to the closest following of Christ, detachment must be in deed, not in desire or inclination only, just as the poverty, hunger, thirst, sufferings, passion and death of Christ were actual. Those not called to this final form of detachment (of necessity the greatest majority) may reach a high and heroic degree of sanctity by renouncing in spirit the things of earth and, in overcoming the endless obstacles by which they are surrounded, may advance with ever-increasing strides in charity. Thus, they prepare themselves for that more intimate union with the Divine which is the ideal of Christian perfection.

As the purpose of renunciation is to secure more ample freedom to 'follow Christ', so the disciple will imitate the Master by a more intense love of God and his neighbour. 'Thou shalt love the Lord thy God with thy whole heart and with thy whole soul and with thy whole mind, and with thy whole strength. This is the first and great commandment. And the second is like to this: 'Thou shalt love thy neighbour as thyself. On these two commandments depend the whole law and the prophets.' Love of God finds expression in praise, reverence and adoration, and in conformity to the Divine Will. Love for one's neighbour (and neighbour is a term in which all men, even enemies, are included) is shown especially by humility, then by the practice of the other virtues. Through such practice, begun in faith, the aspirant pursues the ascetical path towards the goal which he has set himself.

It was the determination to pursue this goal with as great an intensity as possible that impelled many in the early Christian centuries to seek a life of solitude. One, named Paul, lived in eremitical retirement in a cave near the Red Sea, where he died about 340. St Jerome wrote the life of this 'first hermit', but in a style so rhetorical that many doubted whether such a person had ever really existed. In any case, Paul's influence on the development of the anchoretical life was not, as far as one can tell, very great. The real father of this life is St Antony.[9] Antony was born of well-to-do parents in 251 at Coma, a village near Heracleopolis, in middle Egypt. His childhood was marked by great shyness. He never went to school, and never learned to read his native Coptic language, let alone Greek. When his parents died he sold off his property and gave the proceeds to the poor; he then placed a younger sister who remained under his care in a *parthenon* or house of virgins. Thus unburdened, he began to live as an ascetic near his home. Hearing, however, of an aged holy man who led a rigorous life on the outskirts of the village, he went to live near him. There his day was spent in prayer, and in manual work by which he earned enough money to provide for his few wants with a little over to give to the poor. Now and then he visited distinguished ascetics:

He observed the graciousness of one, the unceasing prayer of another, another's freedom from anger, the loving-kindness of another; he fixed his attention on one as he watched,

46 Icon of St Antony, father of the anchoretical life on Mount Athos.

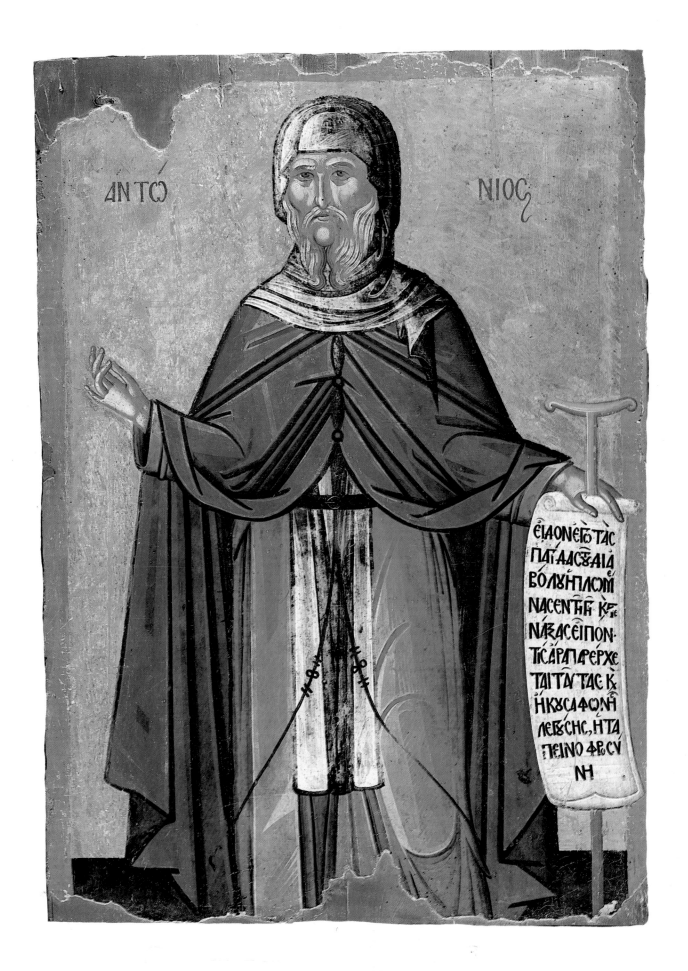

ΑΝΤΩ ΝΙΟ

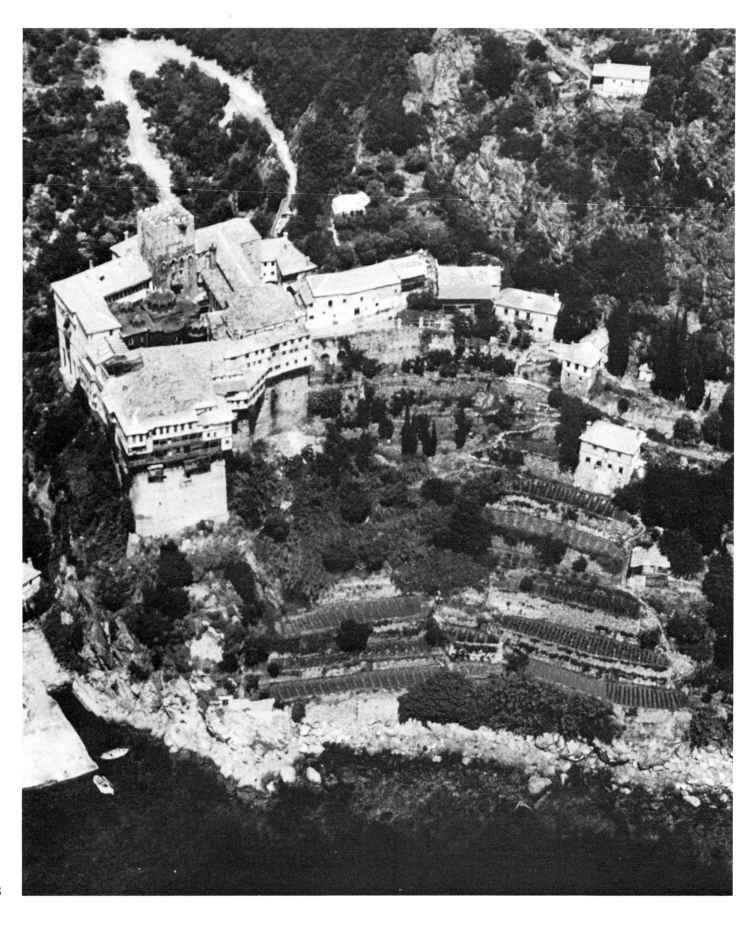

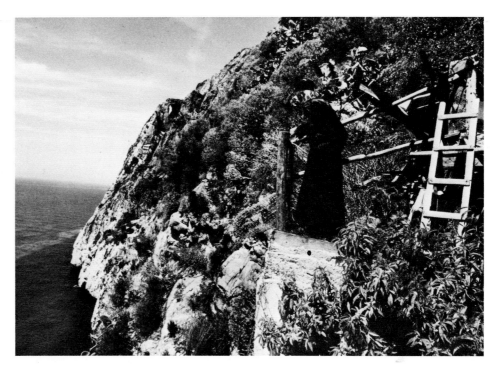

on another as he studied; one he admired for his endurance, another for his fasting and sleeping on the ground; the meekness of one and the long-suffering of another he noted with care, while he took heed of the piety towards Christ and the mutual love which animated all.

Everywhere he was esteemed as a true friend of God. He ate once a day, after sundown, and then only bread, salt, and water; he slept on a mat of rushes or on the bare ground, and often spent the night in vigils.

After fifteen years of this form of life, Antony felt an irresistible call to withdraw to greater solitude. In 285, he crossed the Nile and went towards the mountains on its right bank. There, at a place called Pispir, in an appallingly wild and lonely district, he found the ruins of an old fort, and by building up the entrance he made this into a suitable dwelling. A nearby spring gave him water, and friends from among the ascetics brought him bread every six months. He lived thus isolated for twenty years, never leaving his retreat and rarely seeing anyone, and occupied in prayer, the weaving of mats, and wrestling with the hostile influences which sought to undermine his purpose.

Meanwhile, his fame had spread, and gradually he found himself besieged by newcomers determined to become his disciples. Eventually he emerged from his long solitude to teach, advise and direct a group of those who had settled round him. Their number grew. The desert round Pispir became a busy human settlement. The anchorites dwelt in separate cells and spent the day in reading, prayer and manual work. From time to time, Antony called them all together and expounded in brief addresses the principles by which their lives should be governed. It was the beginning of Christian monasticism.

However, for Antony there was now a new difficulty. The number of hermits at Pispir grew with increasing rapidity, especially after his visit to

48 A hermit outside his isolated dwelling.

47 *Left* An aerial view of the monastery of Dionysiou, showing how tightly the buildings are packed together on their narrow summit. Terraced kitchen-gardens lead down to the rocky shore.

49 *Left* A *hesychasterion* or hermitage perched on the edge of a sheer cliff.

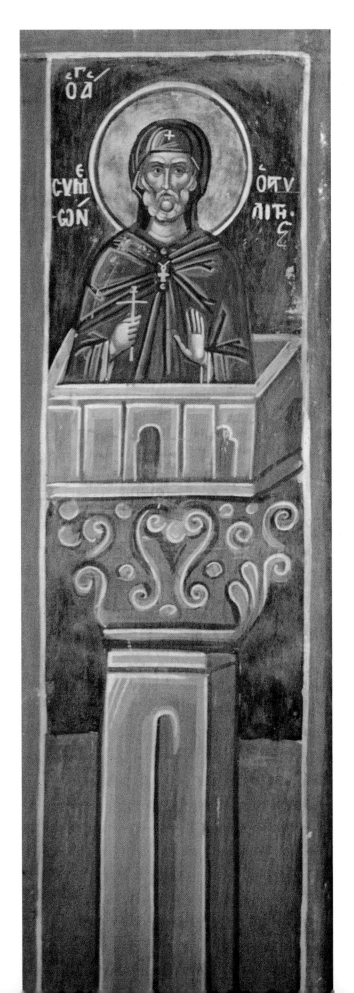

50 St Symeon Stylites, who lived in the north Syrian desert on a column for thirty years. Detail of a wall-painting from the *katholikon* of the monastery of Dokheiariou.

61

Alexandria in 311 at the time of the persecution of Christians under Maximin. Conditions were becoming such that the anchoretical life itself was endangered, especially for Antony. With a simplicity learned of the desert, he solved the difficulty: he fled. Joining a caravan of Bedouins, he journeyed for some days in the direction of the Red Sea, until he came to a mountain district where there was a spring, some palm-trees, and a patch of fertile ground. Here he rested for the remainder of his life, only occasionally returning to Pispir to guide and encourage his disciples. Once, in 338, at the age of eighty-seven, he again dragged himself to Alexandria to proclaim in his own person his attachment to St Athanasios and his enmity to the Arian heresy. He died in 356 at the age of 105, leaving to his friend, St Athanasios, his sheepskin tunic and the worn cloak which for many years he had used as a bed. On his own instructions, he was buried by two of his followers in an unknown place, lest honour beyond the common should be shown to his remains.

Two of the three forms of monastic life we have noted as typical of Athos were, thus, established and practised by St Antony, and they spread in the years after his death. The purely eremitical life, as led by Antony before disciples flocked to his solitude, and again in the last years of his life, continued to attract many in Egypt during the fourth century. But even so, hermits were few when compared with those who led a semi-eremitical life of the type that grew up at Pispir under Antony's guidance. Here, each lived in solitude, and more or less according to his own ideas, but the cells were placed at relatively short distances from each other, and there was a guide or a teacher, voluntarily chosen, whose influence was felt over the whole colony. Such colonies were established at Nitria, about sixty miles south of Alexandria; at Skete, to the north-west of Nitria, where Makarios the Egyptian became the head of a group of monks about 330; and at Kellia, or Cells, also not far distant from Nitria, where six hundred hermits lived in single huts so placed that their inmates could neither see nor hear one another. Life in all these colonies was exceedingly simple. There was one meal at the sixth or ninth hour, never before, except when visitors arrived on days free from fast. Some took no food till sundown; others only once in several days, though excess in fasting was not held to favour virtue. The usual allowance of bread was two hard-baked biscuits, weighing between them about a pound, for every day. John Cassian[10] (c. 360–435) describes a 'most sumptuous' Sunday feast – the height of luxury in the desert – where each received a vegetable dish with a liberal amount of oil and salt, three olives, five grains of parched vetches, two prunes and a fig. Sleep was restricted to a couple of hours before dawn. The older and more experienced brethren guided the younger with kindness and sympathy, while all worked with their hands and spent long hours in prayer.

It was, however, in the heart of Upper Egypt that the third form of monastic life, that of the monastery proper, developed. This development took place under St Pachomios. The future patriarch was born of pagan

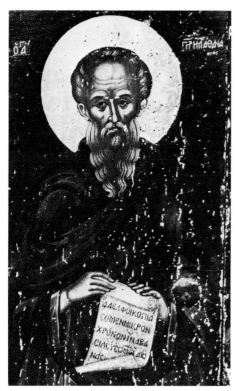

51 St Athanasios the Athonite. Icon from the monastery of the Great Lavra. Eighteenth century.

62

parents near Latopolis, and when young was enlisted in Constantine's army. Passing through Latopolis, he came into contact with local Christians, who gave food and drink to the exhausted soldiery. Pachomios was struck by their example. Constantine's victories allowed him shortly to be free of the army. He went then to Chenoboskion in the upper Thebaid, and after some elementary instruction was baptized as a Christian. Hearing shortly afterwards of Palaemon, spiritual guide to a group of anchorites in the neighbourhood, he became his disciple. Then, like Antony, he felt the call to greater solitude, and built his cell some distance off, in a deserted village, Tabonnisi, on the east bank of the Nile. Palaemon helped his disciple to establish himself, and then returned to his hermitage, leaving Pachomios to embark on his providential mission.

Unlike former directors of ascetical groups, Pachomios decided to place all those who came to him for guidance under his direct authority, and to make them live, as far as possible, under one roof and observe one and the same rule. It was the beginning of a common, or cenobitic, form of monasticism in the strict sense. His decision was criticized, but it was a success. Pachomios soon had more than a hundred monks under his command. When there was no more space available, a new monastery was built at Peboou, three or four miles to the north, also on the right bank of the Nile. One of the hermit groups at Chenoboskion adopted the Pachomian Rule, and turned the settlement into a monastery. Before the death of Pachomios in 346, six other communities had been formed. By the beginning of the fifth century the monks numbered five to seven thousand, and included among them not only Copts, or native Egyptians, but Latins, Greeks and other foreigners as well.

The leading idea of the Pachomian Rule was to establish a fixed minimum of observance which would be obligatory upon all. To this end, all the monks of one monastery were brought within the confines of a wall, and the monastery was made as far as possible a self-contained unit. Within the wall were a church, a general meeting-place, a refectory, a library, a store-room for clothes, kitchen and larder, bakery, infirmary, and blacksmith's, tanner's, carpenter's, fuller's and shoemaker's shops. One monastery might contain as many as thirty or forty houses with from twenty to forty monks in each. In the houses each monk had his own small cell, and there was a large room where the brethren could assemble on occasion. Near the gate of the monastery was a guesthouse, and, further off, another for women. Outside the monastery, too, would be the vegetable gardens. Physical discomfort was not excessive, though greater austerity of life was permitted, even recommended, to those who had strength and zeal enough to undertake it, provided permission was given. For now obedience was given an importance not attached to it before in the ascetical life. The Pachomian institution was a highly centralized system of government: supreme power remained, in fact as well as in theory, in the hands of a single superior, or abbot. Remarkable, too, was the prominence

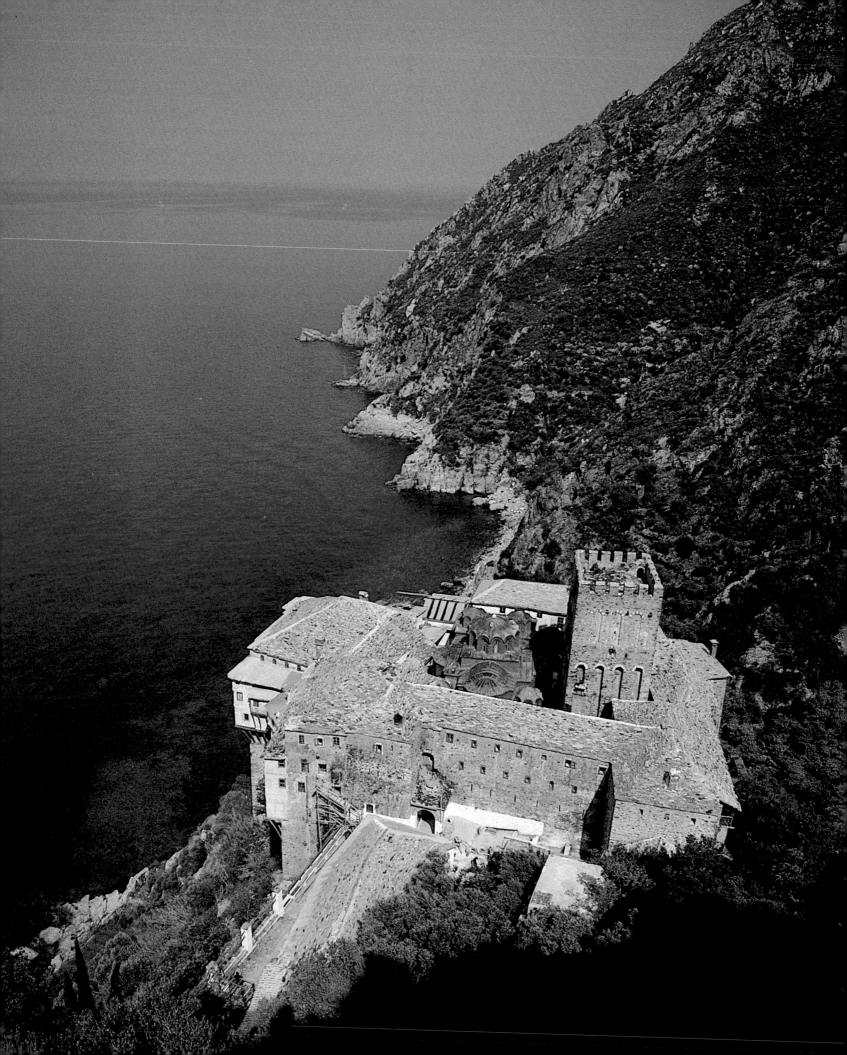

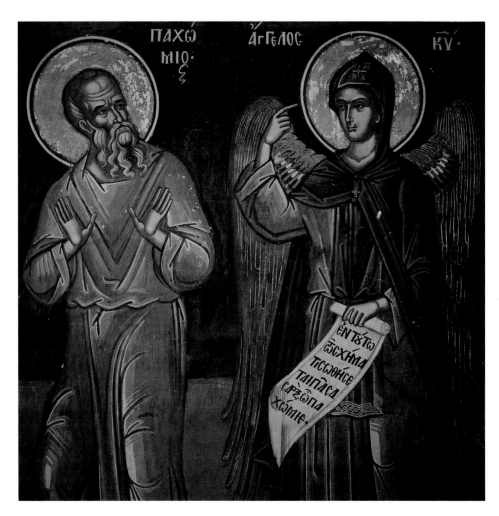

53 An angel wearing the *schema* or monastic habit tells St Pachomios that by wearing this habit he will overcome the temptations of the flesh.

52 *Left* An aerial view of the monastery of Dionysiou, showing the steep forbidding coastline of the peninsula.

given to work. Among the anchorites this was of a sedentary kind, mostly the weaving of osiers into baskets or of thread into linen, and its purpose was to supply the necessaries of life, or to fill in time not occupied with contemplation or spiritual reading. In the Pachomian monasteries, work was undertaken for its own sake as an ascetical exercise; it was strenuous in form – tillage and various other labours – and it alternated with prayer and psalmody in the round of the day. It was not, however, stressed in such a way as to hinder the supreme contemplative life, of which the monks of Egypt provided many fine examples.

Monasticism in this Pachomian form spread to other parts of Egypt, to Palestine, Syria and Mesopotamia, and then on to Asia Minor. There, its first sponsor seems to have been Eustathios, later bishop of Sebaste, who founded a society of monks in Armenia, Paphlagonia and Pontus, and became the author of a strict discipline 'both as to what meats were to be partaken of or to be avoided, what garments to be worn, what customs and precise mode of conduct to be adopted'. But it was the man who continued Eustathios' work who was destined to become the great father of the Orthodox monastic system, as St Antony was of the eremitical and semi-eremitical life.

St Basil was born about 329 of an illustrious family in Cappadocia. Having

65

received an excellent religious training from his grandmother, he was sent to Caesarea, in Cappadocia, and then to Athens, where he studied with great success under the leading teachers of the day. He returned to Caesarea in 356 with the prospects of a brilliant career before him. These, however, he renounced, and devoted himself to the religious life. He journeyed to Egypt, Palestine, Coele-Syria and Mesopotamia, to study at first hand the ascetical institutions of those lands. What he saw filled him with amazement:

I admired their continence in living, and their endurance in toil; I wondered at their persistence in prayer and their triumph over sleep; subdued by no natural necessity, ever keeping their soul's purpose high and free, in hunger, in thirst, in cold, in nakedness, they never yielded to the body; always, as though living in a flesh that was not theirs, they showed in very deed what it is to sojourn for a while in this life and what it is to have one's citizenship and home in heaven.

Basil soon became the recognized leader of the monastic movement in Cappadocia and Pontus. The framework of his system was Pachomian, but he modified this in important ways, most especially by the emphasis he placed on the cenobitic life. In the settlements on the Nile the monks lived under the same or under neighbouring roofs, obeyed the same head, did the same tasks, used the same church or refectory, but apart from this common life any monk could, with permission, practise what discipline he thought most fit. And should he feel strength enough to live in solitude, there was no suggestion that this was not a desirable, and even a superior, course to follow. Basil, however, held strongly that the cenobitical life was both more desirable, and in itself superior, to the anchoretical form of life:

Now all of us who have been received in one hope of our calling are one body having Christ as head, and we are severally members one of another. But if we are not joined together harmoniously in the close links of one body in the Holy Spirit, but each of us chooses solitude, not serving the common welfare in a way well-pleasing to God but fulfilling the private desires of self-pleasing, how, when we are thus separated and divided off, can we preserve the mutual relation and service of the limbs one to another, or their subjection to our head, which is Christ? For it is impossible to rejoice with him that is glorified or to suffer with the sufferer when our life is thus divided, since it is impossible for the individual monk to know the affairs of his neighbour. In the next place, no single man is sufficient to receive all spiritual gifts, but according to the proportion of the faith that is in each man the supply of the Spirit is given; consequently, in the common life the private gift of each man becomes the common property of his fellows.[11]

It was in accordance with this spirit that Basil, through his letters, and especially through his Rule, established the form that was from then on to serve as the model for the Orthodox monastic system. Almost five centuries later, Theodore, abbot of the monastery of Studios at Constantinople, further emphasized certain aspects of this form, and it was thus that, modified to suit local conditions, it was introduced into Athos by St Athanasios, founder of

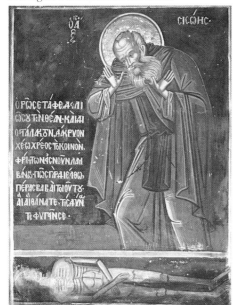

54 'Ah, Death, who can escape thee?' St Sisoes at the grave of Alexander the Great.

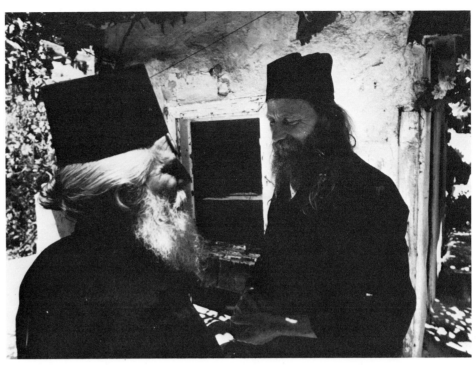

55 Two hermits outside a *kellion*.

the Great Lavra. In one major respect, however, St Athanasios differed from St Basil: he allowed monks already well-trained in the ascetic life of the *cenobium* to retire into the solitary life, recognizing such a life as fit for those capable of achieving the most perfect contemplation. In this way, there have always flourished on Athos both the Antonian forms of the eremitical and semi-eremitical monastic life disapproved of by St Basil, and the Pachomian form, as consolidated by St Basil and modified by St Theodore; though in this connection it must be remembered that Athonite monks, and Orthodox monks in general, are not of the order of St Basil, or of anyone else, for no such order exists. Those living a monastic life are members of a great monastic brotherhood of ascetics; within this brotherhood there are different ideals and types of the ascetic life and, as we shall note, a threefold grade in the practice of asceticism, but there are no separate orders in the Western monastic sense.

In addition to the eremitic, semi-eremitic and cenobitic monk on Athos, there is a further type – the idiorrhythmic monk. This type first made its appearance on Athos (and it appears nowhere else in the Orthodox monastic world) towards the end of the fourteenth century, a time of laxity and corruption in certain of the monasteries. A number of Athonite monks determined it would no longer submit to the prohibition on private property. Monks singly or together acquired property, took possession of it as though it were their own, supported themselves by means of it and bequeathed it to other monks. In this way, they became independent of the abbot of the monastery and impatient of his authority. By degrees, the office of abbot was abolished in many monasteries, and a group of the most influential monks assumed the administration. By the first quarter of the eighteenth century this practice became general, and many of the ruling houses became 67

56 A monk of noble Yugoslav descent in his hermitage. In contrast with the austere location (shown in plate 55), the interior conveys a sense of intimacy and personal care.

57 The refectory of the Great Lavra. It dates from the foundation of the monastery but was seldom used once the monastery became idiorhythmic. Happily, with the monastery's recent conversion to a *cenobium*, it is now back in use.

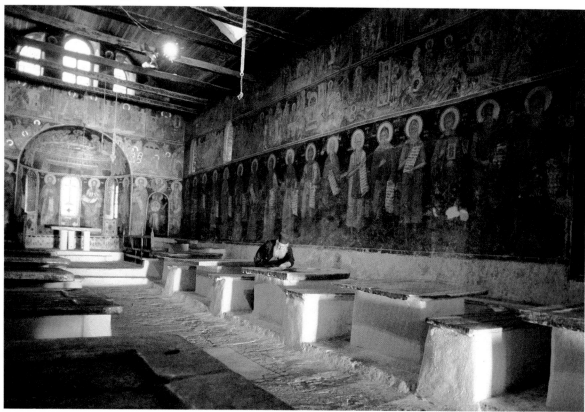

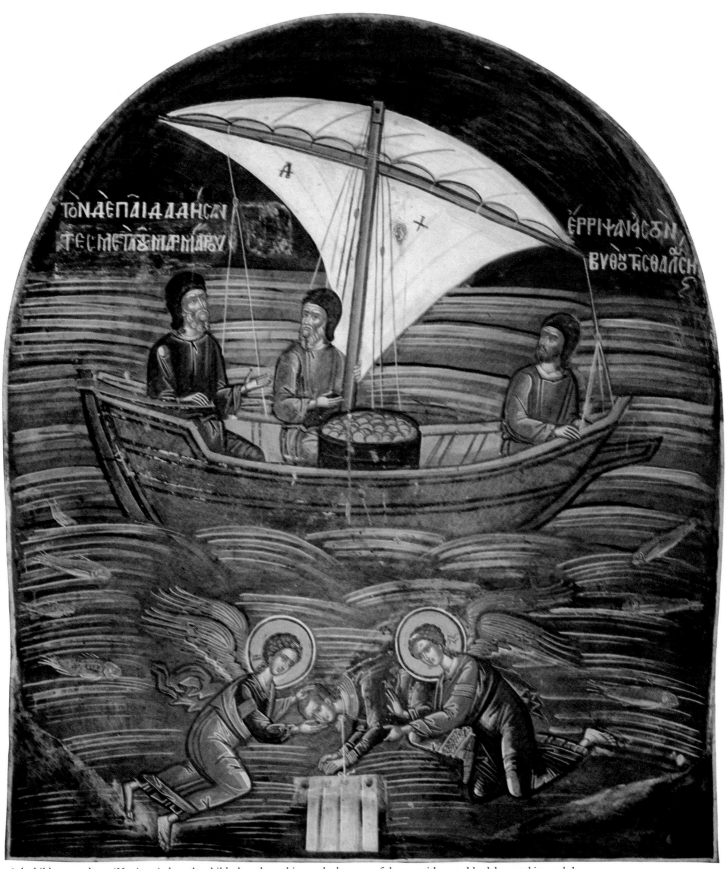

58 A child martyrdom: 'Having tied up the child, they threw him to the bottom of the sea with a marble slab round its neck.'
From the narrative cycle of wall-paintings, in the narthex of Dokheiariou, relating to the foundation of the monastery.

69

idiorrhythmic. Most of these have now changed back to the cenobitic form.

In their way of life the idiorrhythmic monks deviated considerably from the type of life demanded by cenobitism. Their diet was often much like that of the secular world, and was cooked and eaten in the monk's own personal quarters. Meat was introduced and fasting relaxed. Cells were furnished according to individual taste and means; the rooms of well-to-do monks were spacious and furnished with carpets, mirrors and many comforts, and servants kept attendance. While there is nothing to prevent the idiorrhythmic monk from living a holy life, in its present form this practice tends to undermine the stability and order of the traditional Athonite life. It may be added in this connection that whereas no cenobitic monastery is now allowed to change to the idiorrhythmic system, an idiorrhythmic monastery may become again cenobitic.

The responsibility of running the Athonite community as a whole lies with the ruling monasteries, from which are drawn the members making up the two administrative bodies: the Holy Community (a representative assembly) and the Epistasia. The members of both of these bodies reside permanently at the capital of the Holy Mountain, the village of Karyes. Here, among hazel groves and walnut-trees (from which the village takes its name), orchards and vegetable gardens, each monastery has established a residence for its representative and pays for its upkeep.

The Holy Community, whose history goes back to the beginnings of monastic life on Athos, is composed of twenty members, one from each of the ruling monasteries. Its purpose is to preserve the traditions and customs of the community; to maintain peace and order; to settle disputes arising between different monasteries, or between monks and their monasteries; to ratify the

internal regulations of the individual monasteries; to install the administrators of individual monasteries in their offices; to regulate trade; to detect and punish crime; to supervise and control travel; to communicate with state officials in Athens and Church authorities in Constantinople whenever necessary. It meets three times a week, and on special occasions. Its decisions, both legislative and judicial, are carried out by the second body of the central administration, the Epistasia.

The Epistasia, whose origins have already been discussed (see p. 30), is composed of four members, one from each of the group of four monasteries which has control of the Epistasia for the year. Although these four members are equal in status, the member from the senior of the four monasteries has the rank of chief monk of the community, and is called the Protepistatis. As an executive body, the Epistasia enforces the decisions of the Holy Community; it controls the common treasury; it handles the correspondence of the community, all letters sent out being stamped by the common seal which is divided into four parts, each part held individually by one of the four

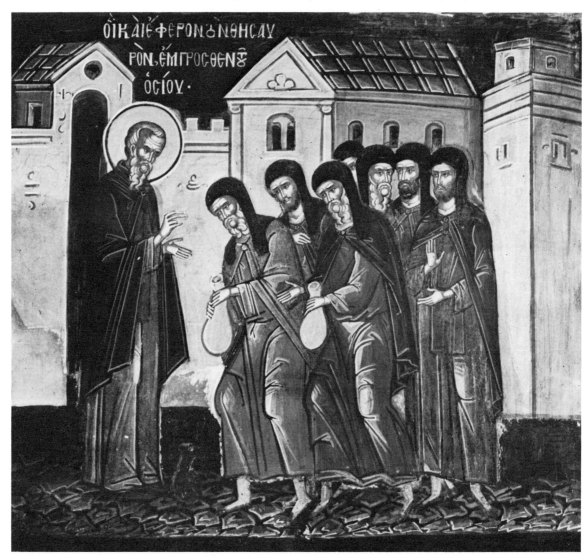

60 Monks present to a saint treasure that they have found. From the narrative cycle of wall-paintings in the narthex of Dokheiariou, relating to the foundation of the monastery.

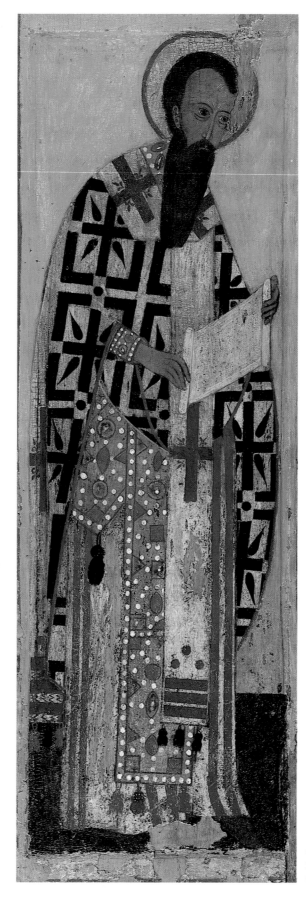

61 St Basil the Great, the founder of cenobitic monasticism. Russian icon of the fifteenth century.

Epistatae. It is also responsible for the cleanliness and the lighting of the streets of Karyes, and for the general sanitation of the village; it regulates food prices, prohibits songs, games, musical instruments, smoking and horseback-riding in the streets. It forbids, too, the opening of shops during vespers, Sundays and feast-days, and the sale of meat and non-ascetic foods on Wednesdays and Fridays and other fast-days; it may expel the drunken, the unemployed and the disorderly from the community; it is, finally, the channel through which inter-monastic disputes may be submitted to the assembly. To assist it in its functions, the Epistasia has at its disposal a local guard, and may also call upon the civil police for assistance.

As far as internal organization is concerned, each of the twenty 'Holy, Ruling, Royal, Patriarchal, and Stavropegiac Monasteries' is an autonomous member of a monastic federation. With the exception of one, Stavronikita, all are imperial institutions founded by the authorization of an imperial chrysobull of a Byzantine emperor. Although immediately subject to the patriarch of Constantinople (it is from the planting in each of the patriarchal cross to signify this that the title 'Stavropegiac' derives), the administration of each is based upon regulations drawn up by the monastery itself and ratified by the Holy Community. All the affairs of each monastery, financial, domestic, disciplinary and so on, are managed by monasterial authorities, though the central authorities retain the right to intervene in case of appeal. In the cenobitic monasteries, the chief authority is the abbot. He is normally required to be over forty years of age, he must have become a monk on Athos, must be exemplary in his conduct, possess a sound ecclesiastical and general knowledge, and have executive ability. He is elected by all the monks of more than six years' standing in the monastery, and his election is sanctioned by the Holy Community, which in its turn at once informs the patriarch at Constantinople, this being a formality. His installation must take place within a month of his election, and his office, in which he functions as both spiritual and temporal head of the monastery, is for life, unless he is deposed by the majority of the voting members of the brotherhood.

The abbot's authority is limited by a small committee of two or three members elected annually by the assembly of elders out of their own number. No independent action either of abbot or of committee is considered valid. In a sense, the abbot and the committee are the executive body of the assembly of elders, while the final authority rests with the assembly of all the brothers, and it is this body alone which has the power to decide on fundamental questions of policy. The monarchical authority of the abbot in cenobitic monasteries is, in consequence, considerably tempered, and it is only in spiritual matters that his word is absolute.

In the idiorrhythmic monasteries, although a token abbot is still elected out of respect for tradition, the management of each monastery is in the hands of the small committee and of a council of superiors. The members of the committee have much the same powers as the abbot, and are elected annually

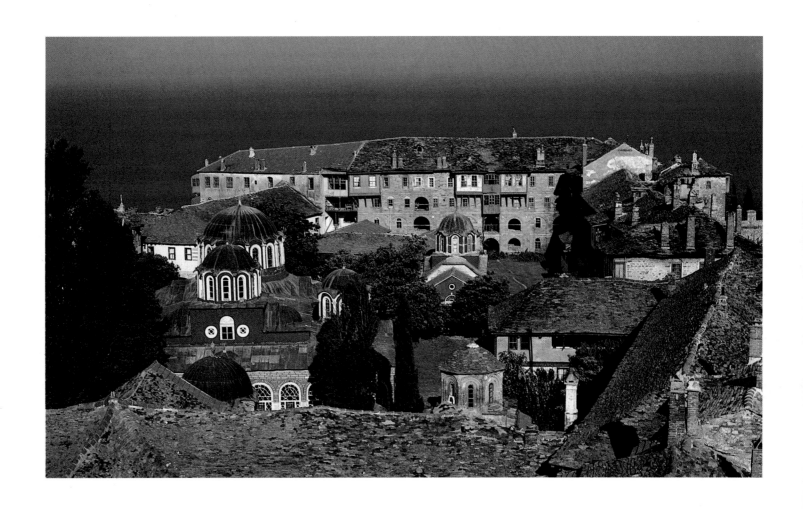

62 The Great Lavra, largest and holiest of the foundations on Athos. Founded in 963, the monastery has never been destroyed by fire and the main tower is part of the original foundation.

63 *Right* The *skete* of St Anne from the sea. The multitude of monastic dwellings are interconnected with irrigation ducts made from hollowed-out tree trunks.

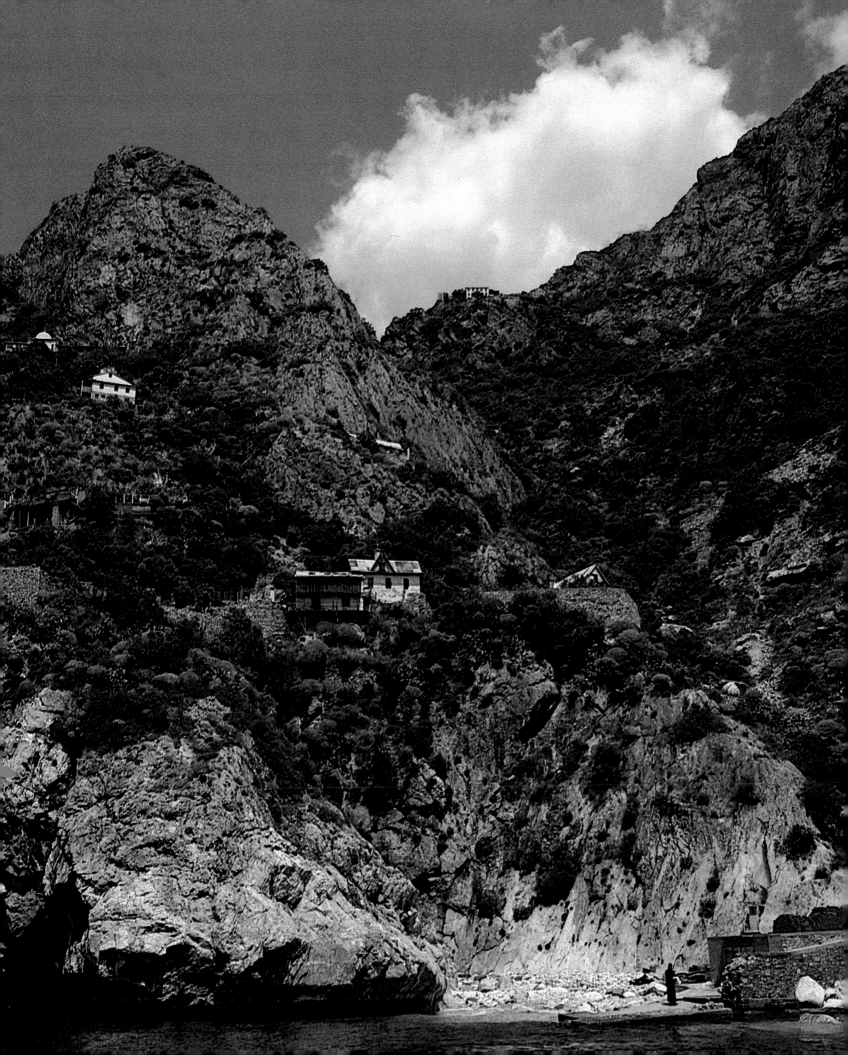

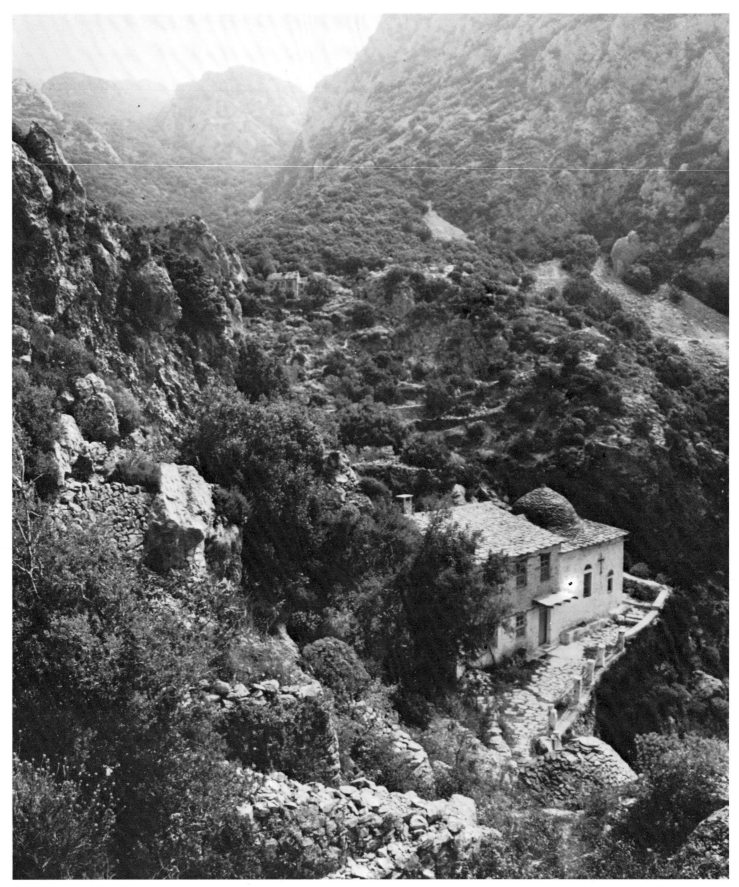

64 *Left* A *kellion* in the mountains.

by the council of superiors out of its own number. It is really the council, which is made up of about ten per cent of the population of the monastery, that governs the monastery. A superior is elected for life, and no monk not of this class has any say in administrative matters. In addition, the superiors themselves have the right to elect a new member. The system, then, is purely oligarchic, and often leads to friction.

The cenobitic and idiorrhythmic monks live, therefore, in these main monasteries. The other monks, eremitical or semi-eremitical, live in a variety of establishments outside the walls of the monasteries. Of these, the first in importance is the *skete*, or small monastic village planted on the soil of one of the ruling monasteries. This is composed of a number of cottages clustering round a central church, the *kyriakon*. Like the monasteries to which they belong, the *sketae* are divided into idiorrhythmic and cenobitic, though this distinction has not affected the administration in the same way as in the monasteries. Both idiorrhythmic and cenobitic *sketae* are administered by a prior, assisted by two or four advisers, and the assembly of elders. The elders meet annually to elect the prior for the following year. The offices, except for the liturgy on Sundays and feast-days, are said separately in the individual cottages, to each of which is attached a small chapel. The three monks who normally inhabit such a cottage, rented directly from the monastery, support themselves by cultivating the ground or by other manual labour. On the death of one of the tenants, a new member must pay a third of the total value to the owning monastery. If all three tenants die, the cottage reverts to the monastery. No *skete* may become a monastery, and the number of monks inhabiting each cottage is limited to six, including the three tenants, to whom a maximum of three lay brothers may be attached.

Next in importance after the *skete* is the *kellion* or cell, a monastic institution of a single building containing a small chapel, with a small area of land attached, and held under a deed of trust from a ruling monastery by three monks. In all, there are some two hundred or more *kellia* on Athos. As in the case of the cottages in a *skete*, the number of occupants in a *kellion* is limited to six, and no *kellion* may become a *skete*.

There are three other types of monastic dwelling, the *kalyve,* the *kathisma* and the *hesychasterion*. The first of these is similar to a cottage in a *skete*, while the second is generally a smaller building occupied by a single monk living alone. The small due which he pays for the dwelling entitles him also to a small dole of bread from his monastery. The *hesychasterion*, or hermitage proper, is generally found on some remote cliff above the sea, in an almost inaccessible position, and is lived in by the true solitary of the Antonian type. He lives in great poverty, and is rarely visible to the eyes of other men. Often he wears no habit and sometimes no clothing at all, though this is rare. In some cases the *hesychasterion* is a cave, but usually it is a rough unadorned hut, perched precipitously on a cliff's ledge.

65 The jetty at the *skete* of St Anne.

THE ART
ICONS AND RELICS

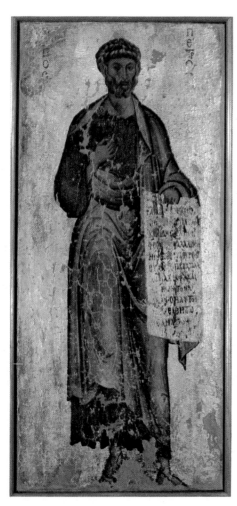

66 St Peter. Twelfth-century icon of the Comnenian period, from the treasury of the Protaton, Karyes.

67 *Right* The iconostasis of the Protaton. The icons are the work of Theophanes the Cretan in the sixteenth century.

As well as guarding a whole spiritual tradition, Athos also preserves a vast cultural and artistic heritage. Here pride of place must go to the unparalleled wealth of icons and wall-paintings that cover the screens, walls and ceilings of churches, chapels and refectories throughout the peninsula. Fortunately, the days are gone when this form of art was abused for its lack of perspective and its artists for their ignorance of human anatomy. But even so, the crucial role that these paintings play in the liturgical life of the monasteries is still not appreciated as much as it should be. Only too often the icon is regarded merely as a further example of religious art, similar in purpose if not in technique to a picture of the Holy Family by Raphael or of the Crucifixion by Matisse. It tends to be forgotten that what determines the nature of a work of art is not so much its subject as its form; and that while a work of art may be called religious because its subject is drawn from the storehouse of scriptural text or sacred legend, it cannot be called an icon unless its form derives from a particular spiritual vision.

Moreover, the icon is not something that can be regarded as a self-contained whole, complete in itself. We have become accustomed to looking at works of art as independent entities, areas of line and colour cut off from surrounding space, enclosed in a frame and hung up on a wall. The icon is not like this. On the contrary, its proper nature cannot be understood unless it is seen in relationship to the organic whole of the spiritual structure of which it forms a part. Divorced from this whole, hung in a frame upon a wall, and looked at as an individual aesthetic object, it may be an attractive piece of decoration, but as an icon it ceases to exist. For as an icon it can only exist within the particular framework of belief and worship to which it belongs. This framework is the Christian liturgy. The art of the icon is a liturgical art. It is a visual system conveying and giving support to the spiritual facts which underlie the whole liturgical drama. Consequently, to understand the icon, there must first be some understanding of the spiritual facts underlying the liturgy.

The liturgy is something like a mystery play or an ancient Greek drama which leads the spectator act by act towards its climax. In this case the climax is represented by the central Christian mystery, the sacrament of the Eucharist, in which the worshipper is also asked to participate. The liturgy

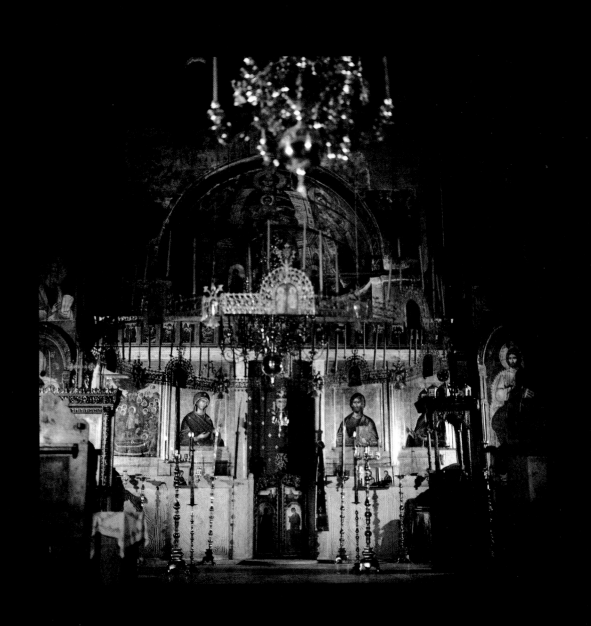

68 Sts Ephraim the Syrian and Pachomios. Panel icon from the Great Lavra, seventeenth century.

then is designed to lead the worshipper towards participation in this sacrament. The various stages of the liturgy are means to this end. They act as a preparation for the approach to the central mystery.

What has to be conveyed to the worshipper is a sense of the reality of those two main events of which the sacrament of the Eucharist is the consummation – the Incarnation and the Transfiguration. They, indeed, might be called the two poles of the whole Christian scheme of salvation. The one pole – the Incarnation – signifies the entry of the Spirit into matter, into human and natural existence. The other pole – the Transfiguration – makes evident the consequence of this, the sanctification or spiritualization of matter and of human and natural existence. 'God became man so that man might become God' is the traditional expression of this scheme of salvation. The Eucharist imitates and repeats this scheme. In it, the Spirit enters into matter – into the elements of bread and wine – and in the same instant sanctifies matter, filling the elements with divine grace. The Eucharist is thus the means through which God's redemptive and transfigurating activity continues through time. It is an image of the Saviour, an image of mercy that is able to bring about the salvation of man.

An image, it should be said, is not simply a sign for something. It does not simply indicate something other than itself, as smoke may indicate fire or as a cry may indicate pain. An image shares in the nature of the object of which it is an image, there is an actual presence of the one in the other, a physical fusion (though not confusion), so that in knowing the image we are in the same instant made aware of the object which it reveals. And an image does not, as a sign, merely indicate; it also brings about the effect it indicates; it compels us, to the degree to which we submit or are receptive to its influence, actually to experience that life which it mysteriously mirrors and enshrines. And it is in this sense that the Eucharist is an image: it is an instrument charged with the divine, which has the power to confer an inner sanctity on whoever moves towards it.

It is in this way that the icon can be understood as a liturgical art. If the Eucharist is the image of the Christian Saviour, the divine masterwork, then the icon in its turn is an image of the Eucharist, leading the mind directly to the heart of the Christian mystery. For the icon testifies to the two basic realities of the Christian faith – that of the divine penetration of the human and natural world, and that of the sanctification which results from this. And as these realities also contain and imply a whole cosmology, the icon also testifies to the Christian scheme of the universe. The icon is not an imitation of the natural world; it does not enter into competition with the unattainable perfection of the world, as Classical art, for instance, so often tries to do; nor does it aspire, again as Classical art so often does, to a serenity in terms of this world. On the contrary, the icon seeks to convey a picture of the divine world order – how things are in their true state, or in 'the eyes of the God', and not as they appear from our limited points of view.

This can most clearly be seen in the fully developed iconographic scheme of the Christian Church. The church is itself an image of the universe – an icon of the universe according to the Christian pattern. According to this pattern, the universe is built up on a hierarchic scale; or, rather, there are different levels of being, each level issuing from and depending on the one above it. This scale is often regarded as threefold. The highest level is the heavenly and uncreated world of divine being; the next level corresponds to the world of paradise, to the world as it was created 'in the beginning' – a world which was lost through the 'fall' of man, and was 'reformed' through the Incarnation and the whole cycle of events which make up the life of Christ, or the New Testament. The third level is that of human and terrestrial existence – not in its fallen state but in the process of 'deification' through the activity of the Holy Spirit by which it comes to realize that state of human nature 'recreated' by the Saviour.

These three levels can be clearly distinguished in the iconographic (and architectural) scheme of the church. First, there is the divine world represented in the dome and on the high vaults; second, on the squinches, the pendentives and upper parts of the walls are scenes dedicated to the life of Christ, to that 'recreating' of human and other nature in Christ, and to that 'regaining' of paradise in the heavenly Jerusalem; third, on the lower or secondary vaults and on the lower walls are images of the saints and martyrs, holy men and women who already have a part in the redeemed world. Thus, on entering the church the worshipper has before him a whole picture of the universe, the hierarchy indicated by the various figures occupying the different levels.

In the dome there is the figure of the Son of God, the Logos or Divine Word, who is not only being itself, but also the source of being for all lower levels. He is the all-ruler, the Pantocrator and the creator. He occupies the centre of the dome, the centre of the heavens and of the universe. Below and round him radiate like spokes of a wheel other divine powers, archangels or angels, sometimes apostles or prophets. These are, as it were, intermediaries between the uncreated and timeless divine world and the world created in time and space. Also, in relation to the liturgy, they are announcers and mediators of the Incarnation, of the descent of the Son of God to earth.

The events of this descent are figured in the second zone, in the secondary vaults and on the straight walls. Here are depicted scenes from Christ's life on earth: these comprise, in their classical form, the twelve main feasts of the Christian year – the Annunciation, the Nativity, the Presentation in the Temple, the Baptism, the Transfiguration, the Raising of Lazarus, the Entry into Jerusalem, the Crucifixion, and the Anastasis (Descent into Hades), the Ascension, the Pentecost and the Koimisis (the Dormition of the Virgin). These correspond to the various stages of the scheme of salvation – they are reminders of the way to be followed in the 'return to Paradise'.

Beneath these are standing figures of saints and martyrs. They testify not

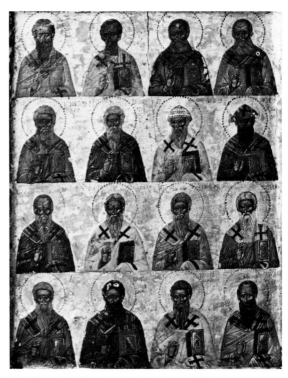

69 A four-tiered icon depicting fathers of the Church, from the Great Lavra. Paleologue Period, fourteenth/fifteenth century.

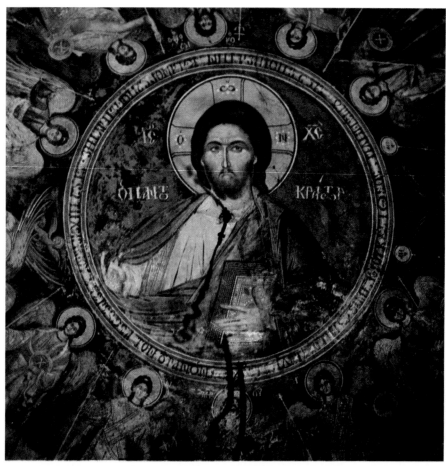

70–72 Wall-paintings by Dionysios of Fourna, author of *The Painter's Manual*, from his cell in Karyes: Christ Pantocrator on the dome; the evangelist Mark and Matthew on the pendentives. Late seventeenth/early eighteenth century.

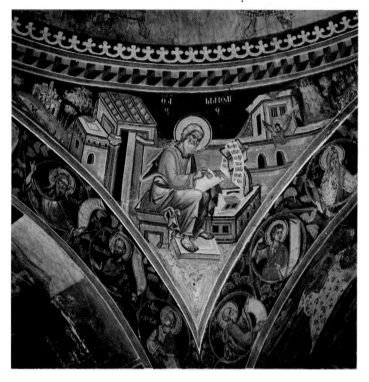

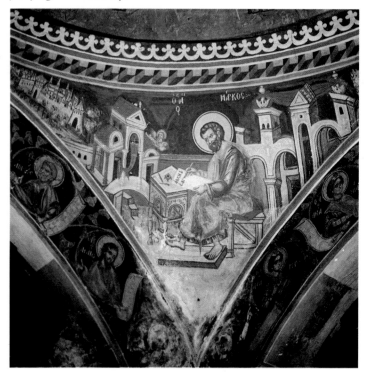

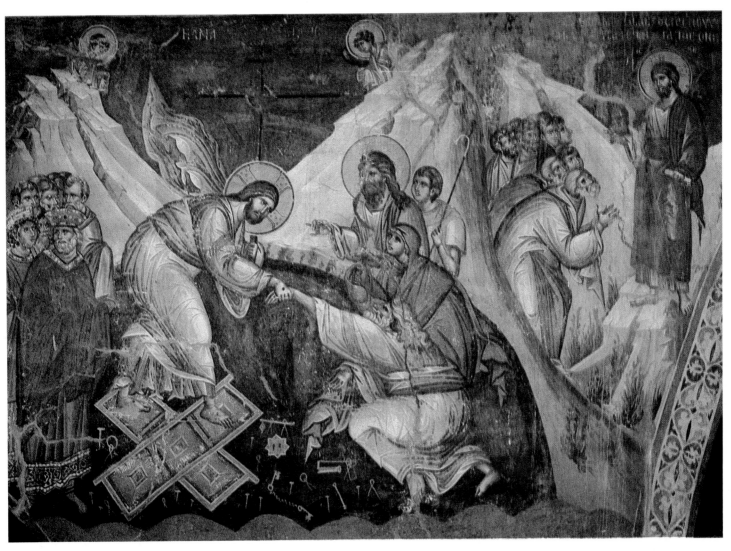

73 The Raising of the Dead. Wall-painting by Manuel Panselinos, from the Protaton, Karyes (as shown in Plate 76 in the scenes from the life of Christ.)
Thirteenth century.

74 The evangelist Luke. Detail of a wall-painting from the Protaton, Karyes (as shown in plate 76).

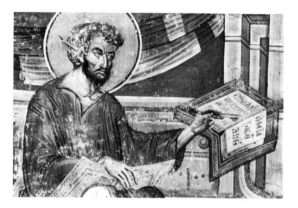

75 Two military saints: Sts Theodore Stratelates and Theodore Teron. Wall-painting from the Protaton, Karyes (as shown in plate 76).

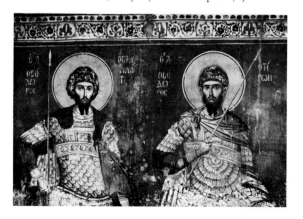

only to the reality of the Incarnation, but also to the reality of that sanctification in the Spirit which is, as it were, the purpose of the Incarnation. These are not portraits of men and women in their 'fallen' state. They are portraits of a deified humanity, of men and women who have cleansed the divine image in themselves which had been obscured and troubled by the Fall, and who participate here and now in the new heaven and the new earth. What they represent is the state of being which it is, or should be, the worshipper's desire to achieve through his initiation into the Christian mystery. Once again the connection with the liturgy is obvious and intimate.

On the floor of the church is the congregation – the congregation of those who have entered on the way of salvation and are aspiring towards those levels of being which they see imaged on the walls around them. They are between outer darkness – the world outside the church – and the kingdom of God, the New Jerusalem, which is revealed to their 'inner eye' through its projection in visible terms into the space of the church.

It must be remembered that these various levels of being mirrored in the space of the church are not, according to Christian understanding, merely outside man; they are also within him. The church, with its iconographic scheme, is not merely a diagram in miniature of the universe; it is also a diagram of man's inner world. According to the Christian view, in man are contained all those levels of being occupied by the various forms of the created world. Thus, in his spiritual intelligence, man is angelic; at the same time he has a rational soul, and also a body similar to that of an animal. In this way he holds a middle position between the higher and lower levels of creation. In his triple nature of spirit, soul and body he unites these higher and lower levels. The position of man constitutes his dignity and it makes him not only superior to the animals but also to the angels, since he is more inclusive than an angel. Normally, however, he behaves and regards himself as though he were made up only of the lower levels of his nature – as though he were only a creature of reason and sense – and forgets about his angelic and spiritual nature. He forgets his true dignity. The iconic forms of the church are thus reminders to him of what this dignity is. They show him what he is in reality – or what from his immediate point of view he is capable of becoming: a dweller in eternity, a sharer of angelic life, as well as an earthbound creature of time. If he were but capable of mobilizing the higher levels of his being which he sees reflected in the icons about him, he would then be capable of occupying the position for which he was originally created.

It is the bringing into play of these higher levels of being that is the intention of the Eucharist. And here another aspect of the iconographic scheme of the church is evident: it conveys the reality of the continuing nature of the divine activity in the eucharistic sacrament. Here the centre of attention is the sanctuary. This is separated from the main body of the church, and thus from the congregation, by a screen, the iconostasis, which itself bears icons, the main two being those of Christ and Mary on either side of the royal door.

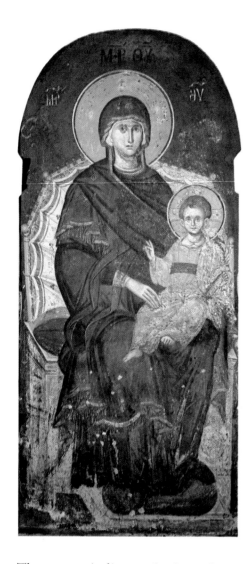 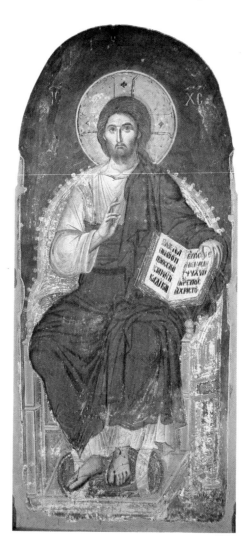

77, 78 Enthroned Virgin and Child, and Christ enthroned. Wall-paintings by Manuel Panselinos, from the *templon* of the Protaton, Karyes. Thirteenth century.

The screen indicates the boundary separating the world of sense from the spiritual world, and so the icons appear at this point, uniting the two worlds, in the same way as the world of imagination in man stands between his spiritual nature and his sensory faculties.

It is in the sanctuary, the holy of holies, that the sacrament of the Eucharist takes place, and hence the images which surround it express the whole 'economy' of the sacrament in a still more direct way than those in other parts of the church. First, according to Christian understanding, it is Christ himself who is invisibly present in the visible form of the sacrament; and this too is shown in the icons which stand by the altar. Christ is shown as a sacrificer and what is sacrificed, offerer and offered, priest and victim. The Eucharist, being the image of the Saviour, is also an imitation of the Incarnation. Thus, in order for it to be accomplished there must be an imitation of all those divine-human events, of which the prototypes are revealed in the gospel narrative of the birth of Christ. There must, that is, be a descent of the Spirit into matter, into the human and natural world, a 'taking of flesh' of the Holy Spirit and of Mary the Virgin. That is why above the altar – symbolically the place of the

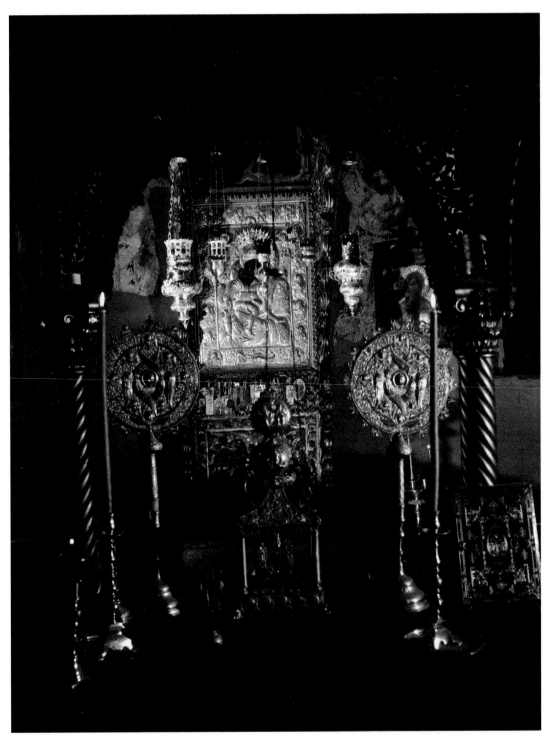

79 View of the Holy of Holies in the Protaton, Karyes.

Divine Birth, the image of Bethlehem – is the icon of the Mother of God. For the Mother of God also stands between the divine and the human worlds, between the higher uncreated levels of being and the lower created levels; she mediates between these worlds, receiving the Spirit 'from above', from the spiritual world, and giving it birth in the human and natural world. And this is represented iconographically by placing her between the icon of the descent of the Spirit at the Pentecost and the altar on which the presence of the incarnate God is manifested in each eucharistic sacrifice. And, to complete the whole movement, what is participated in through this mystery is no less than the Lord of all, the Divine Logos, the alpha that begins and the omega that completes the whole cycle and whose image radiates from the central medallion of the dome.

This, briefly, is the fully developed iconographic scheme of the church, where the whole liturgical nature of the art of the icon is most evident. But the same principles are also those which determine even single icons used for personal devotions: they are all means for conveying and, indeed, for actually bringing about in the beholder a realization of the truths of the Christian faith. In doing this, the icon has to conform to very precise rules. Not only is the disposition of the icons in the iconographic scheme of the church determined by their liturgical function, but the formal rules according to which each single icon has to be painted are equally strict. Indeed, it is the quality of its form which makes an icon an icon and not simply a religious picture. For an icon to be an icon, its form must derive from spiritual vision. We like to think that because the Spirit is free to blow where it will it can be expressed in any form; and we interpret this as giving a liberty to the artist to choose what form he likes for his work. However, the icon is based on the idea that a spiritual vision expresses itself necessarily in a certain formal language, and that deviation from this language distorts or obscures the vision. Far from the individual artist choosing the form, it is the spiritual reality that is to be expressed which itself chooses, or imposes, the form in which the artist must express it.

This principle is made clear, both in a literal and in a symbolic fashion, in the existence of those icons which are known as *akheiropiiti*, 'made without hands'. The best-known example of these is the image of Christ on the Mandilion. Abgar, king of Edessa, being unable to see Christ in person, asked for his portrait and this Christ sent him miraculously impressed on a piece of material. There are several other icons called *akheiropiiti* because the holy persons they represent have themselves impressed their images on to the material from which the icon has been made. But the miracle which occurs in these cases in an absolute sense also occurs in a relative sense in the case of every icon that is painted: it is the prototype of the icon which impresses its own image on the material. For this is only another way of saying that spiritual realities have a certain definite formal equivalent, which has to be obeyed by the iconographer. Whereas in non-iconographic art the picture is

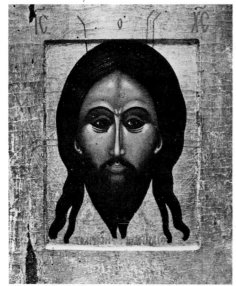

80 *Akheiropiitos* icon of Christ, from the monastery of Hilandari. Russian work of the sixteenth century.

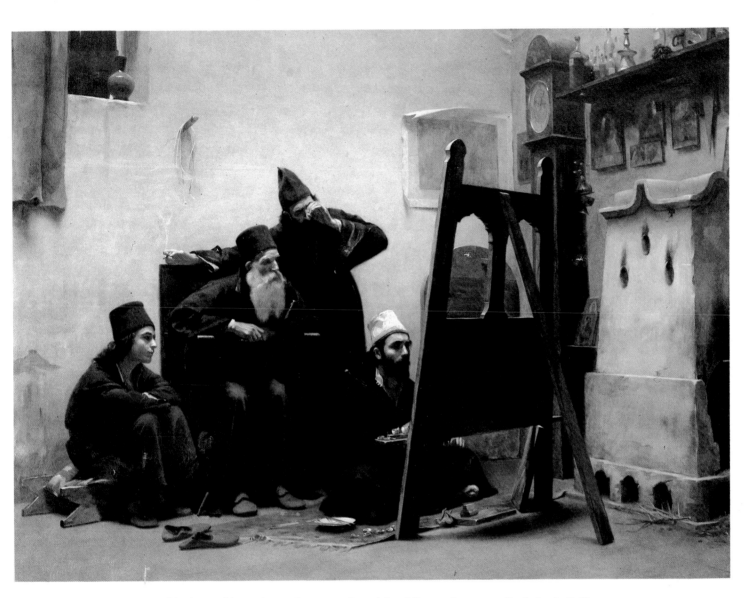

81 Monks watching an icon-painter at work on Athos. Nineteenth-century oil painting by Ralli.

generally conceived as expressing the artist's own response to his subject, it is truer in the case of an icon to think of the sacred subject itself projecting or reflecting itself on to the material of the icon. The form in which this is done then becomes the established form for that particular subject, and is 'canonized' as such by tradition. The material on to which the sacred subject projects or reflects itself should be thought of as including the individual personality of the artist as well as the whole cultural and psychic ambience in which he lives. It is the difference in material in this sense that accounts for the variations between icons expressing the same subject. But these variations – although in retrospect they allow us to study stylistic sequences, date various works, discuss influences and so on – are accidental. What is intrinsic and constant in spite of these variations is the formal element which, where the iconographic tradition is living, will tend to reduce to a minimum all variations due to the individual personality and the cultural environment of the artist. That is why to those of us who are used to the countless modes and mannerisms of modern art, as well as to the idea that an artist is free to express what he likes how he likes, the formal control determining the icon appears an unnatural imposition. What we forget when we think like this is that the rules and canons to which the iconographer must conform are not his own or any one else's invention, but exist in the nature of things; that there is a science of forms as precise as mathematics or astrology.

This does not mean that the iconographer merely imitates in a servile and academic manner certain prescribed images. Such a process would result inevitably in a lifeless kind of art – one in which the forms are no longer experienced and energized by the artist. Whether an icon is 'living' or 'dead' depends on whether the artist himself is spiritually prepared for his task. For the likeness of the holy figure or theme which the artist has to copy is a spiritual likeness and exists only in the spirit; and a knowledge of it is not to be obtained by empirical observation, but only through an inward merging with it. The artist, that is, has to become one with what he is to represent: there is no distinction between art and contemplation. The artist must raise his vision from earthly to divine concerns and perceptions until he can mentally entertain the form which he is to imitate. There has to be an endless renewal of the internal imaginative act, an endless recreation within the life of the artist of the spiritual realities which are the subject of his work. It is these realities which must spontaneously inform his work if it is to live. The iconographic form – the ascertained rules of the art – are simply the means spontaneously assumed by these realities in order to express themselves. Naturally, this expression is, as we said, modified by the personality and environment of the artist. But this intrusion of the artist's local conditions is something quite different from the wilful self-expression often indulged in by many modern artists. The iconographer does not lay claim to that independence of and superiority to discipline which is so much a part of the modern deification of 'artistic genius'. He is concerned not with expressing himself in any superficial

82 The Virgin, from a Deisis series, possibly by the painter Emmanuel Lambardos. Cretan school, *c.* 1600.

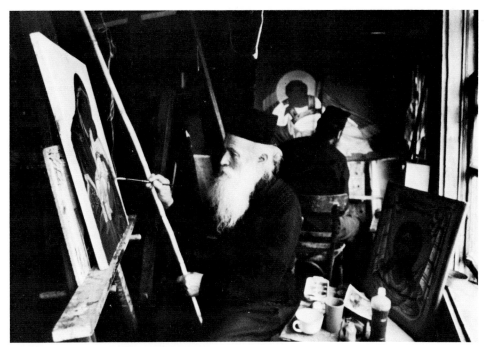

83 Icon-painters at work on Athos. The sentimental European style favoured during the nineteenth century has given way to the making of replicas of Byzantine paintings.

sense, but with revealing those forms which issue, spontaneously and universally, from his own experience of the basic truths of the Christian faith; and his one thought is, or should be, to be moved only by these forms, for what they express is that ultimate freedom and spontaneity which lies at the heart of his own as of every other being.

Thus we return to the original point, to the icon as a means both for presenting a spiritual doctrine and for bringing about a spiritual realization. For in the first place the icon illustrates the Christian creed: it presents a theology, a doctrine of creation and an account of the divine-human events – the 'descent from heaven', the Incarnation, the Crucifixion, the Burial, Resurrection and the Pentecost – which together compose the Christian scheme of salvation. In this respect the icon instructs in the dogmatic truths of the Christian faith. It helps to make us conscious of the whole intellectual framework within which the Christian mystery unfolds. Unless we first have some understanding of this, we are hardly likely to see the point or purpose of the Christian mystery. The icon is a sign pointing towards a knowledge of those beliefs and ideas with which the Christian faith is concerned.

The Christian faith, however, is not only a matter of beliefs; it is also a matter of growing in spirit. And in this the icon also plays its part. For the ideas and beliefs which the icon represents must be regarded not merely as static or abstract concepts – 'Platonic ideas' in the way that these are usually understood – but rather as living realities, centres of power within man as well as in the universe. The icon projects these states into visible forms: it is an image of these states, and is imbued with something of the vitality of what it images. It becomes in its turn a centre of power, an incarnation in its own right of the spiritual energy of its divine or deified prototypes. And because it is an instrument charged with an energy that is more than human, it is able to

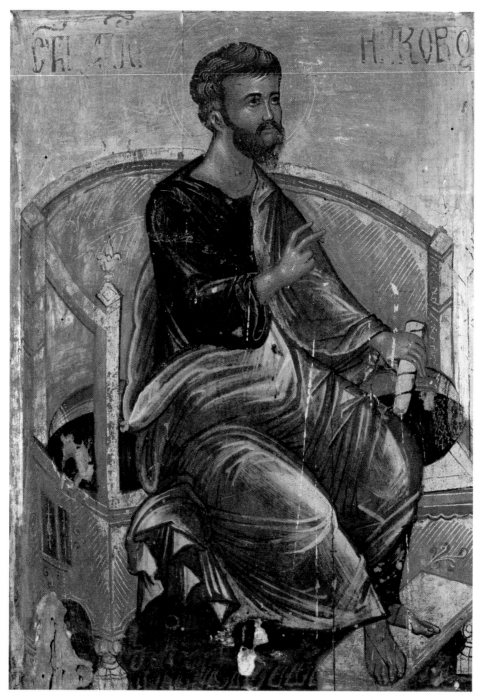

84 The evangelist Mark. Icon from the *skete* of St Anne. Fifteenth/sixteenth century.

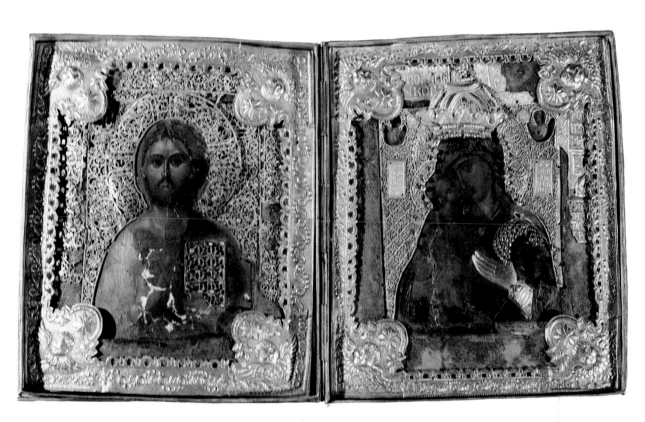

85 This fourteenth-century dyptych showing Christ and the Virgin and Child is associated by legend with the Empress Theodora. They are known as Theodora's Dolls, which is how she justified owning them during the period of iconoclasm. In 843 she restored the cult of icons. The dyptych is kept in the *Katholikon* at Vatopedi.

induce in the worshipper a consciousness of this more than human life which it embodies. Expressing through the beauty of its line and colour the purpose of man, it also helps man to a realization of that purpose. Its holy personages come forth ready to bless and liberate – ready to convert the beholder from his restricted point of view to the full view of their spiritual vision. For the art of the icon is ultimately so to transform the person who moves towards it that he sees the worlds of eternity and time, of spirit and matter, of the divine and the human, no longer as opposites but as united in a single reality, in that unaged and ageless image-bearing light in which all things live, move and have their being.

The fact that the icon enshrines and transmits a spiritual energy means that it is often looked upon as being itself the source of this energy, for so, to the beholder, it may actually appear. In this way the icon may come to possess for the beholder a miraculous nature. It speaks, acts, moves about like a divine being itself. And the veneration with which it is regarded will often depend on the intensity of the miracles that it has accomplished.

There are many such miraculous icons on Athos, far the greatest number of them being of the Holy Virgin. Often these icons have a legend attached to them, either of their coming to Athos, or of some renowned miracle. There is, for instance, the legend of the icon of the Virgin of the Gate, the Portaïtissa, at Iveron, a legend associated with the iconoclastic quarrel between 726 and 843. In the reign of Theophilos, who on Athos is regarded as the greatest enemy of the icon among the emperors, a pious widow lived at Nicaea with her only son. The emperor's agents found that she was concealing in her house an icon of the Virgin. They told her that they would denounce her unless she paid them a sufficiently large sum of money to make it worth their while not to. She and her son fell to prayers, and committed the icon to the waves: 'As you can save us from the anger of the emperor, so you can save yourself from the dangers of the sea', they said as the icon was carried away from them. And the icon gave them a sign in response to their trust: it did not float flat on the water, but stood upright on the surface, and thus it moved off westwards. It sailed in the sea for seventy years. Then one day the monks of the monastery of Iveron saw a pillar of fire standing over the sea and springing up to the heavens, which continued for many days and nights. The fire was rising from the floating icon. The monks were astonished; they came in their dug-out canoes from all parts of Athos. But the icon would not allow itself to be taken from the sea. At last a voice was heard coming from the icon itself: 'Unless Gabriel the Iberian comes from Little Athos, I will not come to you.' 'Little Athos' is a small conical peak rising from the main ridge of the Mountain, and there Gabriel lived as a hermit. Monks went to call Gabriel who walked out across the surface of the sea and brought the icon to land. At once a chapel was built on the spot where it landed, and the icon itself was taken into the main church of the monastery. But in the morning the sacristan found the icon missing, and it was discovered to have placed itself above the old gate of the

86. *Right* Detail of a chrysobull of Alexios III Comnenos

94

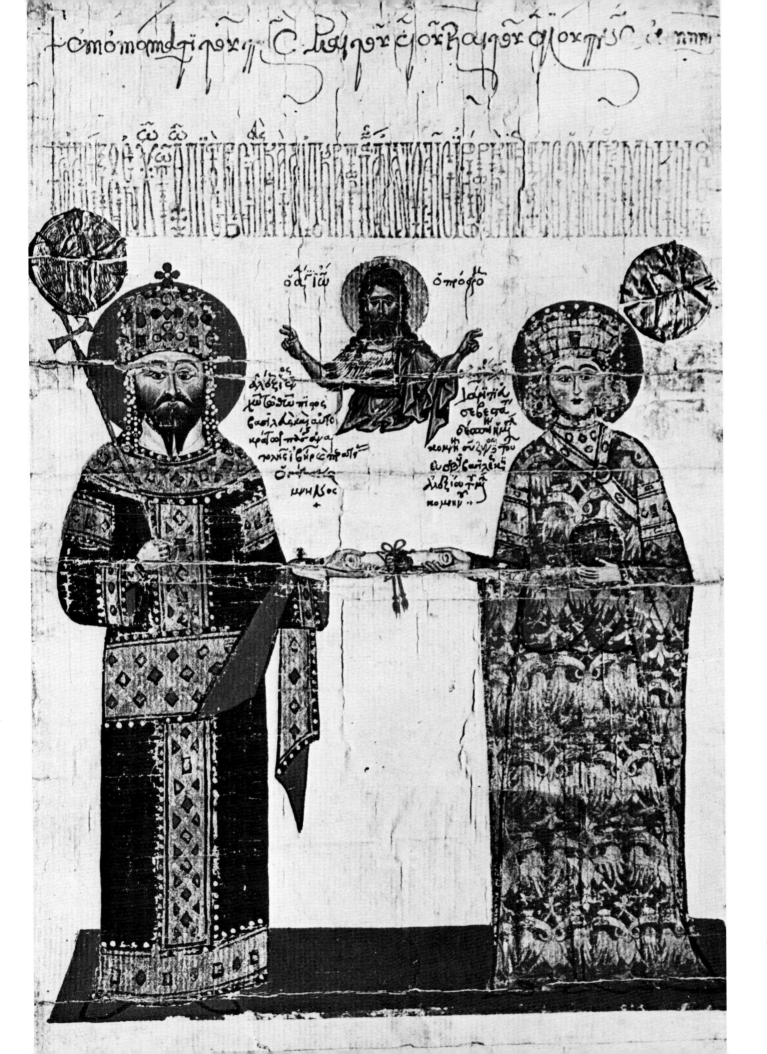

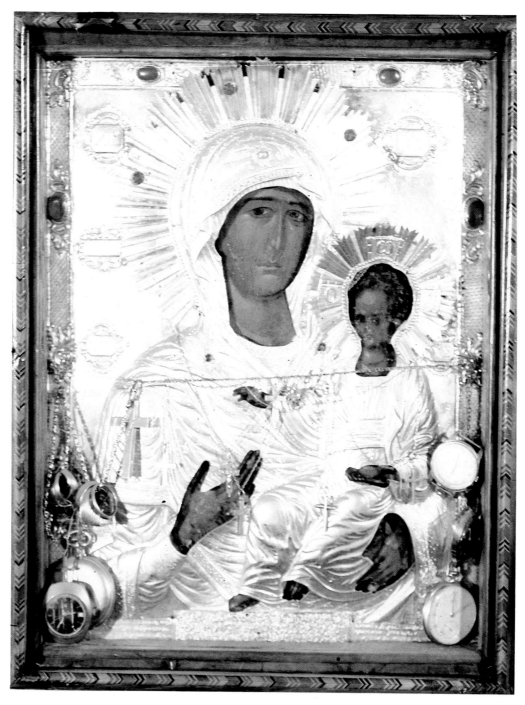

87 Icon of the Virgin and Child with silver cover, from the monastery of Simonopetra.

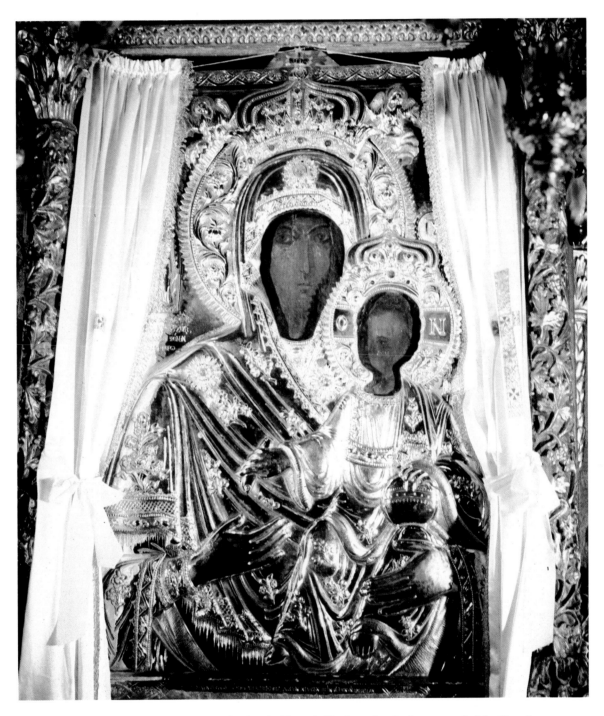

88 Icon of the Virgin and Child, from the chapel of Panagia Koukouzelissa in the courtyard of the Great Lavra.

monastery. Once again it was taken back into the church, and again it returned to its position over the gate. This happened three times. Then the Virgin appeared to Gabriel and told him that a new chapel must be built for her icon at the main entrance of the monastery, 'for I have not come here for you to guard me, but for me to guard you'. So the new chapel was built at the gate, and the icon was placed in it, and there it still is, with the name it has acquired, Portaïtissa, the Virgin of the Gate.

Another legend surrounds the icon of the Virgin with the Three Hands, the Trikherousa. This belonged to the great eighth-century Orthodox theologian, St John of Damascus. In the days of the iconoclast Emperor Leo the Isaurian, John was in the service of the caliph of Damascus. He was also one of the strongest opponents of the emperor's policy. To get rid of him, the emperor forged letters in John's handwriting addressed to himself, in which he was invited, as though by John, to attack the caliph. The emperor then sent these letters to the caliph, who believed that they were genuine, and as a punishment cut off John's hand. 'And thus', comments the narrator, 'was dyed in its own blood the hand which before had been stained with ink in opposing the enemies of the Lord.' The hand was then hung up in a public place as a warning to others. But the pain of the arm where the hand had been severed was more than John could stand, and he begged the caliph to let him have the hand back, that by anointing it he might relieve his own discomfort. The caliph relented and gave the hand back. John took it, and then prayed before the icon that his hand might be restored, so that he could continue his struggle against the iconoclasts. After his prayer, the Virgin appeared to John and promised to heal him, at the same time saying that he must use his hand as 'the reed of a swiftly writing scribe, to compose hymns to Christ and to the Mother of God'. His hand was restored, but there was left a red line round the wrist as a sign of what had happened. The caliph, when told of this miracle, at first thought that some other hand than John's had been cut off, and it was only when he saw the red band round the wrist that he was convinced. He pardoned John who, in gratitude for his healing, had a silver hand made and fixed it to the icon. Hence the icon received its name. The caliph now allowed John to leave his court and to become a monk in the monastery of St Savvas in the desert near Jerusalem. John took the icon with him, and there it stayed for nearly four hundred years until, in the twelfth century, it was given to a second St Savvas, the archbishop of Serbia and son of King Stephan Nemanja. It was this Savvas and his father, whose religious name was Symeon, who founded the monastery of Hilandari on Athos.

John's icon remained in Serbia till 1371, when the Turks, at the battle of Maritza, conquered the country. To save the icon, it was placed on the back of an ass, which was then turned loose. Followed by a group of men, the ass journeyed south, and eventually arrived at the monastery of Hilandari. At a spot a little outside the main gate of the monastery, it fell and died. A shrine was built, and the monks of Hilandari hung the icon in the chancel of the

98

89 Two monastic saints: Dorotheos and Makarios the Roman. Wall-painting in the refectory of the monastery of Dionysiou.

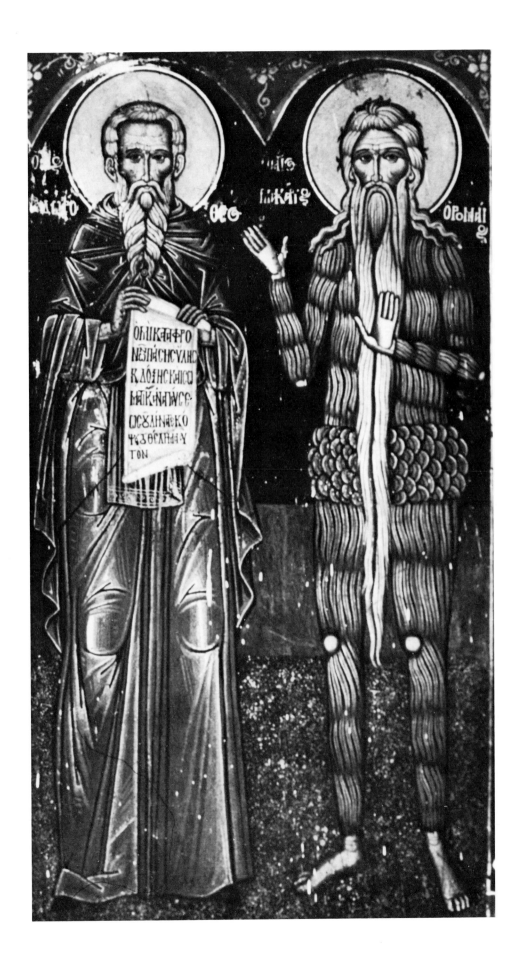

99

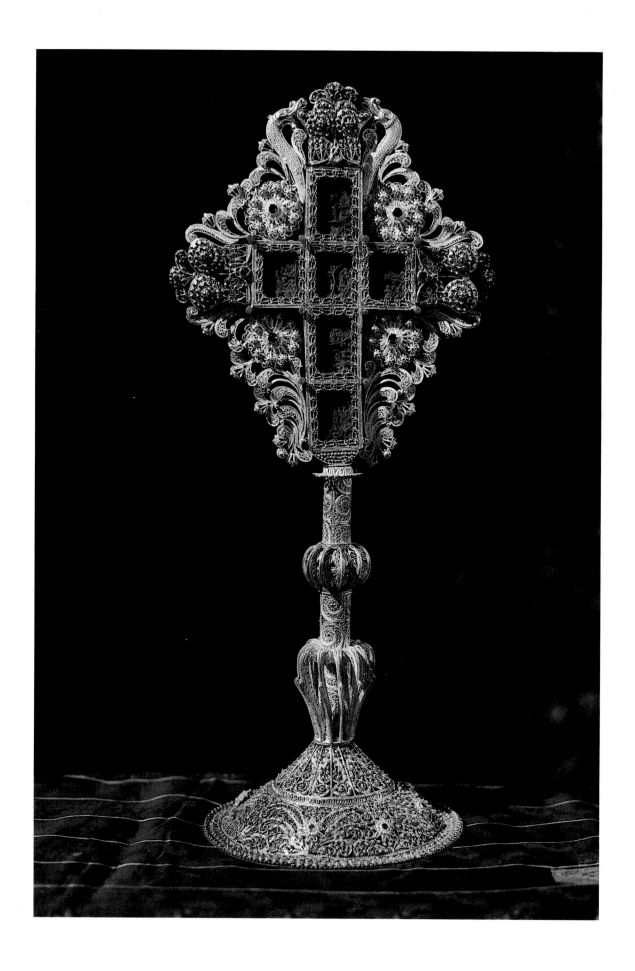

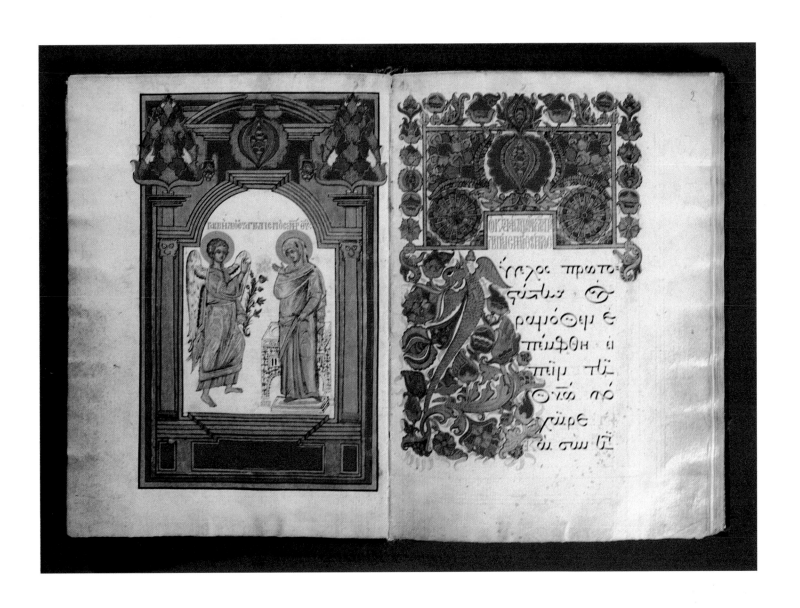

90 *Left* Bejewelled altar cross, from the monastery of Dokheiariou.

91 Post-Byzantine gospel showing the Annunciation, from the monastery of Vatopedi.

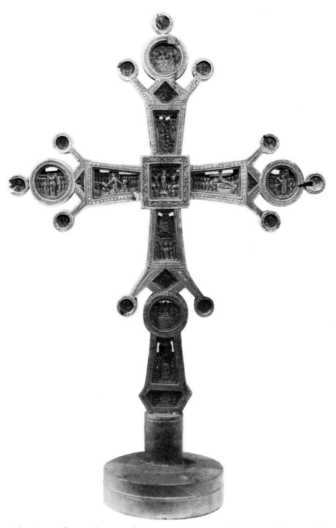

92 A wooden carved cross with feast-day representation, the shape copying a Byzantine metal original. Seventeenth/eighteenth century.

church. There it stayed until one day there was a dispute about the election of a new abbot. The monastery was dedicated to the Virgin, and she chose her own way of settling the dispute. One morning at matins the monks saw that the icon was no longer in the chancel, but was stationed above the abbot's throne. They replaced it in the chancel, but again it moved back to the throne. This occurred three times. Then a hermit came to the monastery, and told the monks that he had had a vision in which the Virgin had told him that, in order to avoid such disputes in the future, she would occupy the place of abbot and govern the monastery: only a vice-abbot should be elected, very much as at Lavra only a vice-steward was appointed to help the chief steward, the Virgin herself. And, indeed, today the icon still hangs on the back of the throne which the abbot would occupy.

The icon of St George at the monastery of Zographou is an example of an *akheiropiiti* icon. According to the legend, the monastery was founded in the time of Emperor Leo the Wise (886–911) by three brothers of the house of Justinian, who came from a town close to the border of Albania and Yugoslavia. When they had built the monastery, they were unable to decide on the dedication. One wanted to dedicate it to the Holy Virgin, one to St

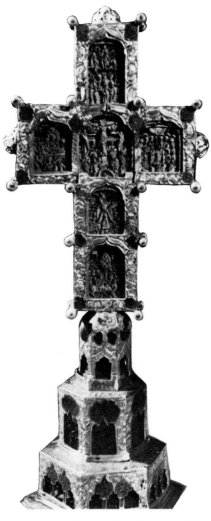

Nicholas and one to St George. To resolve the question they prepared a blank panel, which they put in the church one evening, and locked the doors. They then prayed that on the panel might appear, 'made without hands', the icon of the saint to whom it was God's will that the monastery be dedicated. In the morning they found an icon of St George painted on the panel. So the monastery was dedicated to St George, and called Zographou, 'of the painter'. At the same time, in the monastery of St George at the village of Phanuel, near Lydda, where there was a great cult of the saint, the monks saw that the face of their icon of St George had disappeared. They were told in a vision that the face had been transported to Athos. So they left Phanuel, journeyed from Palestine, and at last arrived at the monastery of Zographou, where they found the face of their own icon. In token of this they settled at Zographou, thus escaping the troubles in Palestine and the ravages of the mad Caliph Hakim who, in about the year 1000, utterly destroyed the church of the Holy Sepulchre at Jerusalem.

Icons, too, have been known to save their monasteries from attack. In the pavement of the main church in the monastery of Iveron there is set, exactly beneath the centre of the dome, a circular slab of porphyry, surrounded by a

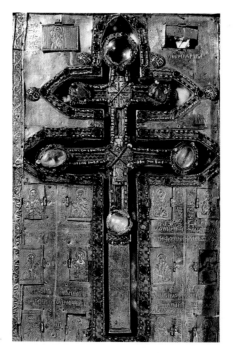

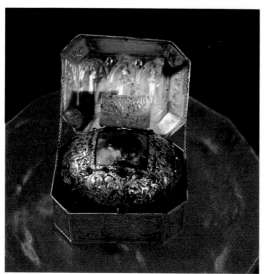

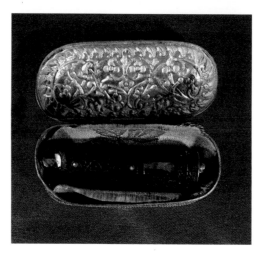

brass rim, on which is the inscription: 'I have set firm her columns, and for all ages she shall not be shaken. George the Monk, Iberian and Founder.' George was the eleventh-century abbot who built the church, but the inscription is taken to commemorate another event, a raid by 'Persian' ships. One day fifteen ships appeared off the coast at Iveron. The monks shut themselves in the tower, taking with them their treasures and also the icon of the Virgin of the Gate. The raiders landed and sacked the monastery. To complete their destruction, they took cables from their ships and bound them round the four central columns of the church. Standing outside the church, they pulled at the cables, hoping to tear up the columns and to bring down the dome of the church. But all their efforts were in vain. Then, at the prayers of the monks to their icon, a storm arose and all the ships were wrecked except that of the Emir. He saw the marvel, repented and made such retribution to the monastery that the monks were able to build the walls high enough to prevent any further disaster of that kind.

Other objects of veneration of which each monastery is the repository are relics of holy men and women – skull, limb, bone or any article intimately related to them. Relics, indeed, are held to be imbued with a spiritual power greater even than that of icons. They are charged with the sanctifying grace of the Spirit that has deified every particle of the being to whom they belong. They witness, in a metaphysical sense, to the incorporation of the Spirit, the spiritualization of the body. In other words, they participate in that mimetic re-enactment of the union of the divine and the human, the Spirit and the flesh, of which the paradigm is the Incarnation – a re-enactment that is the *agon* (trial and test) of the saint and the condition of his or her sanctity. Thus, they belong to a transfigured reality and, like the icon, can help to initiate those who move towards them into a similar state. Their veneration signifies a recognition and acceptance of their transfiguring power.

Closed in cases which are often studded with precious stones – diamonds, pearls, emeralds, huge rubies – these relics are usually kept in the church, particularly in the sanctuary. The monasteries possess large collections connected with some of the greatest figures of the Christian tradition: the skull of St Basil the Great, the left hand of St Chrysostom, the left hand of Mary Magdalen, the Girdle of the Virgin and many others. Some, no doubt, are no more than pious attributions; others exude a sweet odour. Like certain icons, some have a legend attached to them. The Girdle of the Virgin is one of these. Made of camel's hair, it is now at Vatopedi, divided into three parts to guard against possible loss. According to tradition, Mary herself gave the girdle to the Apostle Thomas at her death. In the fourteenth century it was given by the Serbian Lazar I to the monastery. Sometimes it is sent out on miracle-working errands. In 1872 it was transported, at the bequest of the sultan, to Constantinople to stop an epidemic of cholera. Twelve years later it was sent by special ship to the island of Chios to cleanse the orange and lemon trees, the main crop of the island, from a disease which had attacked them.

94–97 Holy relics of the True Cross and saints, set in precious mounts.

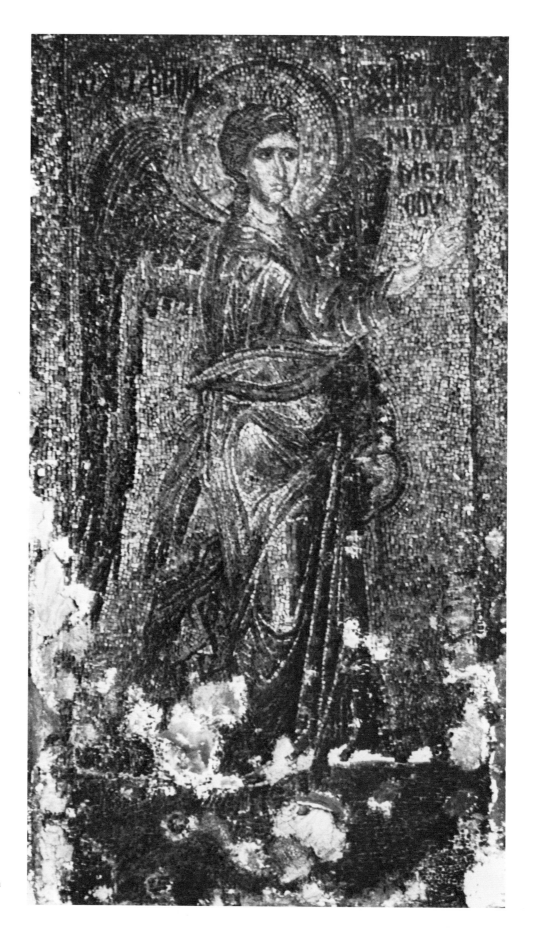

98, 99 The Annunciation. Byzantine gold
mosaic work, from two pillars in the monastery
of Vatopedi. Late Comnenian period, thirteenth
century.

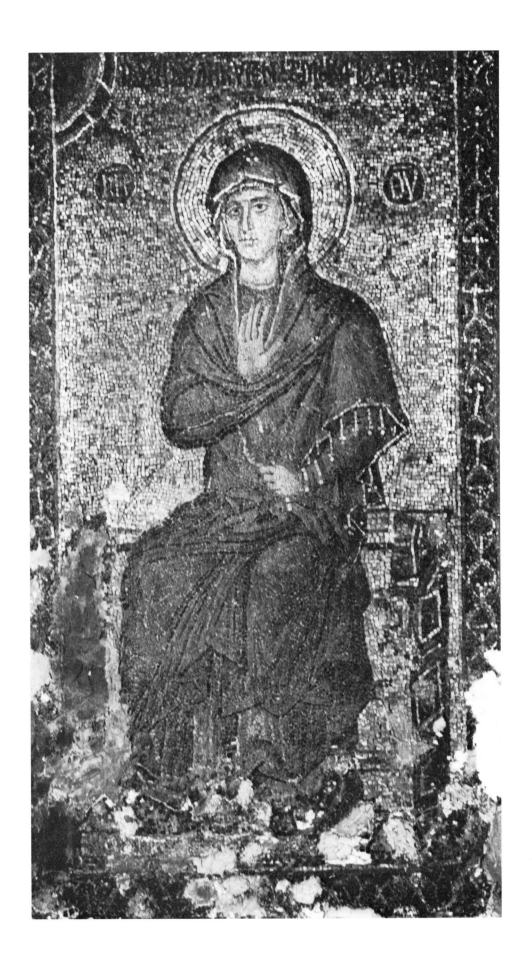

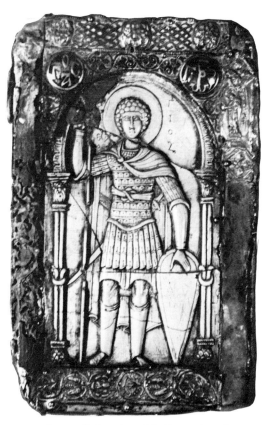

100 Ivory relief carving of St George in a silver
surround. Comnenian period, twelfth/thirteenth
century.

101, 102 Silver gilt reliquary of St Demetrios, one side showing the saint on the ramparts at Thessaloniki.
Probably tenth century.

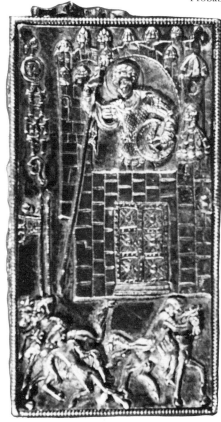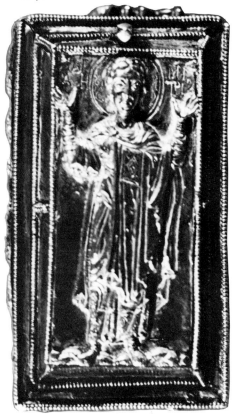

Perhaps, however, no relics are worshipped more and kept in more splendid cases than the fragments of the Holy Cross possessed by the Athonite monasteries, the largest holders of such fragments. The Empress Helena found the cross in 326, and the Church celebrates its feast on 14 September. Some three centuries after its finding, the Persians captured Jerusalem, and carried off this most holy relic. Thirteen years later, however, Emperor Heraclius recovered it after the defeat of the Persian armies. It was then decided to divide the Cross into nineteen parts, as a safeguard against its further total loss. These were distributed among the great centres of Christendom: Constantinople, Cyprus, Antioch, Crete, Edessa, Jerusalem, Georgia, Alexandria, Ascalon and Damascus. With the assaults of Arab, Crusader and Turk on the Byzantine empire and the final fall of Constantinople, much of the cross was again lost. Many fragments, however, found their way to Athos, where, beautifully encased, they now lie. One such fragment, some seven inches long, is at the Great Lavra, presented to that monastery by Emperor Nikephoros Phokas. Its case is of silver gilt, opening on top with folded doors like a triptych. These doors are set with huge *cabochon* jewels – diamonds, emeralds and rubies, as well as pearls – which alternate with medallions of saints in enamel. There are twelve rows consisting of eight of each; and the two largest pearls measure over an inch and a half across. With the exception of the loot taken from Constantinople during the Fourth Crusade and now in the treasury of St Mark's at Venice, such objects – and there are several on Athos – are unknown further west.

Such treasures lie in other monasteries too. In the monastery of St Paul are the twelve triangular cases ornamented with hexagonal stars that contain the gifts of the Magi, the gold, frankincense and myrrh, presented by the Sultana Maria to the monastery. Iveron possesses parts of Christ's mantle and of the sponge and reed used by the soldiers at the Crucifixion. Hilandari has a part of the crown of thorns, and parts of the reed and shroud of Christ, and Philotheou has one of the nails of the Cross. St Athanasios' heavy iron cross hangs from a large iron ring at the Lavra. At the Lavra, too, is the famous Bible presented by Nikephoros Phokas. Its silver cover is now, through age, an exquisite pale gold. Its inset stones are diamonds, emeralds, rubies, cornelian, amethyst, garnet, lapis and beryl. At each corner is set a huge crystal beneath which are the sacred monograms of Christ and the Holy Mother. Below the feet of the carved figure of Christ in the centre is a cushion patterned in dark grey on white enamel. At the shoulders of Christ, on either side, are the half-lengths of two saints in brighter enamels. The halo is of two rows of small grey pearls. Each monastery also has its collection of book-covers, along with its reliquaries, its patriarchal crowns, its patens and chalices, and its crosses. And in the rich monastic libraries are many fine illuminated manuscripts of the Gospels or other holy books. These remain. What has been lost or stolen – for Athos has been systematically plundered many times – it is impossible to say.

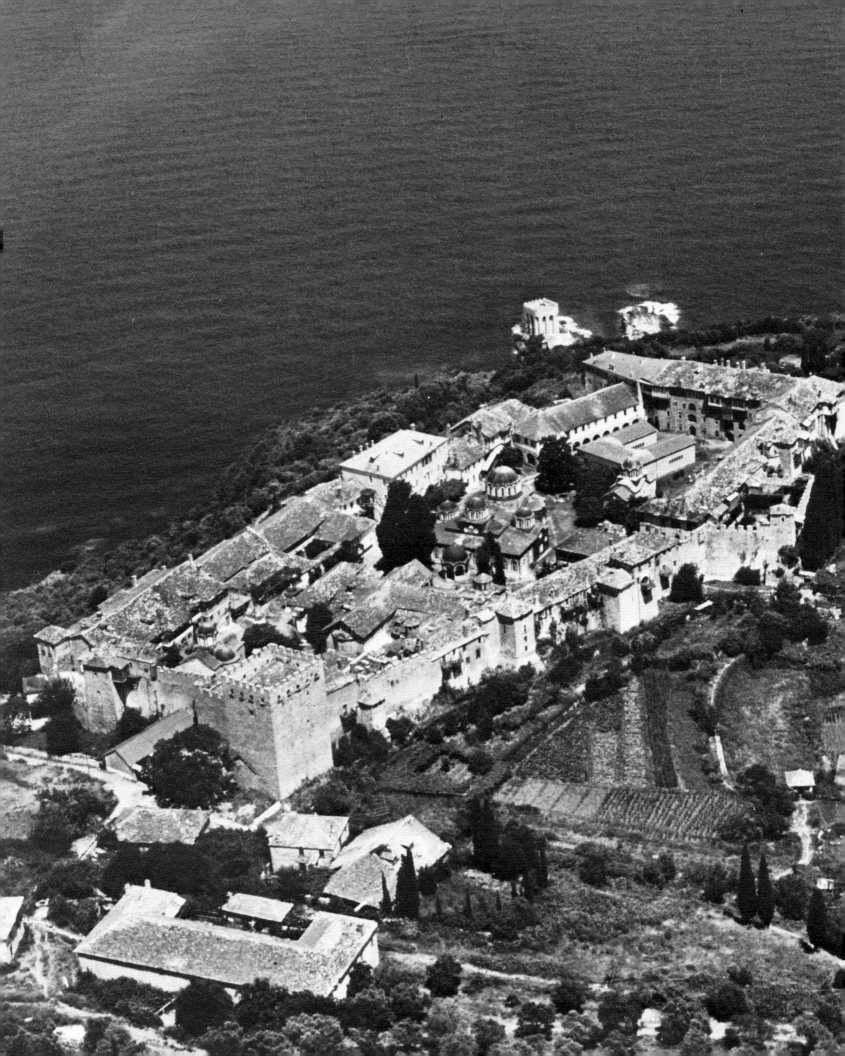

THE MONASTERY

Although some of the ruling houses have been tenanted by monks pursuing an individual and private way of life, they were all founded to meet the demands of the cenobitic life on the Pachomian and Basilian model. This is at once reflected in their architecture. All the monasteries on Athos are built according to a certain basic pattern, modified only to fit an open or a restricted site. Given the demands, the problem for the architect was a relatively simple one, and its solution is a compound of the walled town and the galleried inn. The typical monastery is a four-sided court, more or less rectangular, and generally enclosed completely by ranges of buildings, with the main church, the *katholikon*, in the centre, and with various chapels and other buildings scattered about the court when space allows. Defence against raids from pirates was provided for by making the inside of the court the main façade, avoiding outside windows on the lower floors, and piercing the enceinte with a single strongly defended gate and passage. At some convenient point in the enceinte a tower was built, to serve first as part of the defences and also as a keep. Looked at from the outside, the monastery, its gate closed, seems an impregnable bastion. Massive walls rise from the ground with the first row of small narrow windows usually not less than twenty feet from the base. The windows become larger the higher the building rises, and to the top rows are often attached wooden balconies projecting from the stone structure and supported by wooden buttresses. In many monasteries these balconies are open and three or four rows of them run round the top of the building. The slanting roofs are studded with chimneys, between which may be seen the crosses on the domes of the church inside, or perhaps the waving tip of a cypress tree.

The uniformity of basic architectural pattern does not, however, deprive each monastery of a distinct and strongly individual flavour, for each is adapted to its own natural setting. Simonopetra and Dionysiou are built on huge perpendicular rocks; the first is a towering and soaring mass, looking like its Tibetan counterparts such as the Potala at Lhasa. Pantokratoros and Stavronikita stand at the edges of small rocky promontories like large lighthouses above the sea. Zographou lies hidden in the midst of tall trees growing at the foot of a sloping, thick-wooded hill. St Paul's is tucked in an angle of stupendous cliff, its massive foundations rising to square blocks of

103 The Great Lavra, founded by St Athanasios in the tenth century, became the model for subsequent monasteries on the Holy Mountain. The *katholikon* in the central court dates from 963; the cruciform-shaped refectory this side of it was built in 1512. Behind the monastery are the landing-stage and tower of Tzimisces.

111

cells, backed by a curving, serrated wall which fits to the rock behind. Below runs a river-bed, strewn with huge boulders, dry in summer, but a tearing cascade in winter. Above rears the white peak of Athos, snowy, luminous against the blue, falling in darkening gashed escarpment to the monastery buildings and to the cypresses about it. Hilandari reflects the woods in which it stands; throughout prevails the tint and texture of dead russet leaves. At Vatopedi, too, it is the colour that unifies the buildings, giving a harmony that the diversity of their forms might seem deliberately to flout: the snow-white campanile against the rust-coloured church; the northern range of buildings, light red and grey, the roofs covered with lichen of a daffodil-yellow and sprouting clumps of tall white chimneys against the blue bay below; the high curving rows of cells at the foot of the hills behind, forming a background to the exquisite pink chapel of the Holy Girdle near the gate.

The best overall picture of an Athonite monastery, however, may be gained from a visit to the Great Lavra, prototype of them all. This foundation of St Athanasios stands today, as it has for a thousand years, under the great peak of Athos, on a spur jutting out into the sea and forming a gently sloping platform, planted with gardens. From above, where the vines drop their clusters of grapes against the red earth and where peaches, figs and walnuts flourish by a mountain stream, dammed in a reservoir to work a mill, can be seen – among a sea of olive trees, out of which rise the dark bodies of cypresses – a small embattled town. Flanking the long wall is a four-pillared portico, where crimson oleanders fringe a broad-roofed verandah on which the monks sit at evening. Ahead are the double doors, clamped with plate upon plate of iron. Just inside, the porter has his lodge. Here was a small store where combs, black slippers, bread-moulds chipcarved into the eagles of the church, tins of sardines, sweets, tasselled chaplets and those knotted cords usually of a black wool upon which the monks number their prayers, could be bought. From the lodge, the narrow passage mounts a slight slope, gives a twist, pierces yet another plated door through an inner wall, and issues into the courtyard of the monastery, a narrow rectangle some 400 feet long and 150 feet wide.

At the back of the court, white against the scrub-grown hill behind, the square serrated tower of Emperor John Tzimisces rises from the wall. All round are wooden stairs and balconies which front the long, irregular lines of cells tiled with stone slabs that gleam silver in the sun. In the centre of the court stands the refectory, cruciform in shape, its lichen-covered roofs reaching almost to the ground. Legend has it that on this site once stood an ancient temple to Athene. Inside, the walls are covered with wall-paintings: scenes of the Last Judgment with hell mouthing rivers of flame, of the terrestrial paradise, of the Last Supper serene within the apse, and, upon the opposite end wall of the transept, of the Tree of Jesse and the death of Athanasios; and beneath these a series of terrifying martyrdoms, their colours, dominantly reds and greys upon a indigo background, darkened with centuries of candle-smoke, look down on the long tables made of marble slabs

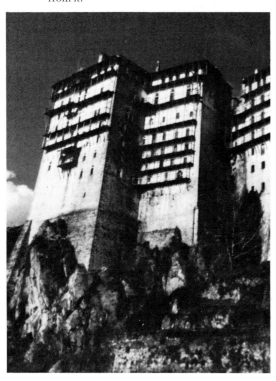

104 Simonopetra from the south. Although the exterior of the monastery dates from the fourteenth century, fires – as with so many monasteries – have ravaged the interior, destroying the library, the treasures and upper buildings. In this view, only the two upper storeys are open to the court behind, the rest being approached by stairways leading down from it.

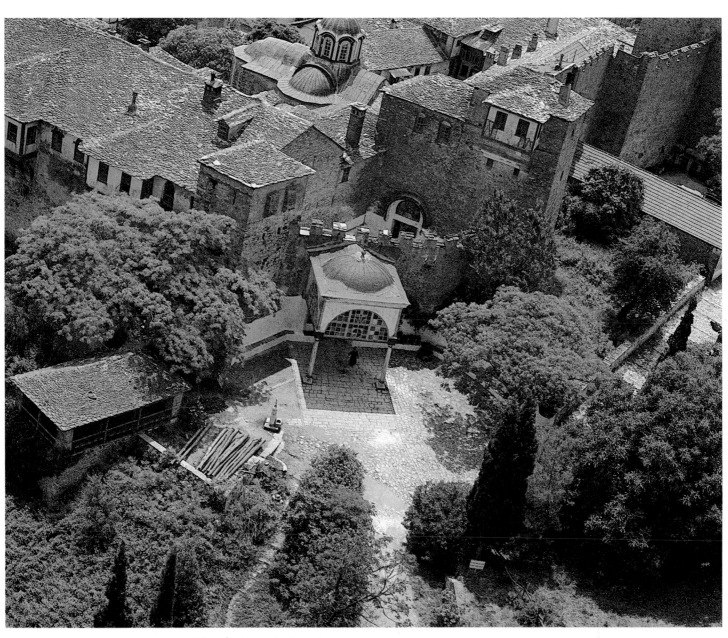

105 The entrance to the Great Lavra monastery. In the angle of the wall stands the
chapel of Panagia Koukouzelissa, named after the singer John Koukouzeles.

which stand in a double row on thick, squat bases surrounded by seats of solid stone topped with wood. The ceiling, of painted planks, is slightly arched, and adorned with coloured baskets of fruit. Over the entrance, in an aura of cubiform grey on a gentian ground, presides Our Lady, protective yet austere.

Opposite the entrance stands the church, built by St Athanasios, and on whose dome the saint was at work when he met his death. But before entering, the visitor must pass between two huge cypress trees – one planted by Athanasios, the other by his coadjutor Euthymios – which rise each from a stone ring, three feet high and one foot thick. Between the two trees is the *phiale*, a deep leaden dome upheld by an open ring of pillars with Turkish capitals and circled at the base with ancient panels of Byzantine relief. With the exception of these panels, the structure, 'the handiwork of Mercury and Atzali', dates from 1635. The paintings within the dome, although probably restored, date from the same period. They are vivid examples of the symbolic anti-naturalism of the monastic artist. The subject is the baptism of Christ. From a circular composition of the company of angels in the centre, golden doors open to emit a tongue of geometric flame, bearing a dove to the head of Christ, immersed in the cleansing Jordan. In the circular frieze that continues round the lower part, formalized vermilion horses prance against mountains alternately of bright orange and deep purple. The whole is made doubly brilliant by the violence of the white highlights. Looked down on and covered by this spectacular dome is the fountain, one of the most remarkable objects on the Mountain. From the centre of an enormous monolith basin, some eight feet in diameter and of extreme antiquity, rises a bronze tube bearing circular tiers of water-spouting beasts, and surmounted by an eagle with outstretched

107 The monolithic *phiale* basin measures eight feet in diameter. Under the dome a painting portrays the baptism of Christ in the Jordan.

115

wings. Beneath the fountain, two ancient marble dogs twist their Oriental faces into a perpetual smile.

Behind the *phiale* and the cypress trees is the church, washed in a dull red colour. From its centre rises a broad, shallow cupola, flanked by two subsidiary cupolas, both coloured white and surmounted by elaborate wire crosses. Today the visitor first enters a coloured-glass conservatory, erected in 1814, and supported on a white marble base. Here formerly stood the narthex containing the cell and library of St Athanasios, demolished to give place to the present poorly painted structure. Magnificent Turkish baroque wooden doors guard the entrance to the church proper; these are deeply undercut to represent the eagles of the church, below which the church that they serve is carved into the likeness of a triple-towered pagoda. The doors are painted gold, brown, mustard, orange and deep blue, with a background of white.

Inside the church, paintings dating from 1535 and very restrained in colour, occupy, as the Rule prescribes, all parts of the walls. To the right and left are two chapels. In one, lying between four pillars of deeply marked pink marble, is the tomb of St Athanasios, covered with a modern silver sheath and hung about with the offerings of pious pilgrims. The chapel opposite is that of

108 The monastery of Stavronikita stands like a fortified chateau on the eastern shore of the peninsula.

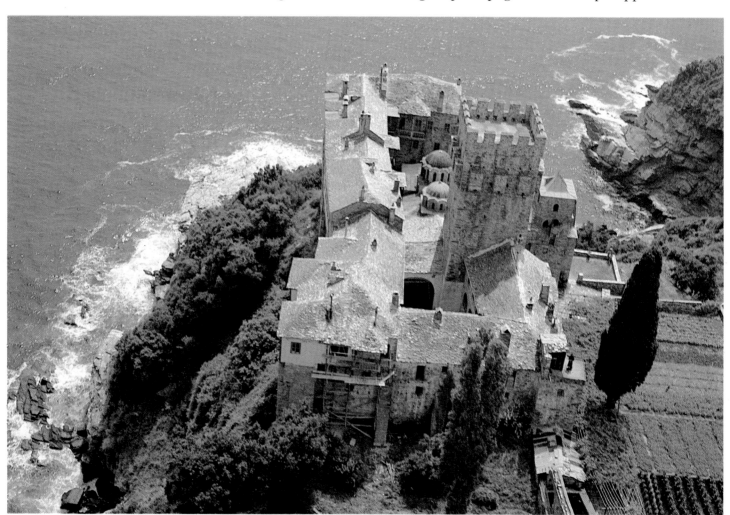

St Nicholas, with a seventeenth-century screen of carved and gilded wood, and its walls painted by the 'hand of the most worthless Frangos Catelanos of Thebes in Boeotia', according to his own testimony signed in 1560. The nave of the church is supported on four pillars, above two of which stand portraits of the two great soldier-emperors of Constantinople, who were the monastery's original benefactors – Nikephoros Phokas and John I Tzimisces – each crowned and invested with the imperial robes: the former with long hair flowing on his shoulders, and the latter bearing in his hands a model of the church, from which may be seen the narthex as it originally looked and the dwelling above of its saintly builder.

Round the court run the ranges of cells hollowing like honeycomb the old wooden-galleried buildings. In one of these buildings, leading off an arcaded verandah on the first floor, are the guest-rooms. It is to them that the visitor to any of the monasteries is first shown, generally by the porter who meets him at the gate. He will be ushered into the main reception room, usually decorated with portraits of heroes of the Greek war of independence or of Russian royalty. There he will wait to be brought the traditional tray of refreshment – liqueur, Turkish delight and black coffee followed by a glass of cool water –

109 The monastery of Dionysiou. This picture clearly shows the arrangement whereby both the defensive and liturgical roles of the building are achieved.

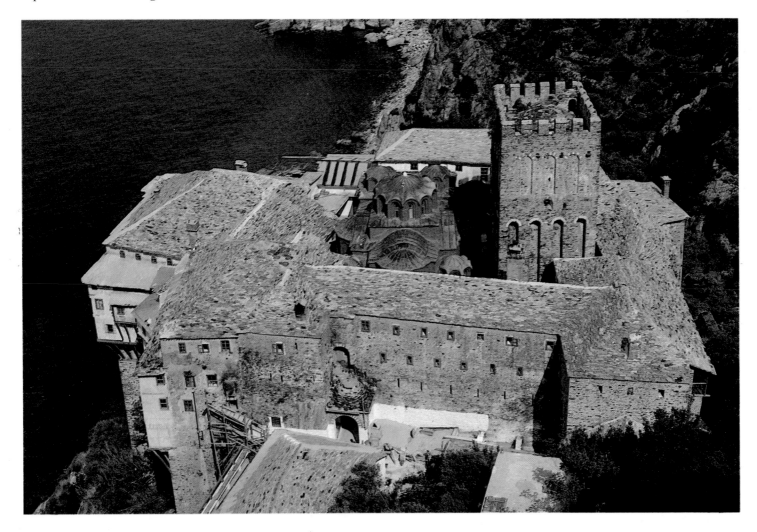

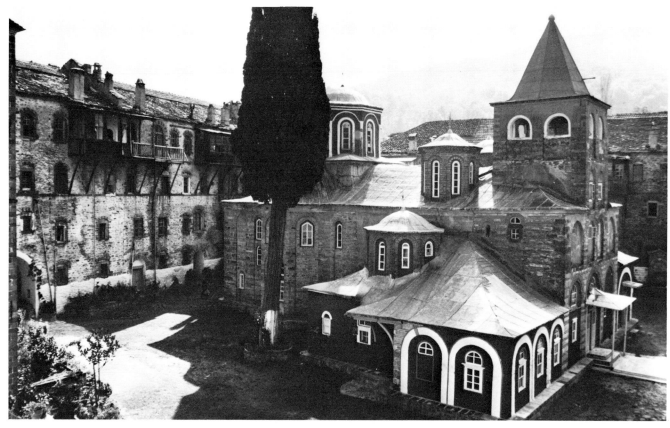

110 The inner court of the monastery of Philotheou, allegedly founded by the tenth-century hermit Philotheos. Only the eighteenth-century church of the Evangelistria and the refectory escaped the fire of 1871.

111 A monk rows timber across a monastery harbour.

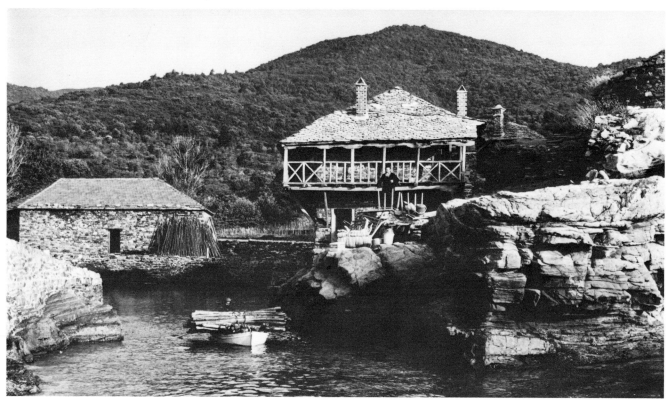

before being taken to his room. The guest-rooms at the Lavra are typical. Round the verandah runs a dado painted to imitate black and pink marble bordered with porphyry. The ceiling is of boards alternately chocolate and dull yellow. The bedrooms are large and low, furnished with broad divans and iron bedsteads, and round the walls hang miscellaneous portraits.

At evening, the usual place for congregating is on one of the balconies. Whether high up on the outside wall of the monastery, strutted out on slender wooden brackets as at Dionysiou or Simonopetra, or, as at Lavra, overlooking the inner court, the balconies are an essential feature of Athonite architecture and monastic life. They are often the most convenient, and sometimes the only means of communication between one quarter of the monastery and another. For the individual monk, especially of the idiorrhythmic monastery, they are his home and empire, filling all functions. Here he grows his pots of basil and his flowers. Here he sits on summer evenings, with only the sea between him and the world he has left. Here he converses with his brothers, discusses the affairs of the monastery, and eats and drinks.

The sun lowers its last segment beneath the horizon and silence falls. So utter is the silence of the monastery after sundown that it is difficult to remember that once the monks lived in continual expectation of attack from pirate or casual marauder. Now civilian police have been stationed on the Mountain, but formerly the monks took their own measures of defence. The arsenal towers at the landing stage of some of the monasteries are protected by ditches and bridges. The towers in the monasteries themselves were places of refuge. Before the Turkish occupation of 1821 the monks possessed cannon mounted at the embrasures of the towers or other strategic spots. Many of the outer gates to the monasteries are iron-plated and, as at Lavra, often give access to a long dark passage which can be barred by two or three further gates. On the iron plates of the outer doors there are often deep dints left by bullets. The cannon have now all disappeared, but in some monasteries can still be seen old maces of iron or of wood, relics of the monastic armoury.

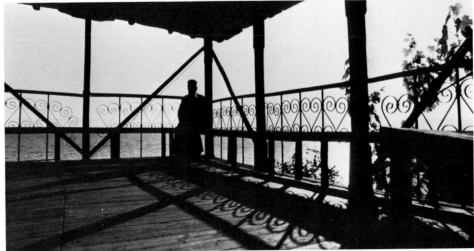

112 On a monastery balcony.

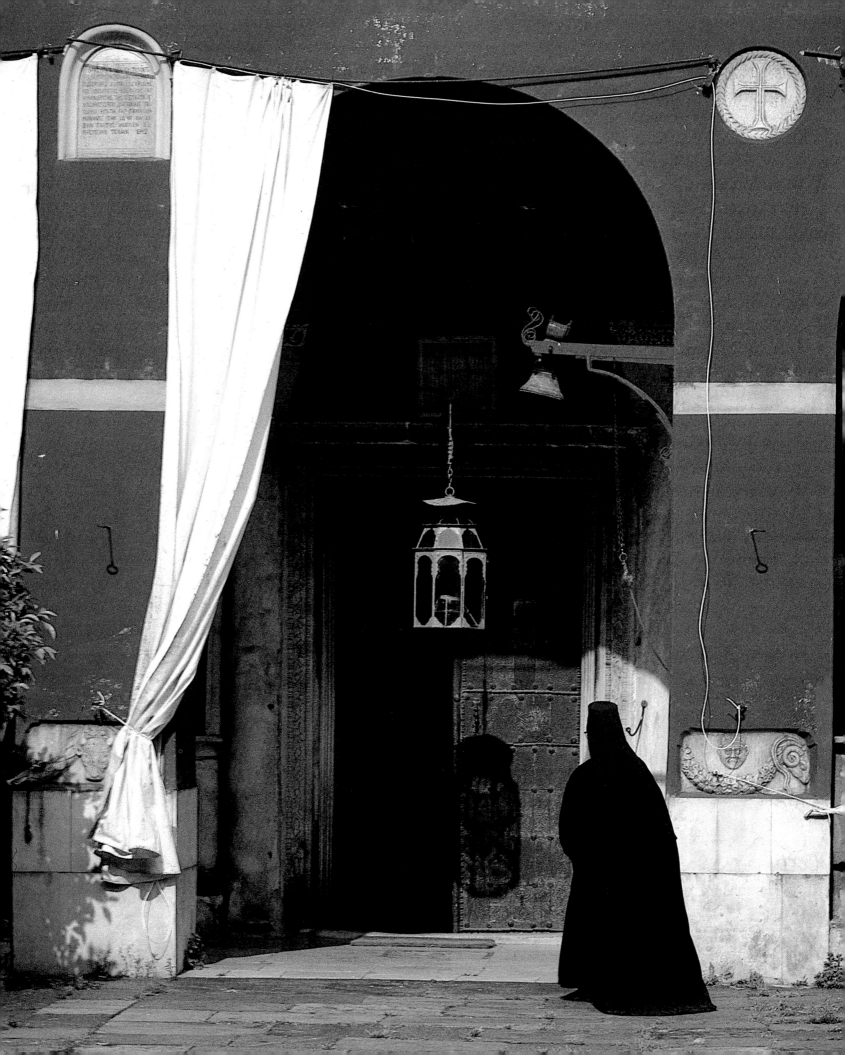

THE LIFE OF THE MONK

Mortal men, let us leave this world of deceit.
Christ calls. Let us go. For life is good
Sailing above the troubled sea of care.
One thought alone employs the solitary man,
How he may reach the port of peace,
May find the final rest from pain.
Delivered of these things, how blessed then is life!
And who is he who truly seeks for gain,
And, leaving all, asks but to bear the Cross?

St Theodore Studite

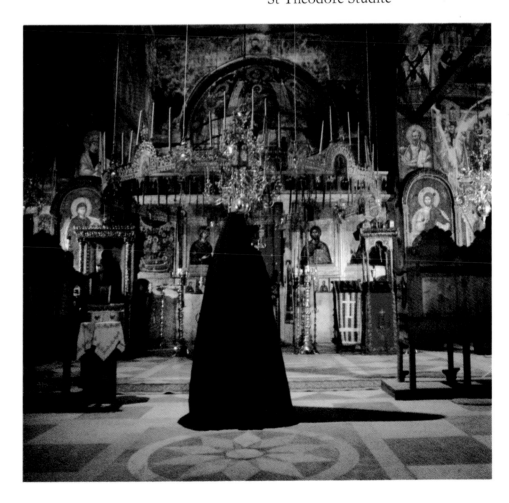

113 *Left* A monk enters the *katholikon* at the
monastery of Vatopedi.

114 In the nave of the Protaton, Karyes.

A vocation for the monastic life may, according to John Cassian, spring from three main sources: directly from God, by a special inspiration; indirectly from man, through the influence of good advice or good example; or indirectly again from force of outward circumstances, where loss of property or loved ones or a general dissatisfaction with what the world offers results in a settled conviction that the world is a fraud and that its pleasures are contemptible. To these may, no doubt, be added various other motives, such as the desire to escape civil punishment for some offence. As one of the canons of the Sixth Ecumenical Council states: 'Any Christian man is permitted to make choice of the monastic life and to wear the *schema* [habit] of monks, even though he may have committed any sin whatsoever when he was living in the world: and no one may prevent his doing so.'

In the early days of monasticism there was only one grade of monks, one tonsure and one habit. Codifying the existing custom in 535, Justinian directed that the term of probation for a monk should extend over three years, during which time the probationer should continue to wear layman's dress. After that period, if he were accepted by the abbot, he should receive the tonsure and habit. But the custom of wearing lay dress did not last long, and the aspirant, after a short postulancy, soon began to wear a portion of the habit proper to the professed monks. This new custom introduced, in effect, a lower grade into the brotherhood of monks; for the wearing of a portion of the habit was regarded as a tacit expression of the aspirant's determination to remain in the monastic life, subject to the approval of the abbot. Towards the end of the eighth century, a third grade seems to have been introduced, for St Theodore Studite refers to the granting of a 'Little Habit' to a grade of monks intermediate between the probationer and the full monk. Theodore disapproved of the custom, which he speaks of as of recent origin, but it has nevertheless persisted to the present day.

The monk of the lowest grade is called a Rasophore, after the *rason* or tunic which he wears as part of his habit. Although he is regarded as a beginner in asceticism until he has completed three years, and as such is an imperfect monk, he is yet more than a novice in the Western sense. Like the monks of a higher grade, he is bound to keep the rules of the monastery, and also, since he has received the tonsure and a portion of the habit, he is under a moral obligation to continue the monastic life. He is, however, under no obligation to continue beyond this grade.

The monk of the intermediate grade is known as Stavrophore, because he wears a wooden cross (*stavros*) or crucifix. He is also referred to as Microschemos, the wearer of the Little Habit. He is sometimes considered as a perfect, or complete, monk, since he has passed the canonical term of probation and has publicly taken life vows before receiving the tonsure and the Little Habit; but his proper designation is a 'proficient monk'. Entrance into this intermediate grade is, in theory, only a stage in the monk's career, the true goal being the strict asceticism of the anchorite; but in practice the life of

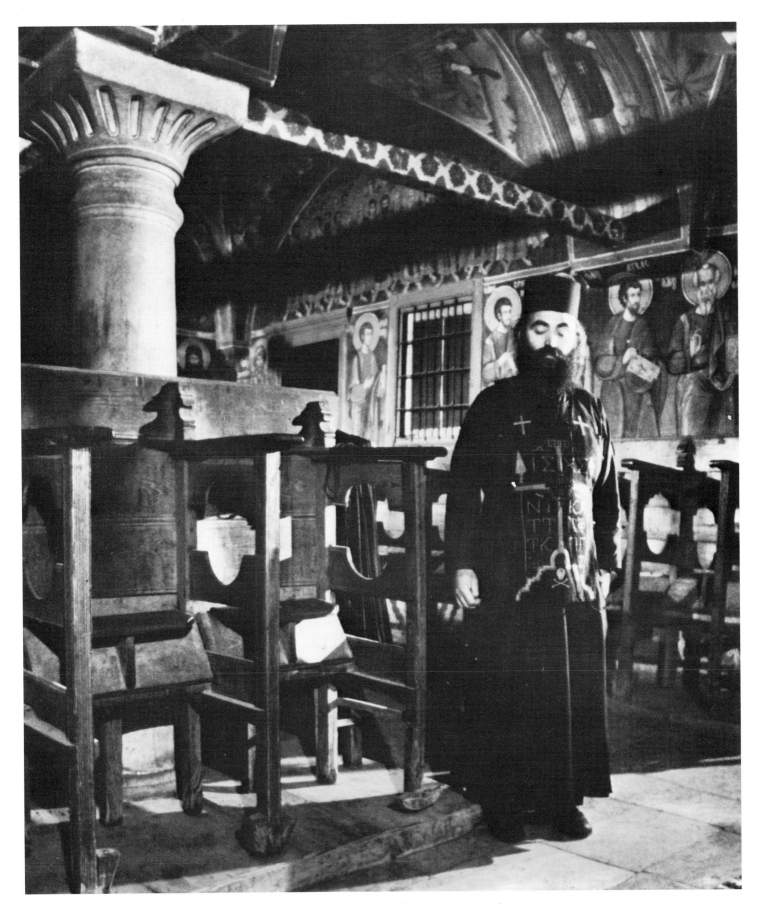

115 A Megaloschemos monk wearing the Great Habit, indicative of the third and highest monastic grade.

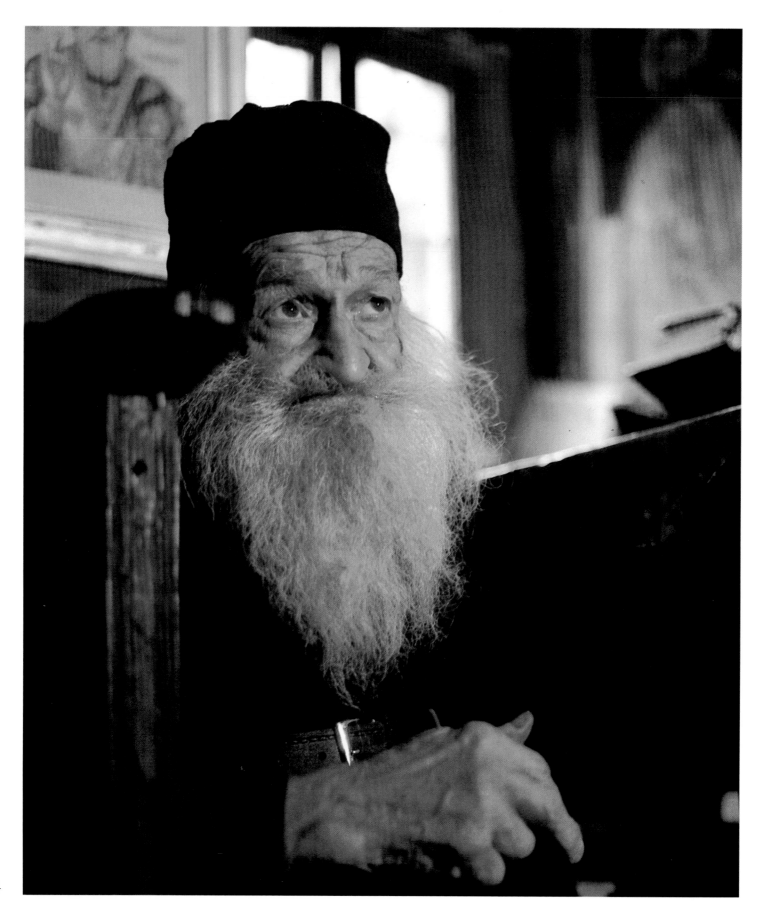

116, 117 Continuity on Athos.

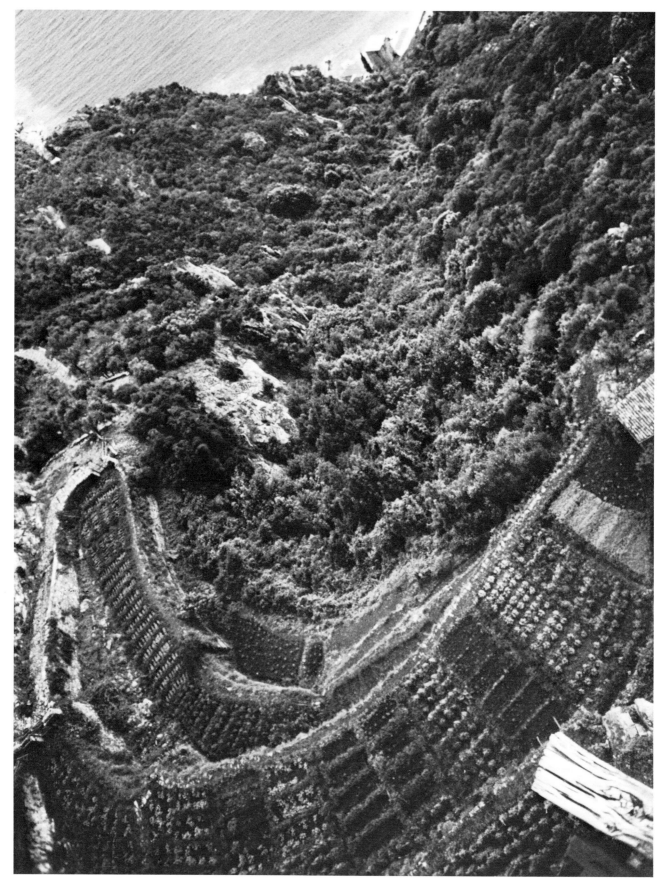

118 The gardens below the monastery of Simonopetra wind hundreds of feet down the slope towards the sea.

the cenobitic monk of this grade is the modern presentation of the cenobitic ideals of St Pachomios, St Basil and St Theodore Studite, as opposed to those of the Antonian type of life, to which the highest grade of monk is pledged.

The monk of the highest grade, who alone may wear the full habit, called the Great and Angelical Habit, is known as Megaloschemos. He is pledged to strict fasts, to spending much time in prayer and to greater silence than other monks. He is forbidden to eat meat, and can drink only a limited quantity of wine. Sometimes he will abstain also from fish, and restrict himself to a vegetable diet. It is not usual to admit a monk to this grade of strictest asceticism until he has lived for some years in strict observance of the asceticism of the cenobitic life as a Stavrophore. Sometimes, however, on approval of the abbot or of the spiritual father, a Rasophore may become a Megaloschemos without first being a Stavrophore.

The monastic vows themselves are not essential to monasticism. The early monk was one who had turned his back on the world, and had entered the narrow way, but he was without either formal vows or the tonsure or a habit. His profession was merely the tacit one of an intention to lead an ascetic life. And for centuries after the institution of monasticism, formal vows were unknown. Pachomian monks did not take formal vows, nor did Basilian monks, although they were to regard themselves as under strict moral obligation to persevere in the monastic life. In the prologue to the Lausiac History (*c.* AD 420), Palladius deprecates vows as subjecting the free will to the binding obligation of an oath. The simple adoption of a coarse dress and the entering into the wilderness, or the taking of a habit with the permission of the abbot of a *cenobium*, constituted the profession of the monastic life, which only became formalized with St Benedict. In his Rule Benedict not only enjoined upon monks the vow of stability, the conversion of morals and of obedience, but also required them to sign a written formula of profession.

The vows of modern Orthodox monks are taken formally by the Stavrophore and the Megaloschemos alike, but merely by the answering of formal questions. There are four questions, and they concern stability, obedience, poverty and chastity. The distinction between simple and solemn vows has never been known in Orthodox monasticism: the vows of the Stavrophore are as little subject to dispensation as the vows of the Megaloschemos, though the ritual in which the latter are taken is longer and more solemn. The difference between the two grades lies in the degree of asceticism proper to each. By traditional custom, no dispensation from monastic vows is given – though there have been exceptions to this. Even expulsion from a monastery for immorality, the shaving off of the beard and the deprivation of the habit, do not constitute a dispensation. A monk remains always a monk.

To join one of the monasteries on Athos, a person must have certain qualifications. He must in the first place be a member of the Orthodox Church: no one belonging to any other denomination is allowed to stay on the

119 The *megalon schema* or Great Habit, depicting the Holy Cross on Golgotha, the instruments of Christ's passion and symbolic Christian monograms.

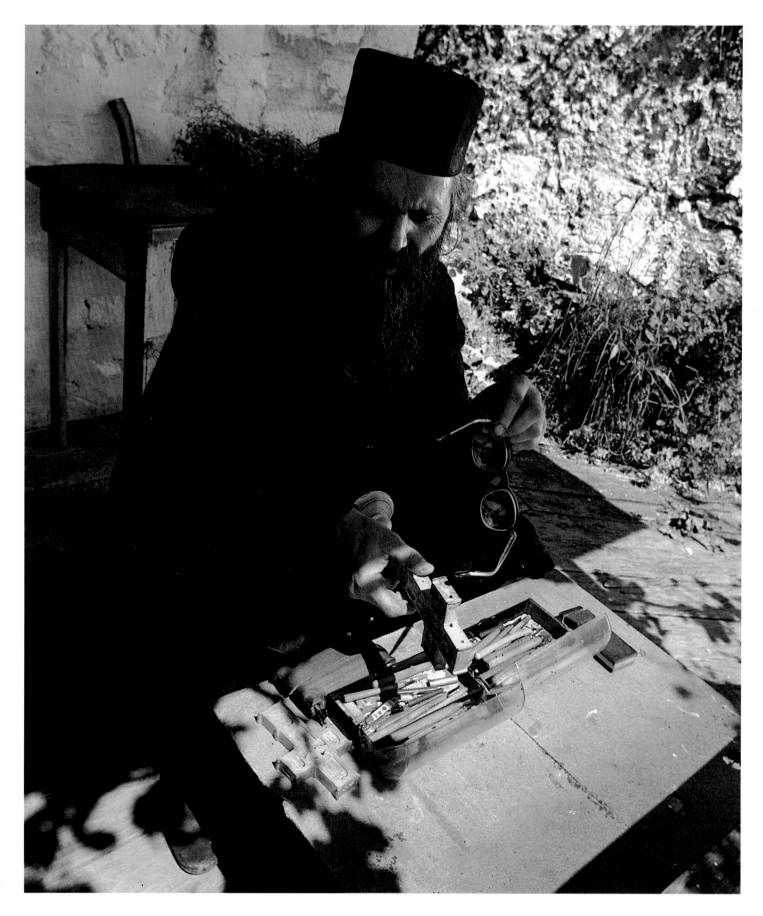

Mountain permanently. He must not be less than eighteen years old, must have come to the monastery of his own free will and, if he has been married, he must first secure a divorce. If he is leaving children behind him, he must settle all questions of inheritance before he becomes a monk, as the monasteries inherit a monk's property at death, and therefore wish to avoid complications. When he is admitted to the monastery, he has first to serve a probationary period of from one to three years, during which time he is attached to one of the monks for instruction and guidance. After a simple ceremony, he is then admitted into the lowest grade of monastic life, that of the Rasophore.

The ritual and ceremony for admittance to the second grade, that of Stavrophore, is far more elaborate, and centres round three main ideas. The first is that the end in view in the act of profession is the marriage of the soul with the Divine Bridegroom. From this point of view, the office of the Little Habit is the betrothal of the soul with Christ, the pledge of the marriage rite which is to follow at the giving of the Great and Angelical Habit. Second, there is the idea of a second baptism. The monastic profession rite is a second baptism, and the aspirant is referred to in the office as a catechumen. He is unclothed in the narthex of the church, as though he were about to be baptized by immersion in water, and to signify the putting off of the old life. A new name is given, commonly with the same initial letters as the baptismal name, and his head is shorn as at baptism. Third, there is the idea of the return of the prodigal son to the father's house, and it is perhaps this that is most emphasized during the ceremony.

The office for the conferring of the Great Habit is very similar to this. It is slightly longer, the instructions given by the priest to the monk are more solemn in tone, and the habit conferred is the full habit.

This habit, the Great and Angelical Habit, grew up over a period of centuries, its origin being in the dress of the hermit and cenobite of the Antonian and Pachomian monks. Its designation, Angelic, is illustrated in a painting in the refectory at the monastery of Hilandari. An angel, himself wearing the habit, is teaching the Rule to Pachomios, saying: 'In this Habit shall all flesh be saved, Pachomios'. In a similar scene in the small chapel of St George at St Paul's monastery, the angel is saying: 'Such must be the Habit of the monks, Pachomios, like that of the angels'.

The habit itself consists first, of an inner *rason*, the girded *rason*, *imation* or Tunic. This is a garment with narrow sleeves and reaches to the ankles. It corresponds to the Western *vestis talaris*, the tunic, soutane or cassock and, like the cassock, it is an undergarment usually black in colour, though sometimes blue or violet. Second, there is the outer *rason*, the *mandorrason* or *pallium*, an over-garment reaching to the ankles with wide sleeves. It is this outer *rason* that gives the name to the Rasophore monk. Thirdly, there is the *koukoulion*, or cowl, a thimble-shaped cap, commonly lined, to which is fitted a black veil that ends in a point. Fourthly, there is the *analavos*, or *polystavrion*. This, with the *koukoulion*, is the distinguishing mark of the Megaloschemos, the complete

120, 121 The carving of wooden crosses is a traditional craft of Athonite monks. Crosses such as this one are sold to visitors and form a supplementary source of income, particularly for the monks living in the smaller communities outside the main monasteries.

129

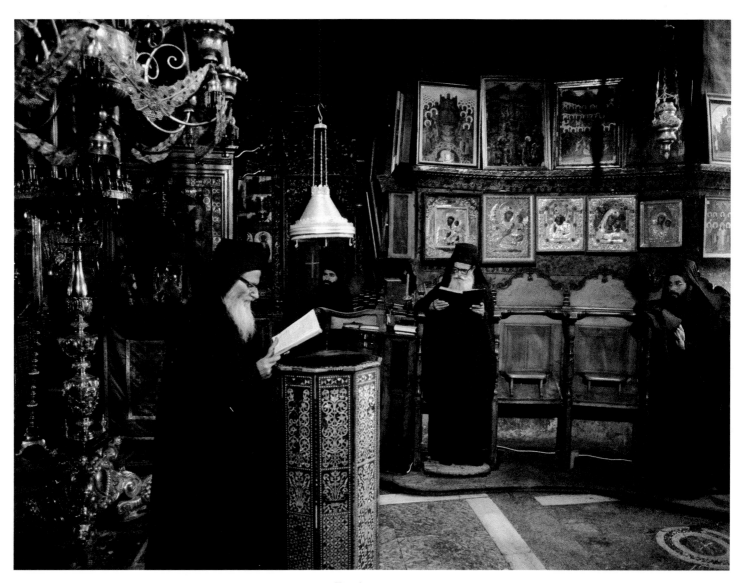

122 Evening vespers.

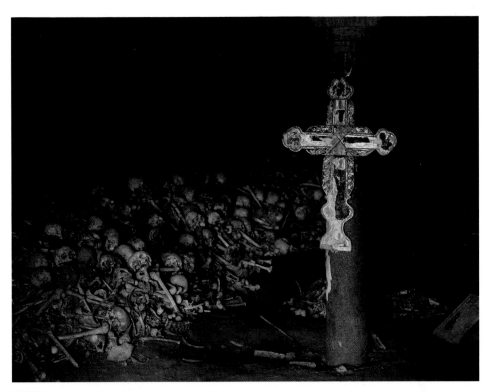

123 After a period of burial, the remains of the deceased monks are disinterred and kept in the monastery's charnel house.

monk. It signifies the cross which the monk must take up daily in following Christ, and it has on it representations of the Cross of Calvary, with the spear, the reed, the sponge and, at the foot of the Cross, the skull and cross-bones of Adam. This part of the habit may well go back to the Antonian hermit. Originally, it was always made of the hide of a dead animal, to remind the monk of the necessity of self-sacrifice and of deadness to the world. Now it is usually made of black cloth or of a soft, dark-brown leather, ornamented with crosses. If it is not made of the skin of an animal, it must be made of the dead product of an animal, of wool or goat's hair, and not of any vegetable material like cotton or hemp. Fifthly, there is the leather girdle, also, and for the same reasons, made of the skin of a dead animal, and with the significance indicated in the words of the priest during the initiation ceremony. Sixthly, there are sandals, or large black slippers. Seventhly, there is the *mandyas*, a large woollen cloak without a hood which reaches almost or quite to the ground, and is something like the Western *cappa nigra* of the canons Regular and the Dominican Friars, though the latter has a capuce or hood. It is worn by the Megaloschemos whenever he goes to church.

The Megaloschemos is also buried in the full monastic habit. The body, clothed in the inner *rason*, the girdle, *koukoulion*, *analavos*, outer *rason* and sandals, is laid upon the outspread *mandyas*, which is then cut into strips. These strips are fastened over the body so as to make three crosses – one over the face, one over the breast and one over the knees. The lower part of the *mandyas* is bound about the feet of the monk. The *koukoulion* is pulled down over the forehead and eyes, and the rest of the face is covered with the veil. It is the final extinction to the world.

Once the ceremony of initiation into the monastic life is over, and the monastic habit is conferred, the new monk begins the task of gradually assimilating to himself the pattern and purpose to which he is dedicated. St Basil has given a portrait of the type of life he must strive to fulfil:

The monk's life must be as follows. First of all, he must possess nothing. Physical solitude must be his lot, propriety of costume, a decorous tone of voice, disciplined conversation. Food and drink must not disturb his mind, and he must eat in quiet. He must be silent in the presence of elders, must listen to men wiser than himself, love his equals, and advise his inferiors in a spirit of love. He must shun evil, carnal and meddlesome men, think much and talk little; he must not be arrogant in speech, nor a chatterer, nor prone to laughter, but must be adorned with shame. He must keep his eyes down, and his soul up, and not gainsay his gainsayers. He must be obedient, must work with his hands, remember always his end, rejoice in hope, be patient in tribulation, pray ceaselessly, in everything give thanks, be humble towards all men, hate arrogance, be sober and keep his heart free from evil things, lay up treasure in heaven by keeping the commandments, and examine himself concerning his daily thoughts and acts. He must not entangle himself in the business affairs and chafferings of this life, or be interested in the life of the slothful, but zealously copy that of the holy fathers. He must rejoice with those who practise virtue successfully and not envy them; suffer with those who suffer and weep with them and grieve for them much and not condemn them.

More vivid and stark is the Portrait of the Monk according to *The Painter's Manual*. This was written on Mount Athos by the monk Dionysios of the monastery of Zographou, and contains directions not only for the preparation of painting materials, but also for the schematic composition of the subjects to be painted. One of these subjects is the monk's life. This is how Dionysios instructs that it should be represented:

Draw a Cross and set on it a monk wearing a monk's robe and cap. His feet are to be nailed to the foot-board of the Cross, his eyes and mouth are to be closed, and upon the tip of the Cross you are to write this: O Lord God, set a guard upon my mouth and a door upon my lips. And in his hands he holds lighted candles; and by the candles is this inscription: So let your light shine before men that they may see your good works and glorify your Father which is in heaven. And on the breast this inscription: Set in me a pure heart, O God, and renew a right spirit within me. And on the belly, this: Let not the glutting of the belly lead thee astray, O Monk. And below the knees, this: Make thy feet ready for the path of the gospel of peace. And beneath the belly, this: Mortify your members which are upon the earth. And above the inscription which is at the head of the monk, this: Let it not be mine to boast but in the cross of my Lord. And on the right arm of the Cross, this: He who endures to the end, the same shall be saved. And on the left arm: He who does not deny himself all, cannot be the disciple of Christ. Under the foot-board, this: Narrow and grievous is the way which leads unto life. Draw also a dark cave on the right side of the Cross, and write above it: Hell which devours all things. And a great dragon coming out of the cave carries in his gaping mouth a naked youth, whose eyes are bound with a kerchief. And the youth carries a

132

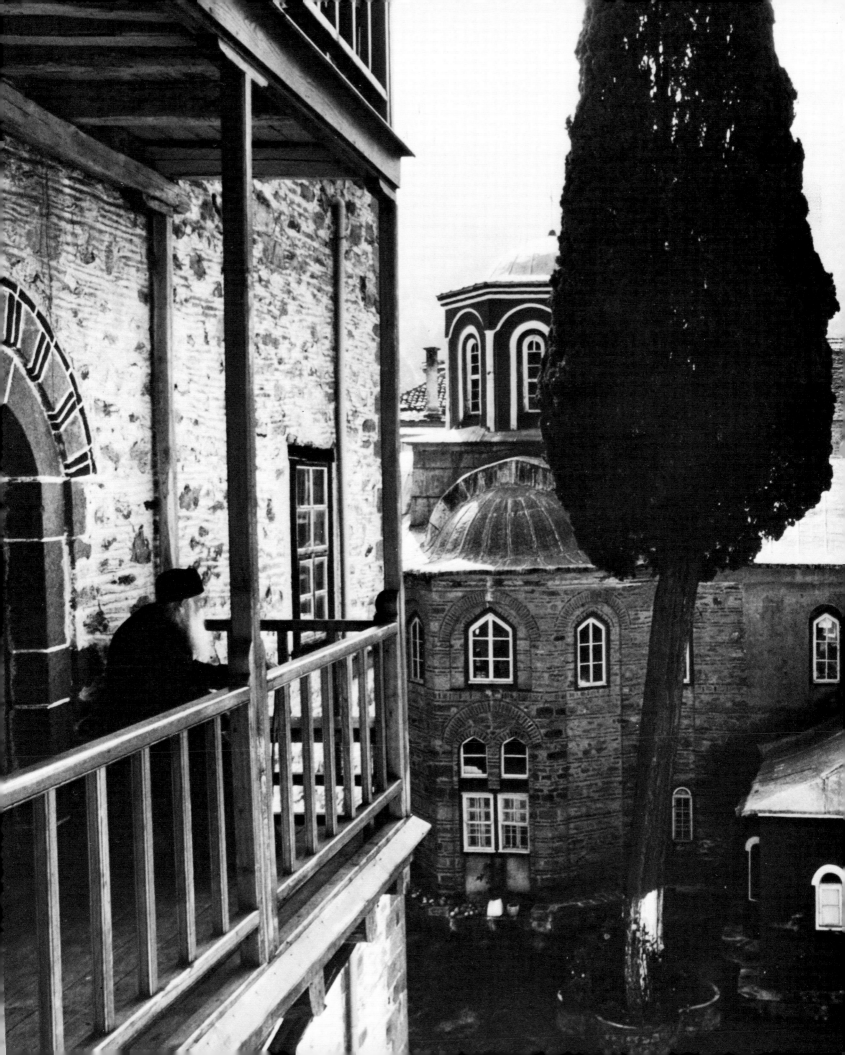

125, 126 Services in the Great Lavra. The officiating monk or *hieromonachos* is in red on the left and white on the right.

bow with which he shoots an arrow at the monk, and his name is The Love of Harlotry. And above the cave draw snakes of various colours and sizes, with the inscription: The Imagination. And by the side of Hell draw a dragon, pulling at the Cross with a rope, and saying: The flesh cannot endure, being weak. And on the right side of the foot-board draw a mast and a flag with a cross on it, and on the flag these words: I endure all things through Christ who makes me strong. And on the left side of the Cross draw a tower and a youth on horseback coming out of the tower; on his head a tiara of gold with side tassels and his dress all of various colours worked with gold. And in his right hand set a flask of wine and in his left a reed with a sponge at the end of it, and hanging from it an inscription: Receive the sweet things of the world. And this he exhibits to the monk on the Cross with the other fair and worldly adornments which he had on his person. And over the head of the youth write: The Vain World. And by the side of the white horse ridden by the youth, draw Death coming out of the sepulchre, carrying a great sickle and above his head an hourglass; he is gazing at the monk, and this is his inscription: Death and the Grave. On either side of the Cross set an angel with inscriptions; the one on the right saying: The Lord has sent me forth to help you; and the one on the left: Do that which is good, and fear not. And also draw Jesus in the midst of clouds at the head of the Cross, and on his breast an open Gospel with the words: He who wishes to come after me, let him take up his cross and follow me. And the Lord is carrying in his right hand a royal crown and in his left a garland of flowers. And by the Cross there are angels, on this side and on that of the Lord, gazing upon the monk and saying by the inscriptions which they carry: Strive that you may win the crown of righteousness, and the Lord will set upon you a crown of precious stones. And now I have written out the Life of the true Monk.[12]

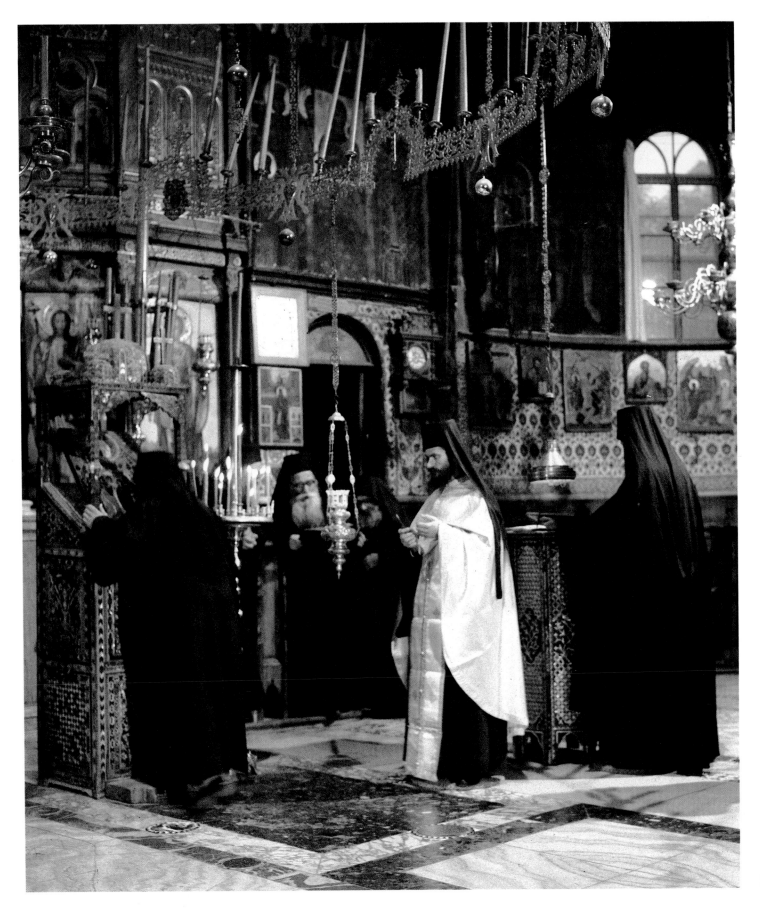

It is the great advantage of the monastic organization that this 'life of the true monk' may be practised systematically. In time, by following the monastic training, the monk should be purged of worldly attachments, able to penetrate into the depths of God's world, and devote himself to divine contemplations. This theory of the monastic life leads directly to the hermitage for, once the process of purification is complete, the monk has little further need for cenobitical exercises and may consider himself impeded by the society of his brethren. But at the same time, purification may last a lifetime, and we have seen how for its accomplishment St Basil regarded communal life in the monastery as virtually indispensable. For this purification is a heroic task. It requires the monk to lead as far as possible a life of continual self-denial, of self-annihilation. It involves a continual struggle against the forces of attachment and individual gratification and, to counteract these forces, the cultivation of the virtues. In return, the monastery provides the monk with protection and subsistence. Outside interference is reduced in this way to a minimum and, his subsistence assured, the monk is able to pursue the monastic life with the least possible distraction.

127 Signalling the monks to prayer, this monk is walking between the walls of the monastery and the *katholikon* sounding a wooden beam or *semandron* with a wooden mallet.

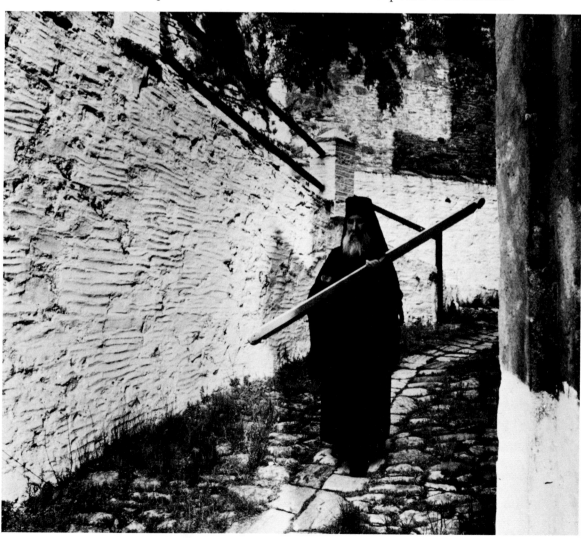

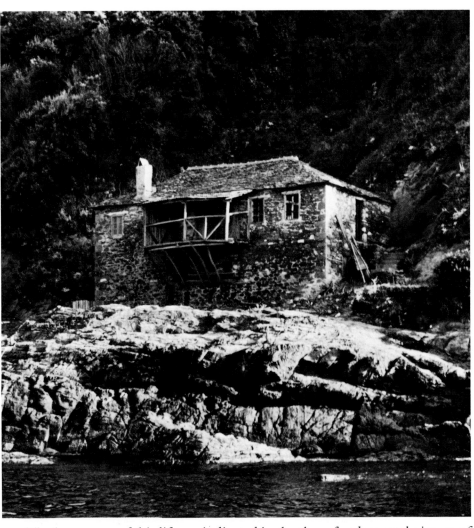

128 A fisherman's hermitage on the shore of the Holy Mountain.

The keystones of this life are indicated in the three fundamental virtues of poverty, chastity and obedience, which the monk contracts to practise. Individual monks should possess no property, though we have seen that idiorrhythmic monks on Athos have subverted this condition. As to whether it is lawful to have private property in the community, St Basil says that 'this is contrary to the testimony of the Acts concerning them that believed. So he that says anything is his private property has made himself an alien to the Church of God and to the love of the Lord who taught us both by word and deed to lay down our life for our friends, to say nothing of external possessions.' The monk is the soldier of Christ, and 'no soldier builds a house, or burdens himself with the acquisition of lands, or mixes himself up with the various money-making activities of commerce'. It is the same with the virtue of chastity: the monk must 'seek not to leave children on earth, but to lead them up to heaven; not to be joined in bodily wedlock, but to desire spiritual marriage, to rule over souls and beget spiritual children'. The Athonite community has come to the assistance of the monk in this matter by forbidding women altogether from even visiting the promontory, and by excluding, as far as it can, females of all species of the animal kingdom.

137

138

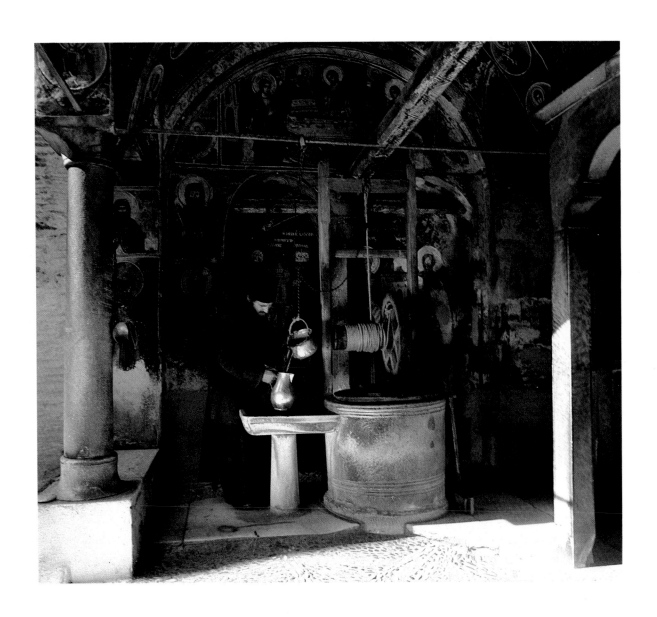

129 *Left* A scene from the Apocalypse series of wall-paintings in the monastery of Dionysiou.

130 Drawing water from the monastery well.

Where obedience is concerned, St Basil lays it down that the sphere of obedience is limited by the Divine Law. If he who commands shows disregard for this, the disciple is bound to disobey:

There is no small difference in the orders given, for some are contrary to the command-ments of the Lord, or perhaps destroy and corrupt it by an admixture of what is forbidden; others help the commandment of the Lord; others again, if not obviously fulfilling it, yet contribute towards this end. . . . So that if we are given an order which fulfils the commandment of the Lord, or contributes to its fulfilment, we must receive it eagerly and carefully as the will of God. But when we receive an order from anyone that is contrary to the commandment of the Lord, or destroys or corrupts it, then it is time to say, 'We must obey God rather than men'. He who hinders the doing of the Lord's command or persuades us to do what is forbidden by him, be he ever so close a relation, or exceedingly illustrious, ought to be shunned and abominated by everyone who loves the Lord. If commands are legitimate, monks must obey one another as servants obey their masters, never seeking to select for themselves what they shall do, and never contradicting, for there are no limits to obedience except death.

To assist the monk in the cultivation of the virtues and in the struggle to control the passions which act against them, the physical conditions of life in the monastery are reduced to the bare necessities. The food is extremely simple. The chief diet is one of dried vegetables – lentils, beans, and so on; dried codfish, and octopus, and canned fish like sardines; eggs, fresh vegetables and salads of tomato, lettuce, onion, olives and herbs, with olive oil and cheese, though in winter such salads are rare. Wine is drunk in small quantities, and also coffee. Moreover, during the long and short periods of fasting the monk is forbidden to eat such foods as eggs, butter, cheese, and even olive oil. The fasts are frequent. In cenobitic monasteries, on Mondays, Wednesdays and Fridays only one meal is given to the monk, and this without those foods mentioned above. In idiorrhythmic monasteries, Monday is no longer counted as a fast-day. But both types of monastic life observe the special fasting periods linked with particular feast-days. The Great Fast begins seven weeks before Easter, and ends on Easter Sunday. The Lent of St Peter and St Paul lasts from the first Sunday after Pentecost till the end of June. In August, there is a fast of two weeks before the Feast of Our Lady on 15 August, and a little more than two months later, on 15 November, the Great Fast of Christmas begins, ending on Christmas Eve. Besides these major fast periods and the weekly fasts, there are a series of minor fasts before certain feast-days; fasting for three days before communion; penitential fasts imposed as a disciplinary measure; and perhaps one or two others. Opportunities for over-indulgence in food on Athos are rare.

Such 'over-indulgence' as there is occurs only on the feast-days at the end of a major fast, and on certain other feast-days, particularly on that of the patron saint of the monastery concerned. This feast-day provides the great social occasion of the year for the monastery. Days before the feast, the monks

131 The best wood-carvers may spend years perfecting a carving of a sacred subject.

begin the preparations. The church and some of the main buildings are repainted. The stores of the monastery are filled with the necessary food. Individual monks clean and decorate their cells. Dishes and vessels, chandeliers and silverware, are polished. Chanters practise their parts. A day or two before the celebration, guests begin to arrive – monks from other monasteries, laymen from the mainland and the surrounding islands – coming in boats to the landing stage of the monastery.

The all-night service on the eve of the saint's day begins in a dark magnificence of colour, tone and fragrance, over which the countless golden points of the candles cast shadows but little light. Slowly the dawn encroaches, fingering through the windows, bringing shape to the pillars, shape to the worshippers propped up in their stalls. While the liturgy is in progress a row of benches is set up outside the church and covered with richly embroidered purple and golden cloth; on the benches are laid the monastery's most treasured possessions – miraculous icons, the skull and bones of saint and martyr. The service over, pilgrims crowd round to worship them with kisses and prostrations to the ground, offering them also their humble gifts. Then the treasures are carried round the court of the monastery, while barefoot workmen, black-clad monks and surpliced priests chant the last hymns of the long office. And so the feast begins. Refectory, private cells and cellars are thrown open. Food and wine are given freely to all. The talk flows. The sun burns. The monastery and its guests rejoice all day long in the saint's honour.

The feast over, life in the monastery resumes its normal course. For the majority of the monks the day is divided up between manual work, sleep and prayer. The theoretical obligation to work, laid down by St Basil and other early fathers, has long been realized by the monks of Athos in practice. The monasteries are not excuses for idleness, but living social organisms to which each monk contributes his share, having a vital function in relation to the whole. 'Here', writes Christoforo Buondelmonte who visited Mount Athos in 1420, 'in lush valleys, teem bees, figs, and olives. The inmates of the monasteries weave cloth, stitch shoes, and make nets. One turns the spindle of a hand-loom through the wool; another twists a basket of twigs. From time to time, at stated hours, all essay to praise God. And peace reigns among them, always and for ever.'[13]

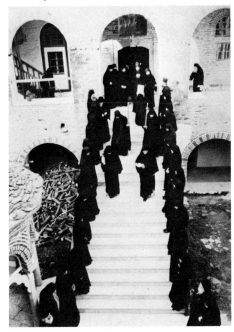

132 A procession in the monastery of Philotheou for the celebration of the finding of the Holy Cross.

Round the main building of the monastery lie cultivated terraced lands planted with vegetables and the vine. Here too are the stables, the blacksmith, the olive press and the flour mill. Immediately beneath, or not far distant, is the port of the monastery with its tall port tower, once a defence against pirates, now a store-house. Within the monastery the care of the church, the refectory, the storerooms, the guest-rooms, the library, demands the monk's attention. For carpentry and masonry it is usual now to hire lay labourers. Lay labourers also assist the monks to fell trees, and to carry the sawn timber to the port's tower; to gather olives, walnuts and other fruit; to gather the grapes,

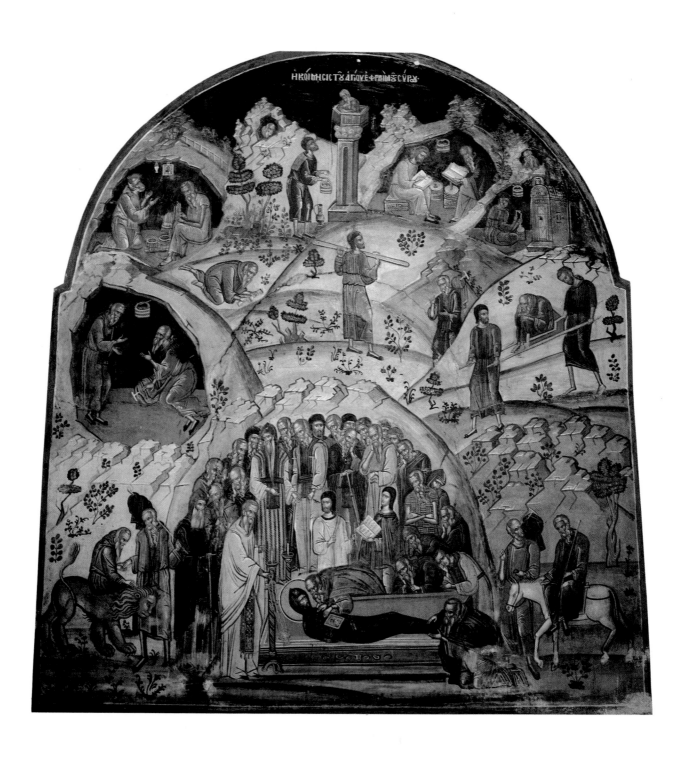

133 The Dormition of St Ephraim the Syrian with scenes from his life. Wall-painting from the monastery of Dokheiariou.

134 *Right* Gardening is a vital part of the monks' life, as monasteries often depend on their own vegetables, olives and fruit.

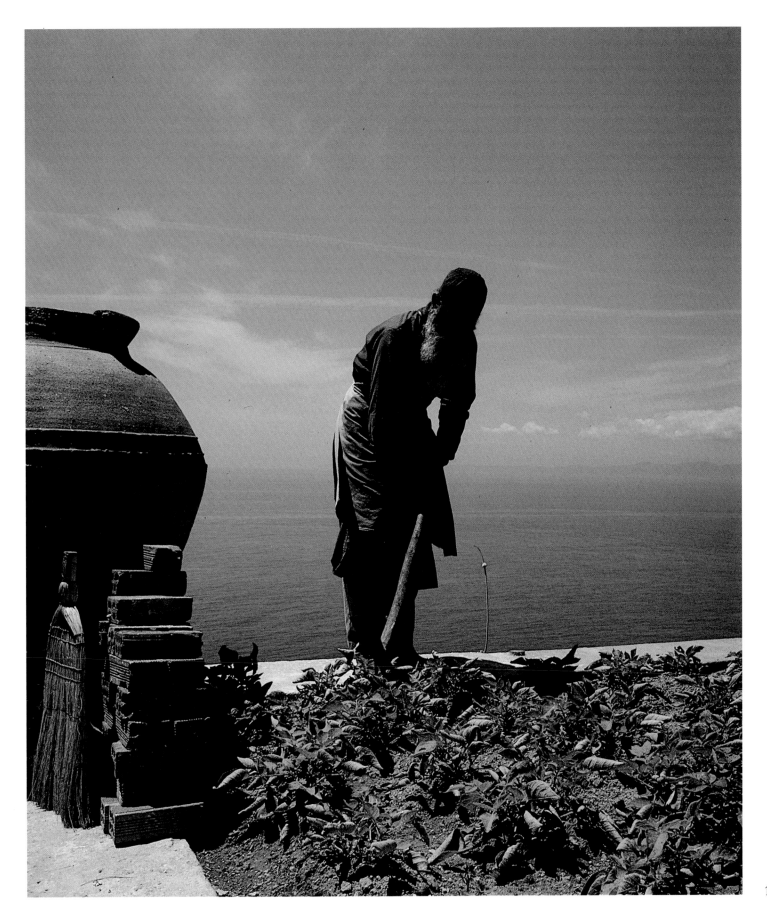

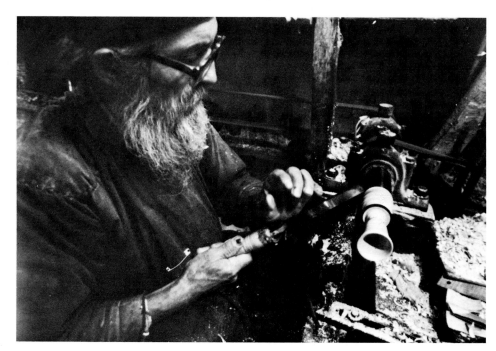

135 A wood-worker in the *skete* of St Anne carefully chisels his wood on a lathe powered by water.

press the grapes into wine, the olives into oil. Indeed, at the time of the grape-harvest, the court of the monastery reflects in its vivid disarray all the multiple activities of the communal life of the inmates and their assistants. Here, on a dust-sheet, figs, purple and brown, are drying in the sun. Beyond, there are other piles of figs and walnuts. Upon a wooden structure stand rows of circular pewter trays supported on trestles, each covered with a paste of beaten tomatoes. Mules, each bearing a pair of tall, conical vats piled with grapes, clatter in and out over the cobbles. Clothes – calico underwear and socks of thick white wool – hang out to dry on the balconies, between the pots of basil and other herbs. Odd corners of the court are stacked with wood, faggots and logs. A carpenter works in the shade by the church, covering the ground with shavings, and from the oven hidden in a recess beneath one of the arches comes the rich smell of new-baked bread. And there is the sound of the shoemaker, emulator of the Apostle Paul, nailing leather strips on to the worn sole of a monastic slipper.

In the *sketae* and *kellia* there is also the gardening. Here, too, it is usual to find handicrafts – book-binding, wood-carving, icon-painting. Small wooden crosses are carved, as are spoons, seals, the portraits of saints. The best of these are done with the most delicate concentration on minute detail. A monk may spend ten or fifteen years carving in wood the Crucifixion, the Resurrection or other sacred subject. Each detail should conform to the set pattern of the iconographic tradition. The same, too, should apply to the icon-painting. Unfortunately, the strict forms of this tradition have on Athos given place in many cases to an insipid and sentimental naturalism, but there is now a return to more authentic standards.

In general, the life of the kelliote or monk of the *skete*, his cottage surrounded by strips of vineyard, fruit-trees, olive-trees and vegetable garden

with the sea spread out like a peacock's tail beneath, is still today much as it was when described by the eighteenth-century Athonite monk, Konstantinos Daponte, in a lyrical passage:

And I had a small axe and I cleared pine-trees, olive, holm-oaks, and I chopped them up. And sometimes I planted olives, sometimes pears, or apples, or almond-trees, or vegetables, leeks and garlic, and I rejoiced in the soil as the worldly man in money. I found myself in a garden of graces, in a true paradise of delight. And sometimes I went down to the sea and gathered limpets, shells, crabs, and sometimes prawns, and in these I rejoiced more than in courtly banquets of lords and ladies. Artaxerxes, the Persian king, founds figs and barley bread in the wilderness, and eating eagerly – for he was hungry – exclaimed: 'What delectable food.' And only now did I realize this, and I said the same thing many times to God. I was all gratefulness to the Lord, and my heart was full of unspeakable delight. The place was full of fragrance, the trees gave out their odours, birds flew round about, singing while one chanted, and the ground was covered with various flowers and lilies, delighting the eye and ear and filling one with gladness. . . . Hearing, sight, touch, smell, all offered thanks to God. You tire of the cell? Go out for a walk, strolling through the solitude's loveliness. Go to the spring, or to the sea-shore with its beauty. Go to the caves, to the cells of ancient ascetics, divine palaces, repeating always as you go the 'Kyrie eleison' so that you do not stop the flow of mercy. You see the mountain? the plain? Wonder at the creator's wisdom and power. . . . You see some beast? Do not fear – it will not harm you. . . . You see your terrible enemy, the devil? Do not be troubled: show him your cross. Your walk is over? Return to your cell, take your work-tool, or your papers. You tire of that? Take your spade up. You tire of the spade? Take again your axe. You tire of that? Take up your chaplet. The chaplet feeds the heart with joy. It is the hour for prayer. Embrace it eagerly, speak a while with God, with unspeakable joy, with such delight and honour as the Angels.[14]

After the prayer comes the sleep. This is restricted to as little as possible, often to no more than two hours at a stretch. Indeed, it is determined by the hours of the offices and prayer themselves, for these are obligatory for the monk. The monk divests himself of whatever goods he possesses when he enters the monastery. But property is an external and minor obstacle on the way of purification. It leaves the real bonds which bind the monk to the world unsevered. Fasts and manual work help to sever these. More powerful, however, is prayer. The monk's whole life, St Basil writes, should be a season of prayer, both public and private. The monk's day, which ends at sunset, is divided into a continual round of various offices and services. Matins lasts from shortly after midnight until, after a short break, the liturgy is sung, this finishing soon after the dawn. The liturgy of the day is prescribed in accordance with the Julian calendar, not with the Gregorian which the rest of the Orthodox world has adopted. Only one monastery – Vatopedi – adopted the latter calendar.

This daily, this annual pattern of work, sleep and prayer, punctuated only

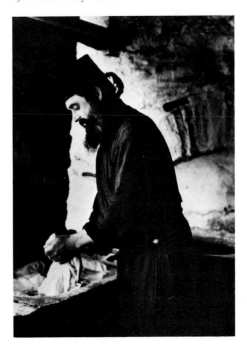

136 The laundry-room.

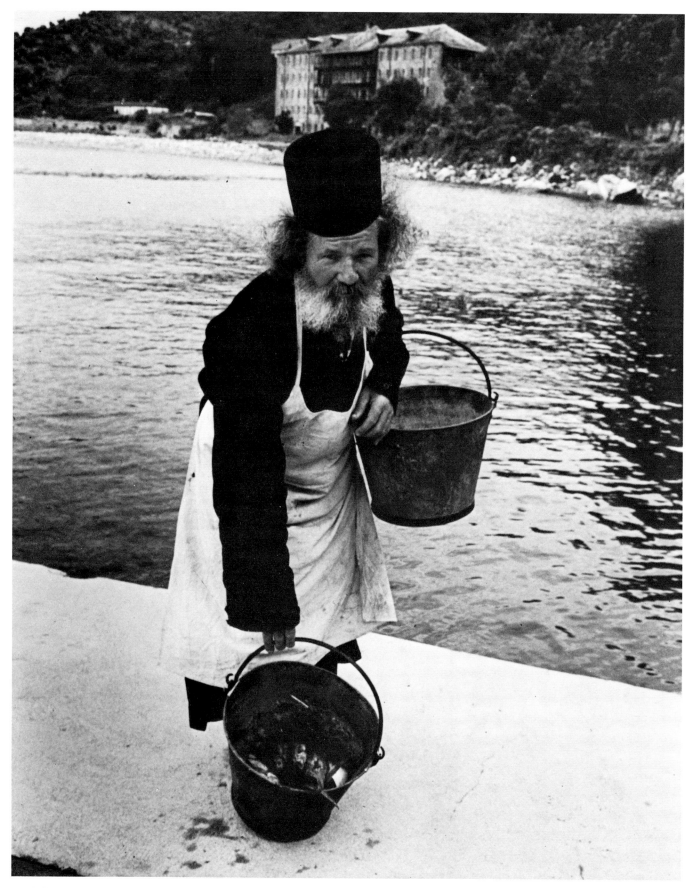

137 Collecting fish from the jetty.

by the meals and the feast-days, is the one that the monk follows toward purification. Social and physical activities are all directed to this end, they are stepping stones toward the attainment of the supreme goal, the spiritual life. They must all be carried out, but they must never be allowed to usurp the end to which they are the means. For this reason they are submitted to a rigorous and meticulous control and supervision. By submitting to this pattern the individual monk bit by bit performs that task of self-annihilation, through which his purpose may be realized. The way to this is the communal life. The monk works in common with other monks for the interest of his brotherhood; he eats at a common table, of the same food at the same time; he has the same church services and other religious ceremonies also at the same time, and he repeats the same prayers. He is dressed in the same way as his brothers. The whole uniform and repetitive pattern of conduct is a ritual enshrined in the monastic tradition. Every aspect of this ritual is permeated with symbolic significance, with the sense of something more than human, down to the last details. The monk of Athos enters into this rhythm of life the moment he enters the monastery. The clothes he puts on are symbolic of the 'angelic life'. In the liturgy, through the relics, the icons, the vestments, the monk is brought into contact with the divine presence. Administration, the installation of the abbot, of the Holy Assembly or of the Epistasia, is also given a ritual form. No workshop or store is opened without a religious ceremony, no work begun without prayer, no food eaten without a service of thanks, of dedication or of blessing.

Each act, steeped thus in symbolic or ritual meaning, is charged with a potential that goes far beyond its mere physical performance. It is linked to the most profound realities of the spiritual world. Submitting as though he had no higher aspirations and with a kind of obtuse compliance to the endless repetitive details of this pattern, with nothing demanded of him than that he should copy them without question or any long-winded explanation, he gradually discovers in the course of years that the form in which his life is immersed no longer oppresses but liberates. Through the mastery of these forms and their meticulous observation, he grows daily more capable of letting their impersonal inspiration reach him unimpeded by irrelevance or self-gratification. Their performance, his whole devotion to their traditional discipline, induces in him that vital loosening and equilibrium, that recollectedness and presence of mind, without which no spiritual work may be done. In this way he is brought into the right frame of mind for the next stage, that in which object and subject, the formal act and the spiritual content, begin to flow together without break; in which imitation is no longer so much a matter of copying the outer pattern, as of consciously learning to exercise control over the inner ways of concentration and selflessness. The monk is now brought face to face with new and unsuspected possibilities; and he may, if his strength is adequate, set out on the road to the mastery of that art of all arts and science of all sciences, the contemplative life.

THE WAY OF STILLNESS

Now hear things that strike us dumb with awe;
We are limbs of Christ and Christ is all our limbs;
He is my poor hand, my lowly foot,
and I am His own foot and hand.
I move my hand and Christ is all my hand;
divinity does not seem divided in me.
I move my foot and, see, His light illumines it.
Do not say I blaspheme, but manifest these things;
worship Christ, fulfil Him in yourself.
For if you want you will become His limb,
and so the limbs of each of us
become the limbs of Christ and Christ becomes our limbs.
All ugly things are changed to gracefulness,
clothed with heavenly beauty, heavenly splendour,
and we become as gods with God united.

St Symeon the New Theologian[15]

The contemplative life, and the training and exercise which lead up to it, have two principal aspects, the theoretical and the practical. Though the one cannot be separated from the other, it is only when the theoretical aspect is adequately grasped that the practical method can be properly applied. A monk may choose his profession for a number of reasons and some of these, such as disillusionment with the world, may have a somewhat negative character. A monk may even have the choice thrust upon him, simply through lack of any alternative. But it is only when the monk becomes aware of fresh possibilities within himself, and when this awareness is accompanied by the desire and the will to realize them, that the training and exercise which lead to the contemplative life can be effectively undertaken.

This sense of fresh possibilities, which may at first be floating, amorphous and without direction, is 'fixed', and is given coherence and direction, by the theory of the contemplative life. In becoming familiar with this theory, in relating his own life to a given framework of ideas, the monk gradually is able to see his own state no longer in purely subjective terms, but as part of an 'impersonal' and objective situation; and at the same time he is enabled to see

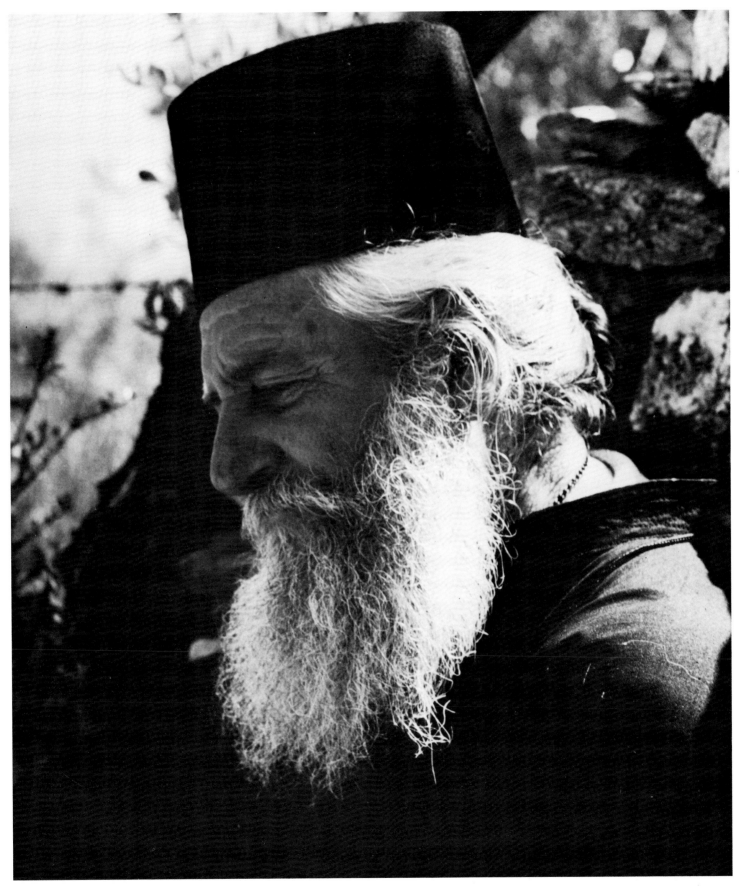

138 A hermit.

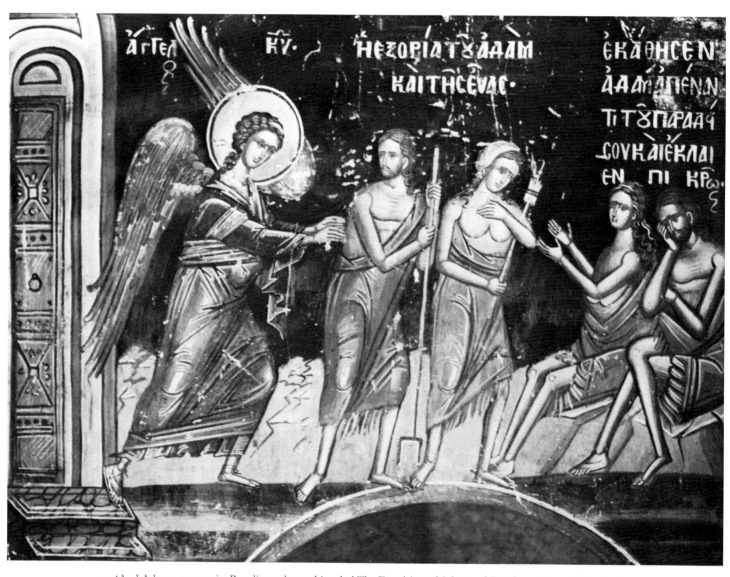

ἌΓΓΕΛ ΚΥ· Η ΕΞΟΡΙΑΤ ΫΑΔΑΜ ΕΚΑΘΗCΕΝ
ΚΑΙ ΤΗC ΕΥΑC· ΑΔΑΜ ΑΠΕΝΑ
ΤΙ ΤΫΠΑΡΑΔΙ
CΟΥ ΚΑΙ ΕΚΛΑΙ
ΕΝ ΠΙ ΚΡΩ·

139 'And Adam sat opposite Paradise and wept bitterly.' The Expulsion of Adam and Eve from Eden. Wall-painting
from the monastery of Dokheiariou.

what must be done in order to change it, and to work towards the realization of those new possibilities. This dawning of a new life has its counterpart in the idea of a life which has been lost, despoiled, forsaken; in the idea of a 'fall from Paradise'. Man 'in the beginning' – and this 'beginning' does not have merely a temporal sense – lives with a vitality and a richness of experience which he either now lacks completely or at best but feebly parodies. He lives 'in the beginning' in a spiritual state, able to perceive and to enjoy sensory things through the senses and intelligible things with the intellect. It is this state which he has lost, and has lost, according to the masters of the contemplative life, through his own fault. For, they say, instead of occupying himself chiefly with the perception and enjoyment of intelligible things, he became instead dominantly preoccupied with what is of a lower order, with sensory things alone. One of the masters writes:

I say not that man (Adam) should not have used his senses, for not in vain was he clothed in the body; but I say that he should not have dissipated himself in sensory things. Perceiving the beauty of created things, he should have ascended to their Cause and henceforth have delighted in wonder at this, having double reason to marvel at the Creator. He should not, abandoning intelligible beauty, have fastened upon sensory things. . . . Yet this is what he did. And because he used the senses wrongly, and marvelled at sensory beauty, thinking its fruit beautiful to the sight, and good to taste, and eating of it, he abandoned the enjoyment of intelligible things. Therefore the just Judge, judging him unworthy of what he scorned, of, that is, the contemplation of God and of all beings, deprived him of Himself and of immaterial realities, and made darkness His hidden place. For holy things must not be given to the profane; but what man loved, this God allowed him to enjoy, leaving him to live by the senses, and with small traces of spiritual vision.[16]

This loss of spiritual vision, and of the vitality and experience which go with it, has various consequences for man. These are often graphically described, as for instance by St Gregory of Sinai:

When God created the soul intelligent through breathing upon it, and spiritual through vital inspiration, he did not create in it rage or animal lust, but endowed it with a desiring power and in addition to this with an erotic virility of attraction; when he created the body he did not 'in the beginning' place in it anger and mindless desire. It was only later, through the transgression, that the body received, and became like, what is mortal, corruptible and bestial. For the body, say the theologians, although able to receive corruption, was created incorruptible, and so it will be resurrected, just as the soul was created, and will be resurrected, dispassionate: and both, the soul and the body, became corrupted and compounded together through the natural law of succession and of interaction one with another. And the soul was given over to the passions or, rather, to the demons, and the body became captive to a mindless bestiality, with the energy of that condition and under the domination of corruption. And the powers of both became one and formed a single senseless animality, subject to anger and to lust; and thus, according to the scriptures, man was brought down to the bestial level and was made like it . . .[17]

St Symeon speaks of the distress and anxiety of man estranged from the source of life and fallen into a world of instability and corruption:

A strange and most astonishing thing have I heard:
non-physical nature more hard than stone
suffered a change, as if a diamond
unsoftened by fire or iron
should become wax mixed with lead.
Lately I believed a small trickle of water
took years to hollow the rock's strength,
but really nothing in life is changeless.
From now on let no one think to cheat me.
Alas for him who sees the fleeting things of life
as permanent, and is content with them.
He, as my wretched self, will be misled.
Night from my most sweet brother has estranged me,
cutting love's uncut light.[18]

Allied to this teaching of man's fall into a world of transitoriness and corruption, of passions and blind thought, is that of a preceding fall of intelligible powers, Lucifer and his host of demons. Lucifer, first among the angels of light, was, as another expositor writes:

an immaterial, unsubstantial, formless and bodiless mind. But he gave rein to his imagination and filled his mind with images of being equal to God, and so became a devil, in a certain way material, multiform, and subject to passion. As he became, so also did his servants – all the demons. . . . the holy fathers call the devil a painter, a serpent of many forms feeding on the dust of passions, a breeder of fantasies, and other such names.[19]

It is the fantastic suggestions insinuated into man's soul by the devil that brought about man's 'fall':

Know that according to St Maximos, a great theologian, the first man, Adam, was also created by God without the faculty of the fantasy. His intellect, pure and free of fantasies, functioned as intellect and so itself acquired no form or image under the influence of the senses or from the images of sensory things. . . . But the devil, slaver of mankind, having himself fallen through his dreams of equality to God, instilled in Adam's mind that he too was equal to God and these fantasies led to Adam's fall. For this, he was cast down from this immaterial, pure, intelligent and imageless life, akin to the angels, into this sensory, complex, multiform life, immersed in images and fantasies – the state of animals devoid of reason. And after man fell into this state, who can tell to what passions, what evil disposition and what errors he was led by his fantasies?[20]

Soul and body are thus subjected to alien and parasitic powers. What the monk must realize before he has the impulse to set out on the contemplative path is that this present state is an abnormal, deformed state. His normal,

140 A monastery courtyard with the characteristic overhanging wooden balcony in the background.

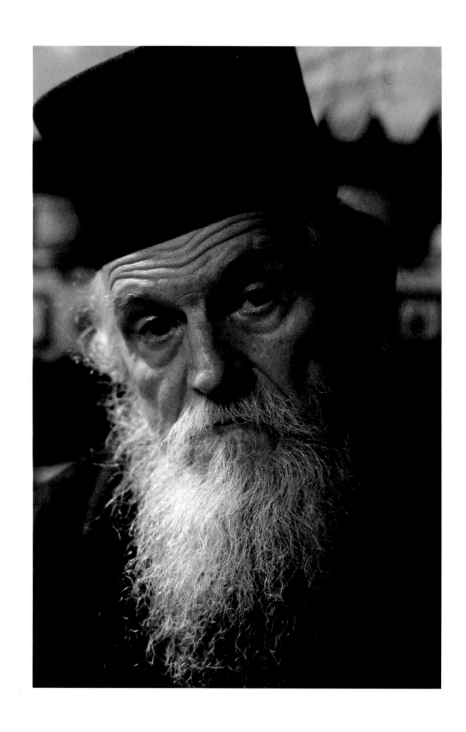

141 An old monk on Athos.

142 The Transfiguration of Christ on Mount Tabor. Detail of a wall-painting from the Protaton, Karyes.

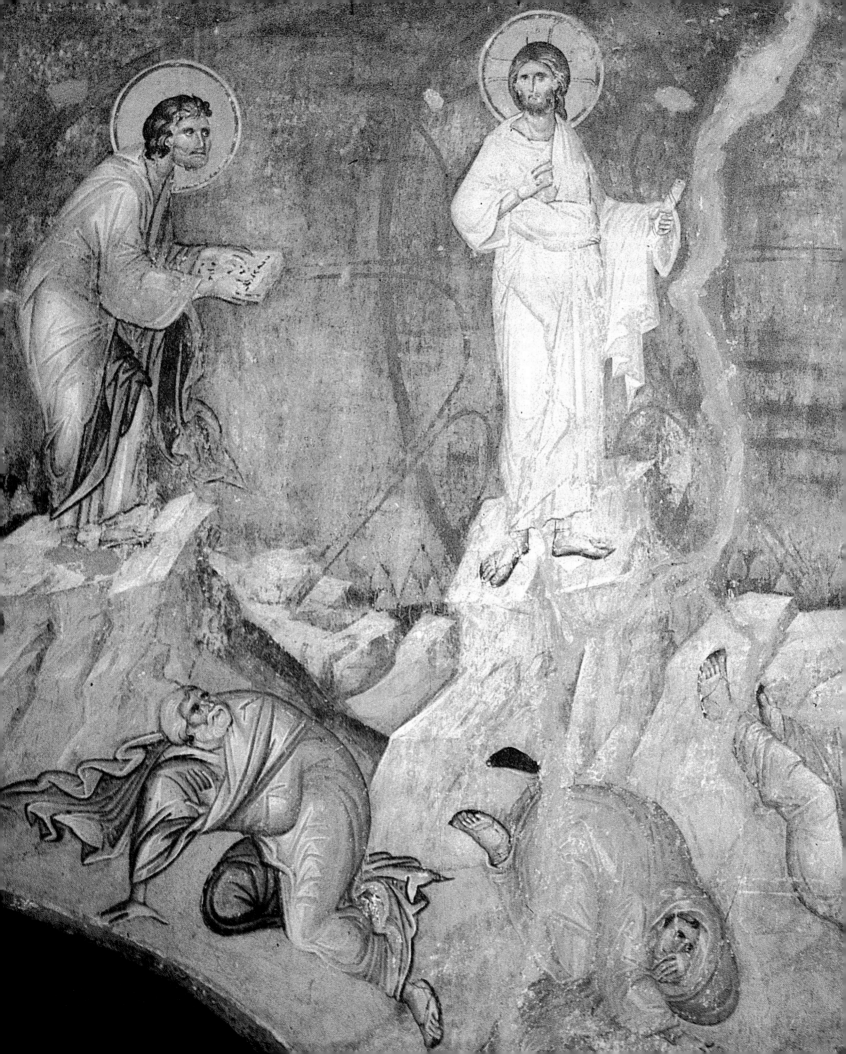

pristine state is the one which he has lost, and his first task consists in trying to recover his spiritual vision and the perception of realities now obscured from him. It is to commune once more with intelligible things. This is the communion for which he was created, which he has abandoned, and which his purpose on earth must now be to revive. The human heart constantly craves and seeks pleasures. It should find them in the inner order of things, by bearing in itself the knowledge and vision of the divine realities, of God in whose image man is created, and who is the source of all benediction:

But when in our downfall, we fell away from God, preferring ourselves, we lost also our foothold in ourselves, and fell into the flesh; thereby we went outside ourselves and began to seek for joys and comforts there. Our senses became our guides and intermediaries in this. Through them the soul goes outside and tastes the things experienced by each sense. It delights in the things which delight the senses; and out of all these together it builds the circle of comforts and pleasures, whose enjoyment it considers as its primary good. So the order of things has become inverted: instead of God within, the heart seeks for pleasures without and is content with them.[21]

Man's task is to reverse this inversion; it is to reawaken the divine image – to re-establish the kingdom of heaven – within. This task of re-establishing the lost order is not achieved at once. There are various obstacles and impediments which hinder man from attaining spiritual knowledge and a vision of divine realities. These may be divided into four main categories: first, the predisposition to practices which draw one towards earthly things; second, the activity of the senses which draw the mind to sensory beauties; third, the dulling of intellectual energy, as a result of the mind's entwining with the body; and fourth, the assault of unclean spirits.

To overcome these obstacles and to purify soul and body from all the consequences of the 'fall' is, then, the work which he who would attain the contemplative life must perform. Moreover, this purification consists not only, or even chiefly, in the purification of the body or in turning away from the pleasures of the senses; it consists above all in the purification of the soul, in completely abandoning its low deluded habits and dispositions, the worries of life, and the misplaced tendencies and ideas that have become established in it.

143 Traditional slated monastery roof.

After this purification, and the stilling or putting in order of unco-ordinated and disruptive powers, there should follow the spiritual ascent and deification. And this means 'not only to contemplate the most majestic trinity, but also to receive the divine influx and, as it were, to experience the deification, and by this influx to make good what is lacking in us and what is imperfect in us to make perfect. And this making good of what is lacking by means of that divine influx is the food of the intelligibles.' Once he begins to be fed again with this nourishment, man is already approaching the end of his task, the conquest of that state for which he was originally created. For from the reception of this nourishment comes

144 Sts John of Damascus and Comas the Poet, among the foremost poets of the Orthodox tradition, shown holding their poems. Detail of a wall-painting from the *katholikon* of the monastery of Dokheiariou.

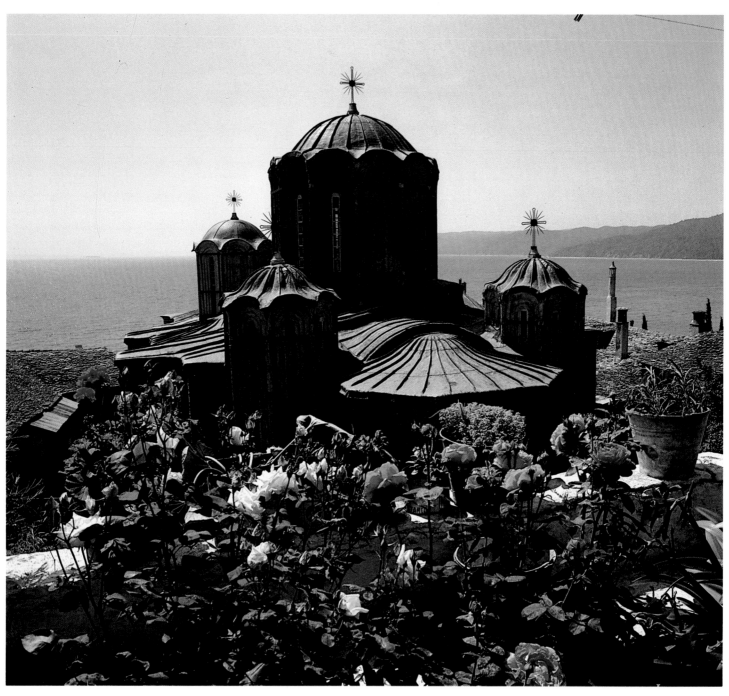

145 The roof of the *katholikon* at Dokheiariou, displaying the elegant elongated domes characteristic of Athonite church architecture.

an unceasing desire and love for the Lord Jesus Christ; and from this, the sweet inflowing spring of the heart's tears, through which soul and body as by hyssop are cleansed and enriched in repentance, in love, in thankfulness and in confession; and from these come quietness or the boundless peace of thoughts, surpassing all understanding; and from this comes illumination, lucid as snow; and finally, as far as it may to man, comes dispassion, or the resurrection of the soul before the body to its divine image and similitude, and our reformation and return to our original state through spiritual exercise, contemplation, faith, hope and love; and a total striving towards God, and a direct union with Him, ecstasy, rest and stability in Him, here in this present time as in a mirror, darkly, and as a betrothal, and in the coming time face to face, in a whole and perfect possession of God and an everlasting enjoyment of Him.[22]

To attain this lost, or obscured, state of spiritual communion, the monk must follow a definite way, a definite and systematic method, and this under the guidance of one who has himself followed this way and has become experienced in the inner working it entails. The first step on the way is the monk's withdrawal from the world itself. The 'world' represents all those habits and tendencies from which deliverance is now sought. Basil writes:

Our first step is to seek a retired habitation, lest through eyes or ears we receive incitements to sin and imperceptibly become accustomed to it, and impressions and forms of things seen or heard abide in the soul causing destruction and loss; and in order that we may be able to continue in prayer. For thus we should overcome previously formed habits, in which we lived alienated from the commandments of Christ – this entails no small struggle, to overcome one's accustomed mode of life, for habit strengthened by lapse of time gains the strength of nature – and we shall be able to rub out the stains of sin by toiling in prayer and assiduous meditation upon the will of God; to which meditation and prayer it is impossible to attain in a crowd, which distracts the soul and introduces worldly cares.

The next step is to find an experienced teacher. The need for such a teacher is continually emphasized by the masters of the contemplative tradition. Two of these Athonite masters write:

If a man is unlikely to take an unexplored path without a true guide; if no one will risk going to sea without a skilful navigator; if no man will undertake to learn a science or an art without an experienced teacher, who will dare to attempt a practical study of the art of arts and the science of sciences, to enter the mysterious path leading to God, and venture to sail the boundless mental sea, that is monastic life, akin to the life of the angels, and to be sure of reaching his goal without a guide, a navigator and a true and experienced teacher? Whoever such a man may be, he is deceiving himself indeed, and has gone astray even before starting, as one who does not conform to the law. On the contrary, a man who submits to the statutes of the fathers, reaches his goal before he has made a single step. How, without such help, can we learn to discriminate between good and evil, when bad passions cling to virtues and for ever stand at their door? How shall we contrive, without their help, to curb our bodily senses and harmoniously tune the

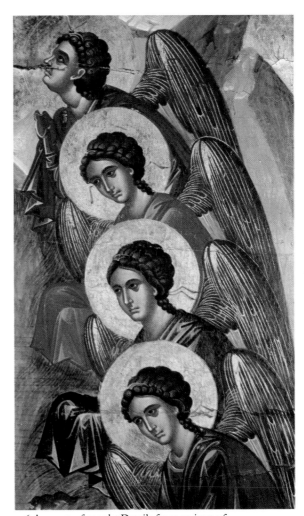

146 A group of angels. Details from an icon of the Baptism in the series of feast-day icons painted by Theophanes the Cretan. Sixteenth century.

powers of our soul, like strings in a harp? Above all, how can we, without these statutes, discriminate between voices, revelations, suggestions, divine visions, and snares, deceits and illusions of the demons? In a word, how can we attain union with God and learn the celebrations and sacraments, whose action is divine, without being initiated into these mysteries by a true and enlightened guide? In no way is this possible.[23]

The way the monk is to follow under the direction of his spiritual guide might well be called the 'way of stillness', for it amounts to an increasing study in and practice of stillness. One of the Fathers has given a concise description of the effect of this practice:

By means of stillness you must thoroughly cleanse the intellect, and give it constant spiritual exercise; for as the eye is turned upon sensory objects and marvels at what it sees, so the pure intellect turns to intelligible things, and is ravished by spiritual contemplation, and it becomes hard to tear it away. . . . By means of stillness it is stripped of the passions and purified, so it becomes worthy of spiritual knowledge. Then the intellect is perfect, when it tramples down its own knowledge and is united with God. Having thus attained kingly rank, the intellect cannot now bear to be impoverished and is not dragged down by false desires, even if all the kingdoms of the world are offered it. . . . Then there is great joy; and a keen desire burning in the soul, and the body also is ravished by the spirit, the whole man becomes spiritual. Such become those who practise blessed stillness and the strict life, and who, having withdrawn from every human consolation, in solitude converse clearly with our Lord in heaven alone.[24]

The actual practice of this 'way of stillness' consists of three main stages: the purification of soul and body from the effects of the 'fall', the raising of the intellect to meditation on divine realities, and the resurrection to an original God-like state. These stages are complementary and interdependent, although there is a certain sequence in the following of them which has to be observed. For instance, to attempt to practise the second stage before the first can produce harmful results. St Isaac explains why:

The service of the cross (that is of the monk who 'takes up the cross') is a double one. And this is in accordance with its two-fold nature: first, patience in the face of bodily afflictions, which is called 'practice', and, second, the subtle service of the intellect, in intercourse with God, constant prayer, and so on, which is called contemplation. The first purifies through zeal the passionate part of the soul, the second the intellectual part. Everyone who, before being trained in the former part, passes to the latter, on account of the pleasure it affords, wittingly or unwittingly causes God's anger to fall upon him; for, not having mortified his members on the earth, not having that is, healed the sickness of his intellect by endurance under the labours and the shame of the cross, he has presumed to occupy his intellect with the glory of the cross.[25]

He further defines what he means by this double service of the cross:

Let the practical activity of virtue be regarded by you as the body, and contemplation as the soul. The two form one complete spiritual man, composed of sensible and intelligible

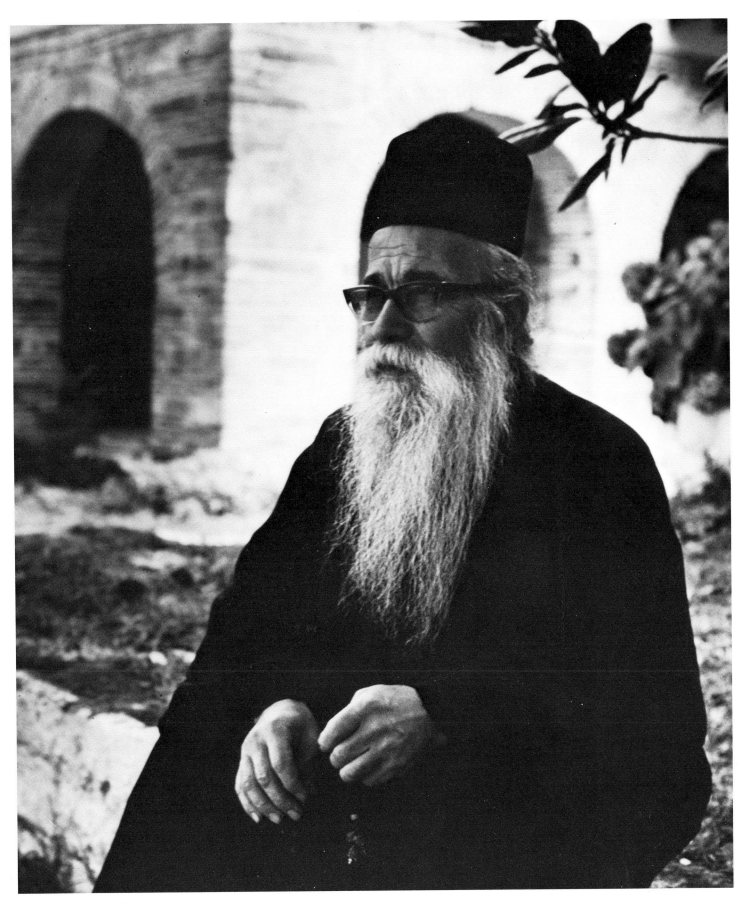

147 Father Athanasios Lavriotes.

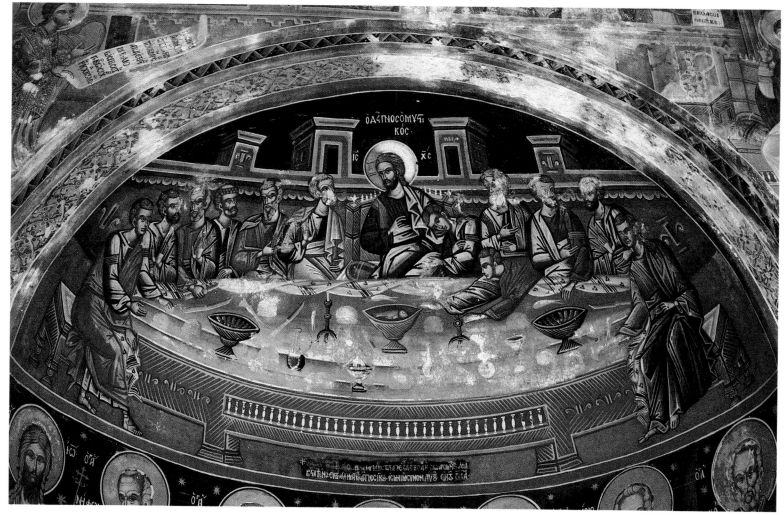

148 The Last Supper. Wall-painting from the refectory at Dionysiou.

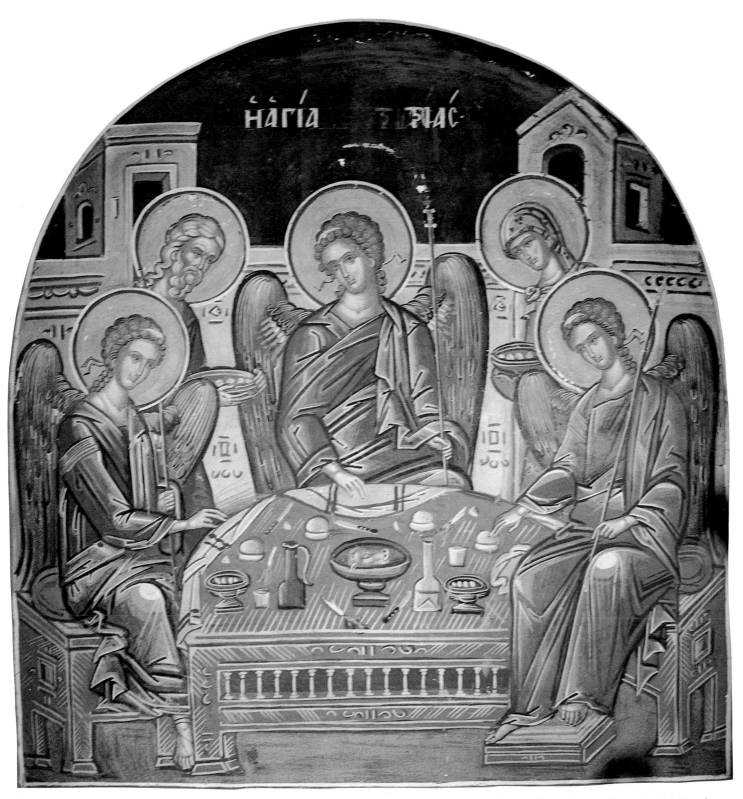

ΗΑΓΙΑ ΤΡΙΑΣ

149 The Holy Trinity. Known also as The Hospitality of Abraham, this scene depicts Abraham and Sarah acting as hosts to the angels of the Lord.

163

parts. And just as it is not possible for the soul to come into existence and birth before the forming of the body, so it is not possible for contemplation, the second soul the spirit of revelations, to be formed in the womb of the intellect by the reception of spiritual seed, without the active practice of virtue.[26]

The first stage of the way, the purificatory stage, is, then, this active practice of virtue, which consists in freeing mind and body from the various alien attachments by which they are bound. But this purification itself has different aspects. The first is the curbing of the senses, so that attention is not continually led out to wander in the labyrinth of sensible objects and pleasures. This requires mortification of 'the members that are upon earth' by the renunciation of possessions, obedience, chastity, fasting, vigils, little sleep, manual labour, and so on – by, in fact, those ascetic practices of which we spoke as typifying the life of the monk. Following this comes the cultivation of positive virtues, variously named and assessed but including courage, wisdom, chastity and righteousness.

Yet the practice and cultivation of the virtues, although indispensable to one who wishes to tread the path to the contemplative life, are not in themselves sufficient to reach the goal. Indeed, in and for themselves they are likely to be quite sterile, a mere external appearance of true asceticism. They should therefore be accompanied by the more inward working of prayer and attention – by that whole process of what is called the guarding of the heart and mind, or watchfulness. One of the masters has written of this relationship between the more outward and the more inward aspects of the purificatory stage in the following terms:

The Old Testament is the image of external achievements of body and senses; but the holy Gospels, which are the New Testament, are the image of attention or purity of heart. The Old Testament did not lead to perfection, did not satisfy the inner man in his work of pleasing God, nor did it give him a surety. . . . You should understand the same about bodily righteousness and bodily labours – about fasting, I mean, and abstinence, about sleeping on bare earth, standing, vigils and other works usually undertaken to subdue the body and to quieten the sinful movements of the passionate parts of the body. Naturally, all this is also good . . . because it serves to educate our outer man and to protect him from passionate deeds. But these labours do not guard us against mental sins . . . envy, anger and the like. But when purity of heart, that is, watching and guarding the mind, the image of which is the New Testament, is observed by us as it should be, it cuts off from the heart all passions and all evil. It uproots evil and brings in its place joy, good hope, contrition, mourning, tears, knowledge of ourselves and of our sins, memory of death, true humility, immeasurable love for God and men and divine zeal of the heart.[27]

It is, then, with the achieving and preserving of a purity of heart through control of the mind, or watchfulness, that the inward working is concerned. Wandering thoughts, the perverse and deceptive fantasies insinuated into the mind by the demons, take man's attention far from the recollection of divine

164

150 From a monastery court.

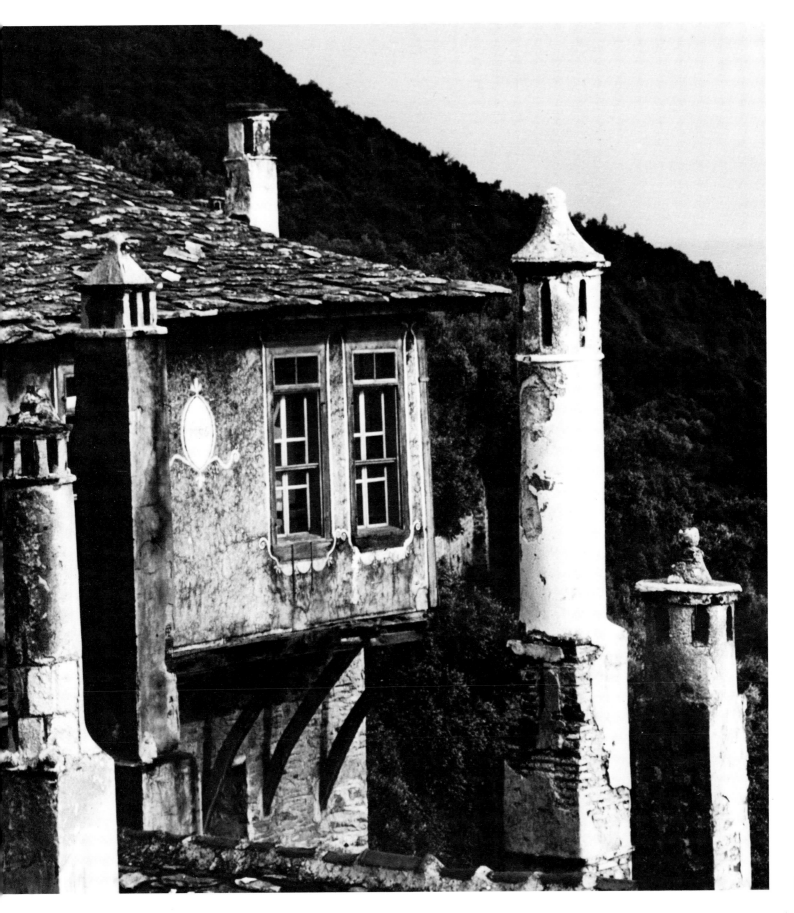

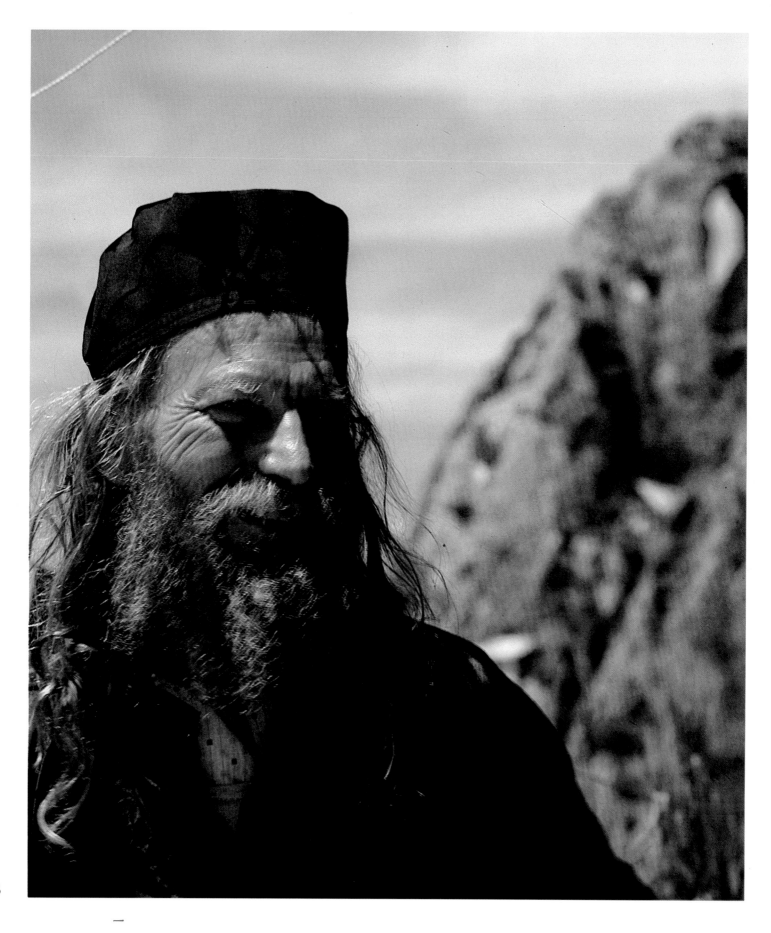

151 *Left* An eremitical father.

152 The Holy Mountain above mist and forest.

things and from communion with God. Watchfulness is a spiritual art which, with long and diligent practice and with the help of God, releases man completely from passionate thoughts and words and from evil deeds. In itself it is, in essence, purity of heart; and on account of its greatness and its high qualities or, more precisely, on account of our inattention and our carelessness, is very rarely to be found. Watchfulness, if it is constant in a man, becomes his guide to a righteous and God-pleasing life.

How, then, is this watchfulness achieved? Several ways are recommended, such as watching any suggestion of fantasy closely and having the remembrance of death always in mind. But one of the chief ways, and the one to which most attention is given, is the practice of the 'Jesus Prayer'. It is simple and short: 'Lord Jesus Christ, Son of God, have mercy upon me, a sinner', or a modification of this. What is crucial is its invocation of the Divine Name of Jesus. For, ultimately, the purification of the mind and heart does not depend upon human action alone, but on the cleansing fire of the Divine; it is this which, becoming active in the heart, liberates man from his unnatural fallen state. The invocation of the Divine Name is no less than the calling down of the divine cleansing fire. 'Call humbly and unceasingly on our Lord Jesus Christ for help', is the counsel given. And the same writer continues: 'In so far as you have perfect attention in your intellect, by so much will you pray to Jesus with warm desire. And again, in so far as you watch over your intellect carelessly, by so much will you become distant from Jesus. And as perfect attention entirely fills the air of the intellect with light, so too, to be without watchfulness and the sweet invocation of Jesus makes it dark.'[28]

This inner prayer of the heart is not something immediately and effortlessly acquired:

The excellence of the gift of the grace, in which we seek to participate, requires us to make corresponding efforts within our powers, and to establish the hours and limits of this work, the purpose of which, according to our holy teachers, is to cast the enemy out of the pastures of the heart and to have Christ actively abide there instead. Thus St Isaac says: 'He who wishes to see the Lord within himself must use every effort to purify his heart by constant remembrance of God; in an intellect thus illuminated he will see the Lord at all hours.'[29]

By means of this prayer, and the watchfulness and purity of heart achieved through it, the aspirant reaches the second stage of the 'way of stillness', that in which he begins to perceive and have a knowledge of divine things:

Then the intellect, in harmony with love, becomes fruitful in wisdom and, under the influence of wisdom, announces wondrous things. For God the Word, invoked by Name in the praying heart, takes out discursive reason like a rib, and gives knowledge. Putting right order in its place, he bestows virtue, creates light-giving love and brings it to the intellect withdrawn into ecstasy, asleep and at rest from every earthly lust.[30]

The end of the purificatory stage has also led to the beginning of man's regeneration to the life he lost through his 'fall':

153 Father Gelasios ('the Smiling One') and his cats.

169

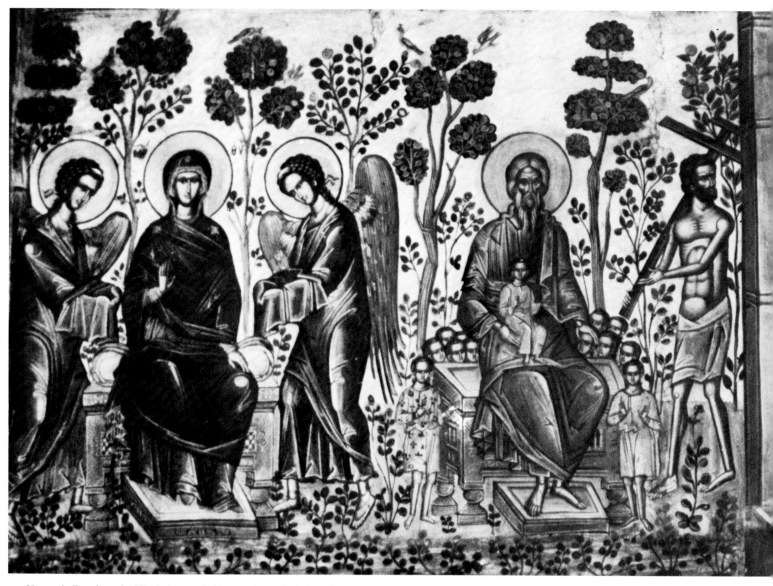

154 Heavenly Paradise: the Virgin is attended by angels on the left, and God the Father is enthroned with the Son on his lap in the centre. To the right the saints are coming into Paradise. Wall-painting from the narthex of the monastery of Dokheiariou.

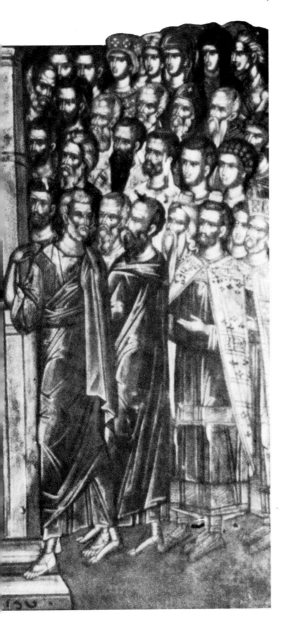

When a man has achieved rest from warfare and is granted spiritual gifts, he is constantly acted upon by grace, and so becomes permeated with light and can no longer be turned from the contemplation of spiritual things. Such a man is attached to nothing in this world; for he has passed from death into life. . . . A man who strives and is close to God, who shares in His holy light and is wounded by love of Him, delights in an ineffable spiritual delight in the Lord.[31]

Watchfulness and prayer lead, consequently, not only to the perception and enjoyment of divine realities, but to union with the Divine Itself. And in this union, the 'way of stillness' achieves its third and final stage. For in it, man is resurrected to, or renewed in, that state for which he was created 'in the beginning'. He achieves his 'deification' and becomes himself God-like. St Makarios speaks of this total renewal of the whole man, soul and body:

Every soul which by faith and zeal in all virtues has been clothed in Christ even in this life, authentically and effectively, always receives a concrete knowledge of heavenly mysteries, since it is united with the heavenly light of its own incorruptible image. But in the day of resurrection for the sake of the same glorious heavenly image, the body will equal the soul in glory and will be caught up by the Spirit to meet the Lord in the air, since it has become conformable to the body of his glory.[32]

St Gregory Palamas adds that, in this resurrected state: 'Man, being himself light, sees the light with the light; if he regards himself, he sees the light, and if he regards the object of his vision, he finds the light there again, and the means that he employs for seeing is the light; and it is in this that union consists, for all this is but one.'[33] And in a short poem, St Symeon describes one who is thus perfected, and in whom the contemplative life is fulfilled:

*Solitary, one who is unmixed with the world,
and continually speaks with God alone.
Seeing he is seen, loving he is loved,
and he becomes light glittering unspeakably.
Blessed he feels himself more poor,
and, being close, yet goes a stranger.
O miracle strange in every way and inexplicable!
For immense richness I exist penniless,
and having as I think nothing, possess much,
and I say I thirst, in the midst of waters.*[34]

155 Detail from an Athonite stone relief of the Byzantine period.

NOTES

1 See Hon. Robert Curzon, *A Visit to the Monasteries in the Levant* (London 1849).

2 See Konstantinos Daponte, *The Garden of Graces* (Athens 1880).

3 For the Life of Peter the Athonite, see Kirsopp Lake, *The Early Days of Monasticism on Mount Athos* (Oxford 1909).

4 For the Life of St Euthymios of Thessaloniki, see Kirsopp Lake, op. cit.

5 For the Life of St Athanasios the Athonite, see Philipp Meyer, *Die Haupturkunden für die Geschichte der Athosklöster* (Leipzig 1894).

6 From 'To my Pupil Nicolas', translated by A. Gardner, *Theodore of Studium (London 1905)*. Later citations from St Theodore are also to be found in this work.

7 Cited by Michael Choukas, *Black Angels of Athos* (London 1935).

8 See Manuel I. Gedeon, *Athos* (Constantinople 1885).

9 For this account of St Antony's life, see St Athanasios' *Life of St Antony*. Palladius' edition, translated by E. A. Wallis Budge (London 1907).

10 John Cassian was a Western monk who spent some years in Egypt and wrote about his experiences of the monastic life there.

11 This and later citations from the works of St Basil are from *The Ascetic Works of St Basil*, translated by W. K. L. Clarke (London 1925).

12 *The Painter's Manual*, by Dionysios of Fourna, monk and painter. Second edition, in Greek (Athens 1885).

13 See Christoforo Buondelmonte, *Description des Iles de l'Archipel*, edited by E. Legrand (Paris 1897).

14 Konstantinos Daponte, *The Garden of Graces*, op. cit.

15 See Hymn XV in Syméon le Nouveau Théologien, *Hymnes I* (Sources Chrétiennes, Paris 1969).

16 From 'The Theoretikon of the Blessed Theodore', in the *Philokalia* (Athens 1893).

17 From St Gregory of Sinai, 'Texts on Commandments and Dogmas', in the *Philokalia*, op. cit.

18 See Hymn X in Syméon le Nouveau Théologien, *Hymnes I*, op. cit.

19 From Nicodemus of the Holy Mountain, in *Unseen Warfare*, translated into English by E. Kadloubovsky and G. E. H. Palmer (London 1952).

20 Ibid.

21 Ibid.

22 From 'Directions to Hesychasts by the Monks Callistus and Ignatius', in the *Philokalia*, op. cit.

23 From 'Directions to Hesychasts by the Monks Callistus and Ignatius', cited from *Writings from the Philokalia on Prayer of the Heart*, translated by E. Kadloubovsky and G. E. H. Palmer (London 1951).

24 From 'The Most Profitable Narrative of Abba Philemon', in the *Philokalia*, op. cit.

25 From 'Six Treatises on the Behaviour of Excellence', translated by A. J. Wensinck, in *Mystic Treatises by Isaac of Nineveh* (Amsterdam 1923).

26 Ibid.

27 From Hesychius of Jerusalem, to Theodulus, 'Texts on Sobriety and Prayer', in *Writings from the Philokalia*, op. cit.

28 Ibid.

29 From 'Directions to Hesychasts by the Monks Callistus and Ignatius', in *Writings from the Philokalia*, op. cit.

30 From 'Nine Texts by Theoleptus, Metropolitan of Philadelphia', in *Writings from the Philokalia*, op. cit.

31 From 'The Narrative of Abba Philemon', in *Writings from the Philokalia*, op. cit.

32 Cited in 'Directions to Hesychasts by the Monks Callistus and Ignatius', in *Writings from the Philokalia*, op. cit.

33 See Triade II, 3, 36, in Grégoire Palamas, *Défense des saints hésychastes*, edited by Jean Meyendorff, Vol. 2 (Louvain 1959).

34 See Hymn III in Syméon le Nouveau Théologien, *Hymnes I*, op. cit.

Bibliographical Note

References to many works, historical, descriptive and spiritual, relating to Mount Athos and cited in the text have been given in the notes above. But I am also indebted to several other works, notably perhaps to Robert Byron's *The Station* (London 1928), R. M. Dawkin's *The Monks of Athos* (London 1936) and Amand de Mendieta's *Le Presqu' île des caloyers. Le Mont Athos* (Paris 1955) that have received no explicit mention. For an exhaustive bibliography on the subject, see *Le Millenaire du Mont Athos 963–1963, Etudes et Mélanges*, 2 Vols (Chevetogne 1963–4). I would like also to draw attention to the new translation into English of *The Philokalia*, that collection of texts on the spiritual life as practised on the Holy Mountain, which is currently being published in three volumes by Faber & Faber (London; Vol. I and II 1982; Vol. III to follow).

INDEX

WITHDRAWN

i·WASIC